NEW DIRECTIONS IN
SOCK
KNITTING

18 *Innovative Designs* **KNITTED FROM EVERY WHICH WAY**

Ann Budd

INTERWEAVE.
interweave.com

Table of Contents

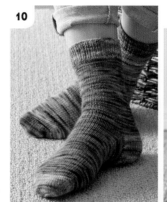

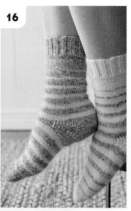

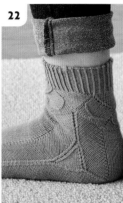

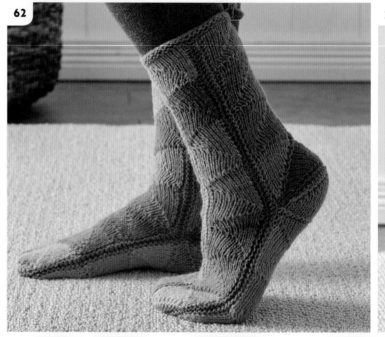

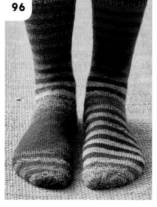

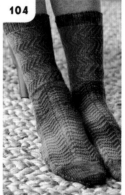

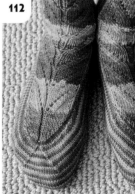

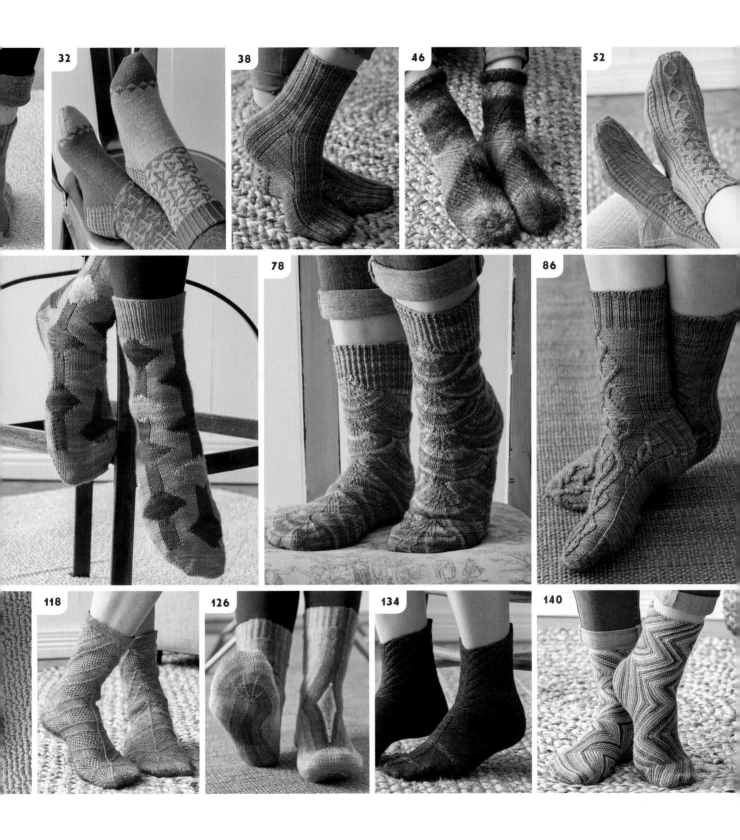

32

38

46

52

78

86

118

126

134

140

INTRODUCTION
SOCKS EVERY WHICH WAY

When I set out to acquire socks for this book, I wanted to assemble a collection that differed from every other sock book on the market—hence the title *New Directions in Sock Knitting*. In this book, you'll find an array of socks that deviate a little to a lot from the traditional top-down or toe-up construction. From the imaginative ways that heels, gussets, and toes are formed to the ingenious directions of the knitting, this book will change the way you think about knitting socks.

The eighteen designs herein represent the efforts of seventeen designers who have puzzled out new ways to knit socks. The designs range from quite simple socks that are appropriate for first-time sock knitters to quite challenging socks that may require a leap of faith for those accustomed to traditional sock constructions.

The socks in this collection include mitered triangles and scallops, double knitting, intarsia in the round, short-row shaping, mirrored color and texture patterns, the addition of laceweight mohair for warmth and durability, and multiple knitting directions. In all cases, the instructions are written in step-by-step detail that will ensure success, no matter which design you choose to knit.

The designs are separated into three chapters. Chapter 1 (beginning on page 8) covers socks that are knitted from the top down. Chapter 2 (beginning on page 60) includes socks that are knitted from the toe up. But don't expect "normal" socks in these chapters—they all feature something different, whether it's unusual heel, gusset, or toe shaping, a clever use of color, or a neat trick in construction. Chapter 3 (beginning on page 94) includes socks that are knitted from side to side, bottom of the sole to the top of the leg, and in multiple directions. These socks include true engineering feats that are the marks of sock-knitting genius.

But before you begin any sock, you need to take fit, yarn, and gauge into consideration.

Fit

The best way to determine the size to knit is to wrap a tape measure around the widest part of your foot (**Figure 1**). To measure your foot length, place a ruler on the floor and lightly step on it, aligning the back of your heel with the "0" and measuring the length to the tip of your longest toe (**Figure 2**). To measure your leg length, hold a ruler against a wall with the "0" on the floor, then place the back of your leg against the ruler and measure how high up your leg you want the sock to extend (**Figure 3**). If you're knitting socks as a gift, use the table on page 5 to get a general idea of foot (and therefore sock) size based on shoe size.

In general, socks should fit with negative ease so that the stitches have to stretch to hug the foot and leg.

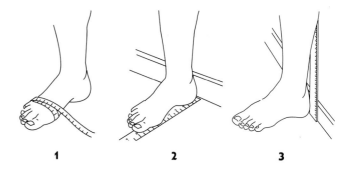

1 **2** **3**

Choose a finished size that's about ½ to 1 inch (1.3 to 2.5 cm) smaller in circumference than your actual foot measurement, unless otherwise directed. If there's not enough stretch, your foot will slide back and forth in the sock and cause friction points that are likely to wear out more quickly that the rest of the sock.

Yarn and Gauge

Many sock yarns contain some percentage of man-made fiber (such as nylon) that adds strength to the dominant fiber (typically wool). If your yarn doesn't contain one of these additions, consider working a strand of reinforcing nylon thread or yarn (available at most knitting stores that carry sock yarn) along as you knit the heel, toe, and any other areas of stress. Although the nylon doesn't prevent the yarn from wearing, it's much slower to wear and therefore provides a thin foundation of stitches that you can use as a guide for darning worn areas.

The knitted fabric of a sock should be sturdy enough to withstand the friction that results from walking and rubbing inside a shoe. A perfectly fitting sock will not wear well if the stitches are so loose that they slide along the path of friction at the toes, bottom of foot, and back of heel. For me, the sturdiest socks are knitted at a gauge that's one stitch per inch (2.5 cm) tighter than recommended on the ball band. For example, if the ball band recommends knitting at a gauge of 7 stitches per inch (2.5 cm), I'll knit that yarn at 8 stitches per inch

(2.5 cm). Denser stitches wear better because only the outer fibers are subject to abrasion. But be careful not to knit the sock so densely that elasticity is lost and the sock can't be pulled over your heel.

Be sure to measure your gauge on a swatch that has been knitted the same way (in rounds or rows) that the sock will be knitted, using the same yarn, needles, and stitch pattern you'll use for the sock. Many knitters knit more tightly than they purl, or vice versa, so that the gauge they get working stockinette stitch in rounds (when the right side is always facing forward) is different from the gauge they get knitting back and forth in rows (when stockinette stitches are alternately knitted and purled). Work a swatch large enough that you can measure at least 2 inches (5 cm) both horizontally (stitch gauge) and vertically (row gauge) well away from the edges of the swatch. To ensure an accurate reading, take measurements in two or three places. Also, be sure to include any partial stitches in your gauge measurements. Although a half stitch may not seem significant over a 2-inch (5-cm) width, it can add an inch or more to the entire sock circumference.

SOCK SIZE AS A FUNCTION OF SHOE SIZE

U.S. (EUROPEAN) SHOE SIZE	FOOT CIRCUMFERENCE	TOTAL FOOT LENGTH
Children's 9–12 (26–30)	6½" (16.5 cm)	7" (18 cm)
Children's 1–4 (31–34)	7½" (19 cm)	8¼" (21 cm)
Women's 5–7 / Men's 4–6 (35–38)	8" (20.5 cm)	9½" (24 cm)
Women's 8–10 / Men's 7–9 (38.5–43)	9" (23 cm)	10¼" (26 cm)
Women's 11–14 / Men's 10–13 (44–48)	9¾" (25 cm)	11" (28 cm)

HOW MUCH YARN DO YOU NEED?

The amount of yarn you'll need for a pair of socks depends on the gauge and sock size. In general, the finer the yarn and the bigger the sock, the more yarn you'll need. If you plan to add a heavily textured pattern such as cables, you'll also need more yarn. Use the table here as a guideline for yarn amounts based on gauge and foot circumference.

		FOOT CIRCUMFERENCE			
		8¼" (21 cm)	9½" (24 cm)	10¼" (26 cm)	11" (28 cm)
GUAGE	6 stitches/inch	266 yd (243 m)	317 yd (290 m)	394 yd (361 m)	466 yd (426 m)
	7 stitches/inch	293 yd (268 m)	349 yd (319 m)	434 yd (397 m)	513 yd (469 m)
	8 stitches/inch	322 yd (294 m)	384 yd (351 m)	477 yd (437 m)	564 yd (516 m)
	9 stitches/inch	357 yd (326 m)	423 yd (387 m)	524 yd (479 m)	620 yd (567 m)

Needle Choice

Historically, most socks were knitted using double-pointed needles with the stitches held on three or four needles, and a fourth or fifth needle was used to knit with. More recently, knitters use circular needles that they find easier to manage and that reduce the number of transitions between needles within each round of knitting. Most of the projects in this book specify the needle configuration the designer used, but as long as you keep track of the instep (or front-of-leg) stitches, the sole (or back-of-leg) stitches, and any other key sections of the pattern, you can substitute the type of needle you prefer, as long as it's long enough to hold the specified number of stitches (an important consideration with the socks that are knitted side to side).

One Very Short Circular Needle

Recently, 9-inch and 12-inch (23- and 30.5-cm) circular needles have been manufactured specifically to accommodate the relatively small number of stitches around a sock. The rigid needle sections at the tips of these needles are quite short and take some getting used to, but the advantage is that all of the stitches are on a single needle, and you can knit around and around without interruption. It's a good idea to use markers to separate the front-of-leg (instep) stitches from the back-of-leg (sole) stitches to ensure that the heel and toe stitches are perfectly aligned. The round typically begins at the back of the leg and along the bottom of the sole.

Many of the socks in Chapters 1 and 2 can be knitted with this type of needle.

Four or Five Double-Pointed Needles

Most Americans learn to knit socks with four double-pointed needles—the stitches are distributed between three needles and the fourth is used for knitting. When you work from the top down, the stitches can be evenly distributed on three needles while working the leg, but they're rearranged at the start of the heel flap so that the heel stitches are worked on one needle while the instep stitches are distributed equally between the other two. After the heel is completed, the stitches are rearranged so that half of the heel stitches are on the first needle (Needle 1), all of the instep stitches are on the second needle (Needle 2), and the remaining half of the heel stitches are on the third needle (Needle 3). The round typically begins at the back of the leg and along the bottom of the sole.

Europeans typically learn to knit socks with five double-pointed needles—the stitches are distributed between four needles and the fifth is used for knitting. The stitches are arranged so that the back-of-leg, heel, and sole stitches are equally divided between two needles, and the front-of-the-leg and instep stitches are equally divided between the other two. The round typically begins at the back of the leg and along the bottom of the sole.

Many of the socks in Chapters 1 and 2 can be knitted with these needle configurations.

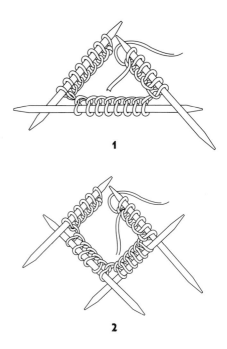

1

2

Two Circular Needles

Some knitters prefer to knit socks on two circular needles. The back-of-leg, heel, and sole stitches are worked on one needle, and the front-of-leg and instep stitches are worked on the second. For this method, the round begins at the side of the leg (between the instep and sole). The key is to keep the stitches and the needles separate—each needle is used only for the stitches it holds. Most followers of this method use 16-inch or 24-inch (40 or 60 cm) circulars, which have longer rigid needle sections that are easy to handle. The advantages are 1) because there are only two breaks between the needles, no needle is ever completely empty (making it difficult to lose one), and 2) the stitches can stretch over the cables, allowing the sock to be tried

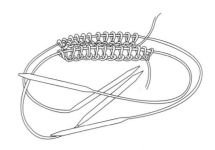

on as it's in progress. However, some knitters find that the needle not in use flops about in an annoying way.

Anne Campbell's Zigzags (page 104), Jennifer Leigh's Tilt-A-Whirl (page 4), and Heidi Nick's Gold Digger (page 52) specify this needle configuration.

One Long Circular Needle (Magic Loop)

In a method called "the magic loop," Sarah Hauschuka simplified the method of working socks circularly on a single 40-inch (100 cm) circular needle. To use this method, cast on the stitches as usual, then slide them to the center of the cable, fold the cable and stitches exactly at the midpoint, pull out a loop of cable in the center of the cast-on to make two sets of stitches, then slide each group toward a needle point. Half of the stitches will be on one needle tip and the other half will be on the other tip. Hold the needle tips parallel so that the working yarn comes out of the right-hand edge of the back needle tip. *Pull the back needle tip out to expose about 6 inches (15 cm) of cable and use that needle to knit the stitches off the front needle tip. At the end of those stitches, pull the cable so that the two sets of stitches are at the ends of their respective needle tips again, turn the work around, and repeat from *. When working the socks, the back-of-leg, heel, and sole stitches are in one group, and the front-of-leg and instep stitches are in the other group. The round begins at one side of the leg, between the two sections. The advantage to this method is that all of the stitches are on a single needle so there's no chance of losing the needle. But some knitters are distracted by the "wings" of cable loops between the groups of stitches.

Louise Robert's Boomerang (page 112), Jeny Staiman's Vanishing Point (page 126), and Natalia Vasilieva's Smokey ZickZacks (page 140) specify this type of needle for its length. Their socks are knitted in unusual constructions that involve stitches for the leg and foot to be worked at the same time.

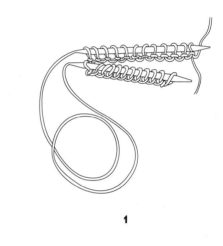

1

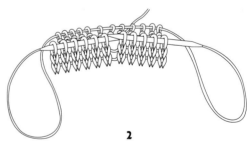

2

Armed with this information, you're ready to start your own adventure in knitting socks in new directions. Even if you opt not to knit every sock shown, I encourage you to read the chapter introductions as well as the individual sock introductions to get a feel for the huge variety and technical mastery they exhibit!

—Ann Budd

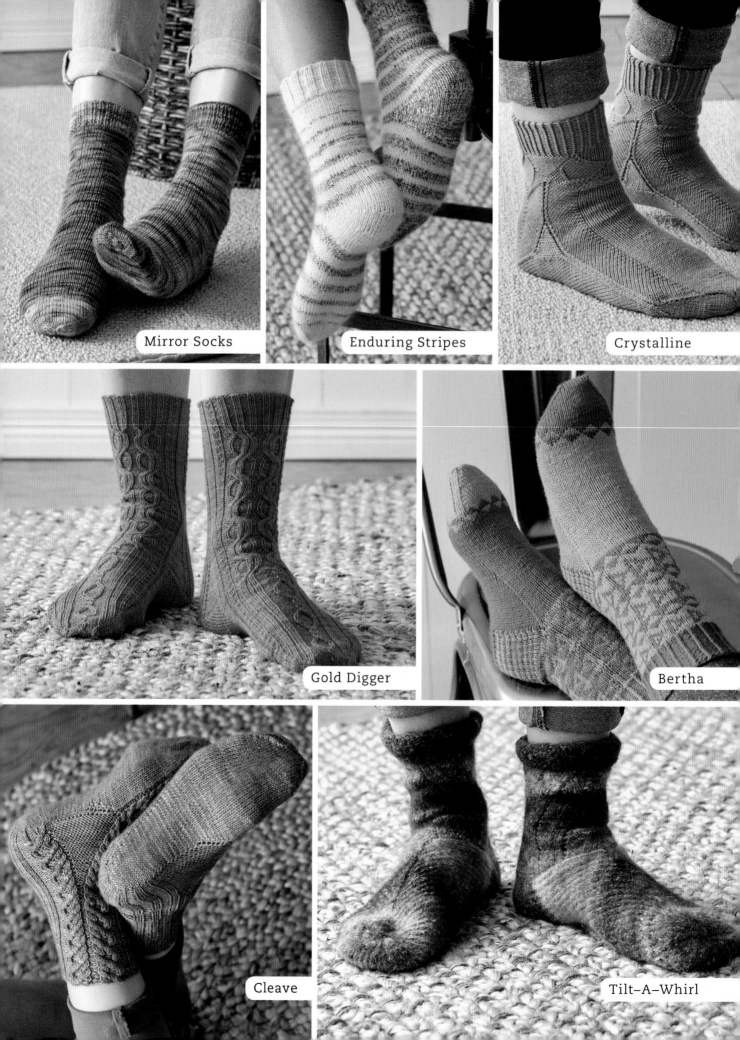

Mirror Socks

Enduring Stripes

Crystalline

Gold Digger

Bertha

Cleave

Tilt-A-Whirl

CHAPTER 1
TOP-DOWN CONSTRUCTION

Top-down sock construction is probably the most common method among Western knitters. The sock begins with a flexible cast-on that can stretch over the heel. The leg is typically worked to the desired length, then the heel stitches are worked back and forth in rows for the heel flap and heel turn. Stitches are picked up along each side of the heel flap, then rejoined to the instep stitches for working in rounds while gusset stitches are decreased to the desired number of foot stitches. The foot is worked in rounds to the toe, which can be shaped a number of ways.

The seven socks in this chapter follow the general top-down method, but include clever alterations or deviations that make uncommon socks from this common method.

Kate Atherley's **Mirror Socks** (page 10) are somewhat of a knitted puzzle. The socks are worked simultaneously, one inside the other, and not separated until the toes are complete. Then, the inner sock is pulled out of the outer sock. For fun—and a bit of mental exercise—Kate alternated the colors for the cuff, leg, heel, foot, and toe on the two socks.

Cat Bordhi's **Enduring Stripes** (page 16) are worked according to standard top-down construction, including her signature Sweet Tomato Heel. Cat added two colors of laceweight mohair along with the sock yarn to provide extra strength, warmth, and a striped pattern that's mirrored between the two socks.

For her **Crystalline** socks (page 22), Carissa Browning worked a short-row variation of the traditional flap-and-gusset heel and wedge toe. Throughout the sock, she added short-rows and multidirectional knitting to create the faceted look of natural crystals. These socks are best worked in solid-color yarns.

Rachel Coopey's **Bertha** (page 32) follow the standard top-down construction, but she added visual interest with colorwork patterns on the leg, heel flap, and toe. Like Kate Atherley's Mirror Socks, Rachel reversed the color placement on the two socks for a "fraternal" pair.

For **Cleave** (page 38), Hunter Hammersen worked a variation of the flap-and-gusset heel that's worked in rounds (no need to pick up gusset stitches). The heel is turned with short-rows, but part of the sole is worked flat in rows.

Jennifer Leigh's mirrored **Tilt-A-Whirl** socks (page 46) are a twist on traditional top-down shaping. The leg is worked in a bias lace pattern, then the heel flap is shaped with gusset increases and the heel is turned with short-rows. The foot follows Elizabeth Zimmermann's arch-shaped foot, then ends in a spiral toe that closes at the top of the foot rather than the tip of the toes.

Heidi Nick's **Gold Digger** socks (page 52) feature a Fleegle heel (no need to pick up gusset stitches) in which the gussets are worked simultaneously with the heel flap. The heel is turned with short-rows. Heidi chose to continue the leg pattern along the top of the foot to the point at which the toes are finished with Kitchener stitch.

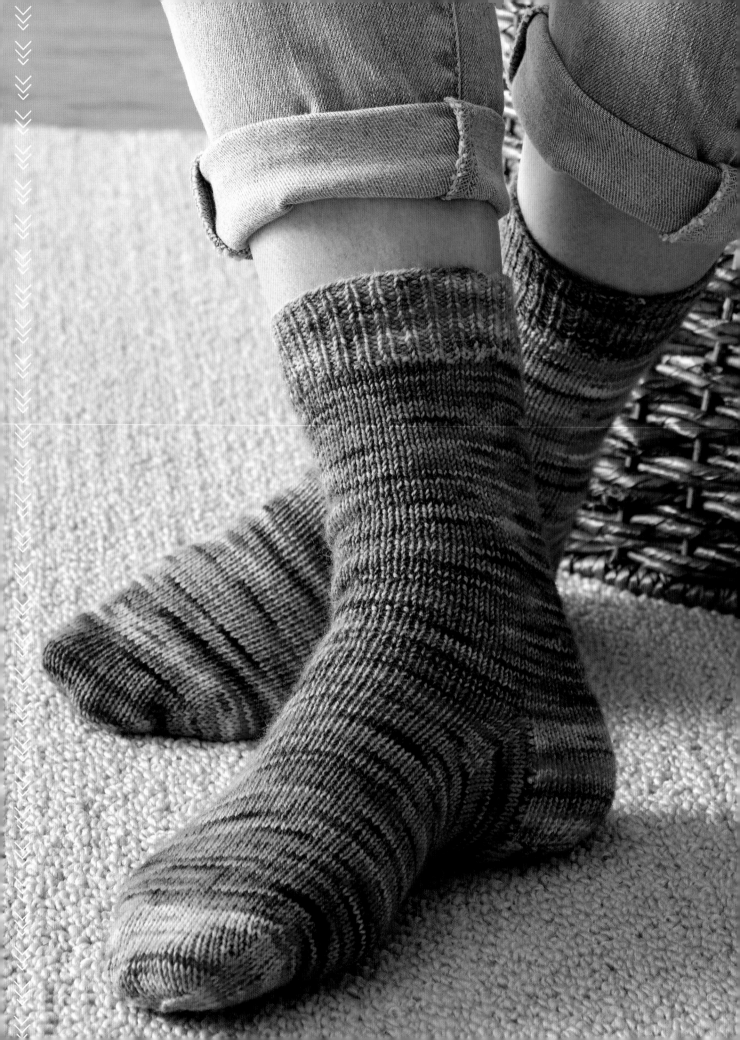

Mirror Socks

KATE ATHERLEY

These socks are perfect mirror images, not just in the coloring, but also in how they're constructed. One is knitted inside out from the other, as the mirror of the first. And for extra fun, they're worked at the same time and on the same needles, using the "War & Peace" method—so called because it's mentioned in Tolstoy's epic novel. It's really just very careful double knitting— the trick is not to let the yarns cross at any point. When you finish the toes, simply pull the socks apart to reveal a perfect mirrored pair!

FINISHED SIZE

About 6½ (7, 7½, 8, 8½, 9)" (16.5 [18, 19, 20.5, 21.5, 23] cm) foot circumference, 8¾ (9¼, 9¾, 10¼, 10¾, 11¼)" (22 [23.5, 25, 26, 27.5, 28.5] cm) foot length from back of heel to tip of toe (length is adjustable), and 6½ (6½, 7, 8, 8, 8)" (16.5 [16.5, 18, 20.5, 20.5, 20.5] cm) leg length from top of cuff to start of heel flap.

Socks shown measure 7" (18 cm) foot circumference.

YARN

Fingering weight (#1 Super Fine).

Shown here: Koigu Painter's Palette Premium Merino (KPPPM) (100% merino wool; 175 yd [160 m]/50 g): #P239 Green Mix and #P157 Pink Mix, 1 (1, 1, 2, 2, 2) skein(s) each.

NEEDLES

Size U.S. 1 (2.25 mm): set of 4 or 5 double-pointed (dpn), one 32" to 40" (80 to 100 cm) circular (cir) or two 16" (40 cm) cir.

Adjust needle size if necessary to obtain the correct gauge.

NOTIONS

Spare needle(s) in same size as main needle(s); stitch holders; removable stitch marker (m); cable needle (cn); tapestry needle.

GAUGE

17 sts and 25 rnds = 2" (5 cm) in double-knit St st worked in rnds, relaxed after blocking.

NOTES

- The two socks are worked at the same time in double knitting, with one sock inside the other; use a separate ball of yarn for each sock.

- The stitches are distributed on the needles so that one stitch for the outside sock is followed by one stitch for the inside sock.

- You might need to use smaller needles than usual to get gauge in double-knitting stockinette stitch.

- The two colors exchange places four times: after the ribbed cuff, at the start of the heel flap, at the start of the gusset joining round, and at the beginning of the toe.

- When swapping colors, cut the old color leaving a 6" (15 cm) tail. Tie the new color around the old color, also leaving a 6" (15 cm) tail, so that the knot of the new color can slide up the old tail and fit snugly against the needle. Doing so will keep the last stitch of the old yarn and the first stitch of the new yarn tight and tidy and reduce the risk of tangling. Tuck the tails between the two socks to keep them out of the way.

- For ease of knitting, the socks are worked with their right sides touching to minimize yarn movement and reduce tangling. For the stockinette portions, the outer sock has its purl side on the outside of the cylinder, and its yarn sits at the front of the work. The inner sock has its purl side on the inside of the cylinder, and its yarn sits at the back of the work. This is considered "home position" for the yarns.

- In "home position," Y1 is whichever color is currently being used for the outer sock at the front of the work, and Y2 is the color being for the inner sock at the back of the work.

- Periodically, check to make sure the socks remain separate. Look between the needle tips as you work to be sure the layers have not become locked together and run your fingers up from underneath, between the two socks, all the way to the needles.

- It's not unusual for the outer sock to get ladders of loose stitches between the needles. This happens because the yarn has to travel a little farther around the outside of the cylinder between the needles. To help alleviate the loose stitches, pull the first two Y1 stitches after a needle change a little tighter than usual. Most ladders will disappear after washing and wearing, so don't worry too much if you can't eliminate them entirely as you knit.

Cuffs

The two socks are CO separately at the start of the cuff. With Yarn 1 (Y1), main needle(s), and using a flexible method (see Glossary), CO 56 (60, 64, 68, 72, 76) sts. Arrange sts as preferred (see page 6), place marker (pm), and join for working in rnds, being careful not to twist sts.

Y1 set-up rnd: *K1, p1; rep from *.

Set aside.

With Yarn 2 (Y2) and spare needle(s), CO 56 (60, 64, 68, 72, 76) sts onto a single dpn or cir needle. Do not work any sts yet.

Transfer sts to same needles: Hold the needles together and parallel so the needle with the Y2 sts is behind the needle with the Y1 sts. The working strand of Y1 should be at the right needle tip, and the working strand from the Y2 cast-on should be at the end of the Y2 sts. Slip all sts purlwise (pwise) with Y1 in front of work and Y2 in back of work.

Without working any sts, slip sts alternately onto the main needles as foll: *Sl 1 Y1 st pwise on front needle, sl 1 Y2 st pwise from back needle onto front needle; rep from *—112 (120, 128, 136, 144, 152) sts total on same needles; 56 (60, 64, 68, 72, 76) sts of each color, alternating Y1 and Y2.

If working with multiple needles, make sure each needle begins with a Y1 st and ends with a Y2 st, and if using a single cir needle for magic-loop, make sure each side begins with a Y1 st and ends with a Y2 st.

Y2 set-up rnd: Working with Y2 only, *sl 1 Y1 st, k1 with Y2, sl 1 Y1 st, p1 Y2 st; rep from *—all Y1 sts have been slipped without being worked; one rnd of k1, p1 rib completed on Y2 sts.

Note: When working k1, p1 rib in double knitting, move Y1 to the back of the work to knit a Y1 stitch, then move it to the front of the work again; move Y2 to the front of the work to purl a Y2 stitch, then move it to the back of the work again. You must always move the yarns in this manner *immediately before and after* working a stitch; otherwise, the two layers will become interlocked.

Rib rnd: Moving yarns as described in the note above, *k1 with Y1, k1 with Y2, p1 with Y1, p1 with Y2; rep from *.

Rep this rnd until pieces measure 1½" (3.8 cm) from CO.

Place a removable stitch marker in the fabric of the outer sock to help you keep track of which is which when you swap the two colors.

Legs

Cut the yarns and swap them so that former Y1 sts will be worked with Y2, and former Y2 sts will be worked with Y1 (see Notes). The new Y1 will rem at the front of the work; the new Y2 will rem at the back.

St st rnd: *P1 with Y1, k1 with Y2; rep from *.

Rep the last rnd until piece measures 6½ (6½, 7, 8, 8, 8)" (16.5 [16.5, 18, 20.5, 20.5, 20.5] cm) from CO, or desired length to top of heel flap.

Heels

Cut the yarns and swap them again so that former Y1 sts will be worked with Y2, and former Y2 sts will be worked with Y1; see the note at the start of the heel flaps for yarn-handling instructions.

Heel Flaps

Notes: The heel flaps are worked back and forth in stockinette double knitting on the first half of the Y1 stitches and the corresponding half of the Y2 stitches. When working in rows, purl or slip the stitches of the front layer (the side facing you) keeping the yarn in front (wyf); and knit or slip the stitches of the back layer, keeping the yarn in back (wyb). Take care that the yarns don't cross or interlock at the ends of the rows; the two heel flaps should remain completely separate from each other.

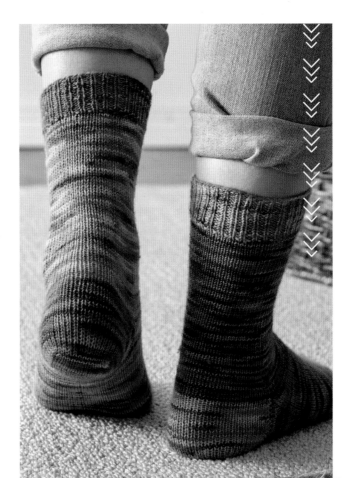

Row 1: (Y1 side facing) [P1 with Y1, k1 with Y2] 28 (30, 32, 34, 36, 38) times—28 (30, 32, 34, 36, 38) sts for each heel flap. Place rem 28 (30, 32, 34, 36, 38) sts for each sock onto holder to work later for instep. Turn work so Y2 side is facing.

Row 2: (Y2 side facing) Sl 1 Y2 st wyf, sl 1 Y1 st wyb, [p1 with Y2, k1 with Y1] 27 (29, 31, 33, 35, 37) times, turn work.

Row 3: Sl 1 Y1 st wyf, sl 1 Y2 st wyb, [p1 with Y1, k1 with Y2] 27 (29, 31, 33, 35, 37) times, turn work.

Row 4: Sl 1 Y2 st wyf, sl 1 Y1 st wyb, [p1 with Y2, k1 with Y1] 27 (29, 31, 33, 35, 37) times, turn work.

Rep Rows 3 and 4 only 10 (11, 12, 13, 14, 16) more times—24 (26, 28, 30, 32, 36) heel flap rows; flap measures about 2 (2, 2¼, 2½, 2½, 2¾)" (5 [5, 5.5, 6.5, 6.5, 7] cm).

Turn Heels

Notes: In order to work decreases, the stitches have to be rearranged so that two Y1 stitches are adjacent to each other, and two Y2 stitches are adjacent to each other. You might find a cable needle helpful for rearranging stitches. With the Y1 side facing, place 2 stitches (Y1 and Y2) onto a cable needle and hold in back of the work, return the Y1 at the beginning of the cable needle to the left needle—2 sts of Y1 adjacent to each other at left needle tip. Work the Y1 decrease, return the Y2 stitch

on the cable needle to the left needle, then work the Y2 decrease. For decreases worked with the Y2 side facing, rearrange the stitches in the same manner, but reverse the colors in the description.

Work short-rows to turn heels as foll.

Short-Row 1: (Y1 facing) [P1 with Y1, k1 with Y2] 19 (20, 21, 23, 24, 25) times, p2tog with Y1, ssk with Y2, turn work.

Short-Row 2: (Y2 facing) Sl 1 Y2 st wyf, sl 1 Y1 st wyb, [p1 with Y2, k1 with Y1] 10 (10, 10, 12, 12, 12) times, p2tog with Y2, ssk with Y1, turn work.

Short-Row 3: Sl 1 Y1 st wyf, sl 1 Y2 st wyb, [p1 with Y1, k1 with Y2] 10 (10, 10, 12, 12, 12) times, p2tog with Y1, ssk with Y2, turn work.

Short-Row 4: Sl 1 Y2 st wyf, sl 1 Y1 st wyb, [p1 with Y2, k1 with Y1] 10 (10, 10, 12, 12, 12) times, p2tog with Y2, ssk with Y1, turn work.

Rep Rows 3 and 4 only 6 (7, 8, 8, 9, 10) more times—24 (24, 24, 28, 28, 28) heel sts total rem; 12 (12, 12, 14, 14, 14) sts for each sock.

Gussets

Note: You'll resume working in rounds with the outer sock facing you. When picking up stitches for the gusset, pick up stitches on the outer sock purlwise (see Glossary); and pick up stitches for the inner sock knitwise (see Glossary).

Cut the yarns. Exchange the colors, but rejoin them in the corner of the heel flap at the end of the instep sts. The former Y1 sts will be worked with Y2; former Y2 sts will be worked with Y1. As for the legs, the new Y1 will rem at the front of the work and the new Y2 will rem at the back.

Set-up rnd: Starting at end of instep sts, with outer sock facing, [pick up 1 st pwise with Y1 from edge outer sock heel flap, pick up 1 st kwise with Y2 from edge of inner sock heel flap] 14 (15, 16, 17, 18, 19) times. Work across 24 (24, 24, 28, 28, 28) heel sts as [p1 with Y1, k1 with Y2] 12 (12, 12, 14, 14, 14) times. [Pick up 1 st pwise with Y1 from edge of outer sock heel flap, pick up 1 st kwise with Y2 from edge of inner sock heel flap] 14 (15, 16, 17, 18, 19) times. Work across 56 (60, 64, 68, 72, 76) held instep sts as [p1 with Y1, k1 with Y2] 28 (30, 32, 34, 36, 38) times—136 (144, 152, 164, 172, 180) sts total: 68 (72, 76, 82, 86, 90) sts for each sock; pm for beg of rnd at start of sole sts. If you're not dividing the sole and instep sts on separate needles, place another marker at the end of the sole sts.

Notes: As for the heel turn, rearrange the stitches as necessary for decreasing. These instructions use the

p2togtbl decrease (see Glossary) for the gusset and the toe so the two completed socks will look exactly the same. If you prefer, you can substitute the ssp decrease (see Glossary) instead.

Rnd 1: [P1tbl with Y1, k1tbl with Y2] 14 (15, 16, 17, 18, 19) times along side of flap, [p1 with Y1, k1 with Y2] 12 (12, 12, 14, 14, 14) times across heel sts, [p1tbl with Y1, k1tbl with Y2] 14 (15, 16, 17, 18, 19) times along other side of flap, [p1 with Y1, k1 with Y2] 28 (30, 32, 34, 36, 28) times across instep sts.

Rnd 2: (dec rnd) P1 with Y1, k1 with Y2, p2tog with Y1, ssk with Y2, *p1 with Y1, k1 with Y2; rep from * to last 6 sole sts (3 sts for each sock), p2togtbl with Y1, k2tog with Y2, **p1 with Y1, k1 with Y2; rep from ** to end of rnd— 4 sts total dec'd; 2 sts dec'd each sock.

Rnd 3: *P1 with Y1, k1 with Y2; rep from *.

Rep Rnds 2 and 3 only 5 (5, 5, 6, 6, 6) more times—112 (120, 128, 136, 144, 152) sts rem; 56 (60, 64, 68, 72, 76) sts for each sock; 28 (30, 32, 34, 36, 38) sts for instep and sole of each sock.

Feet

Cont even until feet measure 7¼ (7¾, 8, 8½, 8¾, 9¼)" (18.5 [19.5, 20.5, 21.5, 22, 23.5] cm) from center back heel or 1½ (1½, 1¾, 1¾, 2, 2)" (3.8 [3.8, 4.5, 4.5, 5, 5] cm) less than desired total length (allowing for a bit of negative ease).

Toes

Cut the yarns and swap them so that former Y1 sts will be worked with Y2 and former Y2 sts will be worked with Y1. As for the legs and feet, the new Y1 will rem at the front of the work and the new Y2 will rem at the back.

Dec rnd: P1 with Y1, k1 with Y2, p2tog with Y1, ssk with Y2, *p1 with Y1, k1 with Y2; rep from * to last 6 sole sts (3 sts for each sock), p2togtbl with Y1, k2tog with Y2, [p1 with Y1, k1 with Y2] 2 times, p2tog with Y1, ssk with Y2, **p1 with Y1, k1 with Y2; rep from ** to last 6 sts (3 sts for each sock), p2togtbl with Y1, k2tog with Y2, p1 with Y1, k1 with Y2—8 sts dec'd total; 4 sts dec'd for each sock; 2 sts for top and bottom of each toe.

[Work 1 rnd even, rep dec rnd] 5 (6, 6, 7, 7, 8) times, then work 1 rnd even—64 (64, 72, 72, 80, 80) sts rem; 32 (32, 36, 36, 40, 40) sts for each sock; 16 (16, 18, 18, 20, 20) sts for top and bottom of each toe. Rep dec rnd every rnd 6 (6, 7, 7, 8, 8) times—16 sts rem for all size; 8 sts on each sock; 4 sts for top and bottom of each toe.

Finishing

Cut both yarns, leaving 8" (20.5 cm) tails. Thread each tail on a tapestry needle, draw through rem sts of the same color, and pull tight to cinch the holes at the tips of the toes.

Pull the socks apart triumphantly.

Block lightly.

Weave in loose ends.

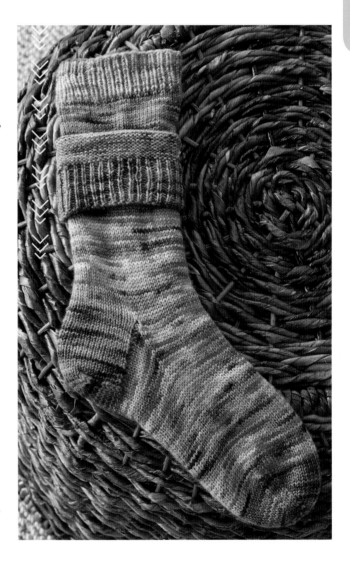

KATE ATHERLEY is a very keen sock knitter who is always seeking new and interesting ways to knit socks. She's written four books—most recently *Custom Socks: Knit to Fit Your Feet*—and is a frequent contributor to other publications, including *Sockupied*. You can find her online at kateatherley.com.

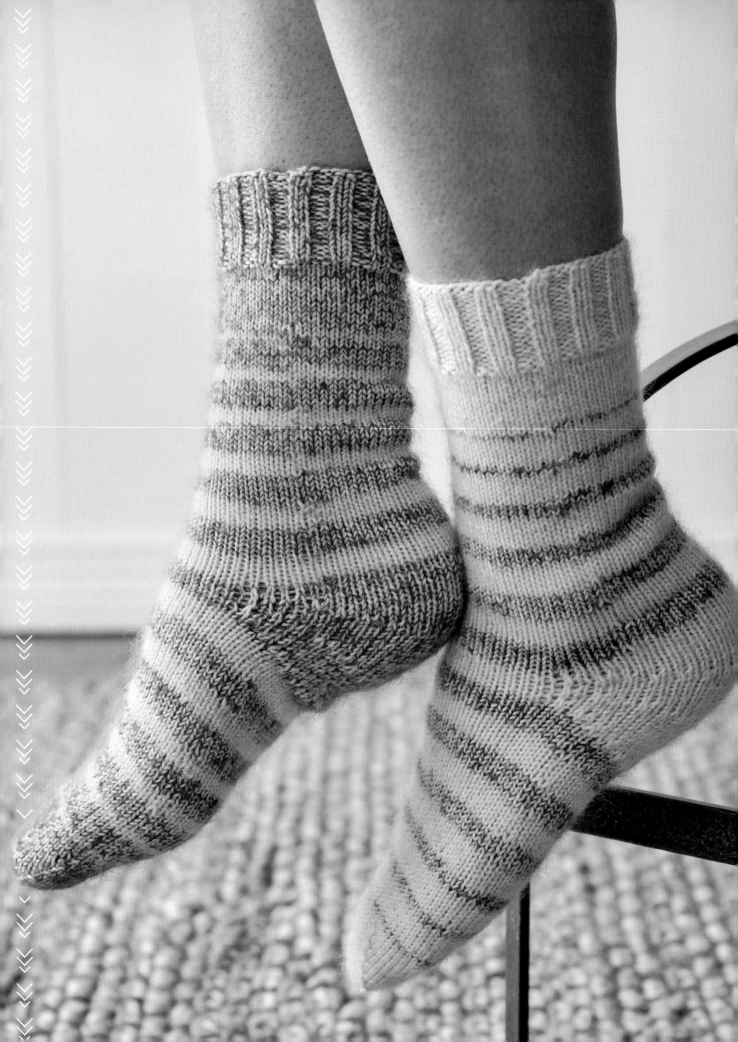

Enduring Stripes

CAT BORDHI

The Sweet Tomato heel used in this sock emerged last winter after several days of sitting with my mother beside the woodstove while trying to fiddle my way toward a new type of short-row heel construction. Almost unconsciously, I did a small thing—and just like that, the clean heel of my dreams existed. This small thing closes gaps without forming holes or requiring wraps. This heel is worked in three wedges with gently sloping sides. The process is logical and user-friendly, so it's easy to accommodate different foot sizes.

To make the socks nearly indestructible while adding a stripe pattern, I worked a strand of laceweight mohair along with sock yarn in stripes according to the Fibonacci sequence pattern. The stripe pattern is reversed on the two socks.

FINISHED SIZE

About 7½ (8, 8½, 9½, 10¾)" (19 [20.5, 21.5, 24, 27.5] cm) foot circumference, 9¼ (9½, 10, 10½, 11)" (23.5 [24, 25.5, 26.5, 28] cm) foot length from back of heel to tip of toe (length is adjustable), and 7¼ (7¼, 7½, 8, 8)" (18.5 [18.5, 19, 20.5 20.5] cm) leg length from top of cuff to start of heel.

Socks shown measure 7½" (19 cm) foot circumference.

YARN

Sportweight (#2 Fine) and laceweight (#0 Lace).

Shown here: Frog Tree Pediboo Sport (80% washable merino wool, 20% viscose from bamboo; 255 yd [233 m]/100 g): #1100 Natural (MC), 2 skeins for all sizes.

Schulana Kid-Seta (70% kid mohair, 30% silk; 230 yd [210 m]/25 g): #02 Almond (CC1) and #43 Regal Blue (CC2), 1 (1, 1, 1, 2) ball(s) each.

NEEDLES

Size U.S. 1 (2.25 mm): set of 4 or 5 double-pointed (dpn), 2 circular (cir), or 1 long circular (cir) as desired for working in rnds (see page 6).

Adjust needle size if necessary to obtain the correct gauge.

NOTIONS

Markers in different colors or styles (m); tapestry needle.

GAUGE

15 sts and 22 rnds = 2" (5 cm) in St st with one strand of MC held together with one strand of CC1 or CC2, worked in rnds.

NOTES

- The stripes are created by changing the color of the laceweight mohair contrast color (CC), which is held together with the main color (MC).
- Work using one strand of MC held together with one strand of either CC1 or CC2 throughout.
- Use the jogless jog technique (see Glossary) to prevent jogs from forming between the last stitch of one color on one round and the first stitch of another color on the next round.
- The first sock is predominantly blue; the second sock is the predominantly natural.

STITCH GUIDE

Leg-Stripe Pattern

Work 51 rnds as follows, exchanging CC1 and CC2 for the second sock.

1 rnd with MC and CC1.
6 rnds with MC and CC2.
2 rnds with MC and CC1.
6 rnds with MC and CC2.
3 rnds with MC and CC1.
6 rnds with MC and CC2.
4 rnds with MC and CC1.
6 rnds with MC and CC2.
5 rnds with MC and CC1.
6 rnds with MC and CC2.
6 rnds with MC and CC1.

Foot-Stripe Pattern

Work 51 rnds as follows, exchanging CC1 and CC2 for the second sock.

6 rnds with MC and CC1.
6 rnds with MC and CC2.
5 rnds with MC and CC1.
6 rnds with MC and CC2.
4 rnds with MC and CC1.
6 rnds with MC and CC2.
3 rnds with MC and CC1.
6 rnds with MC and CC2.
2 rnds with MC and CC1.
6 rnds with MC and CC2.
1 rnd with MC and CC1.

Leg

Work according to the instructions for the first or second sock as foll.

First Sock

With MC and CC2 held tog, use the Old Norwegian method (see Glossary) to CO 56 (60, 64, 72, 80) sts.

Second Sock

With MC and CC1 held tog, use the Old Norwegian method (see Glossary) to CO 56 (60, 64, 72, 80) sts.

Both Socks

Join for working in rnds; rnd begins at side of leg.

Next rnd: *K2, p2; rep from *.

Rep the last rnd for k2, p2 rib until piece measures 1¾" (4.5 cm) from CO.

Change to St st and work even until piece measures 2¾ (2¾, 3, 3½, 3½) " (7 [7, 7.5, 9, 9] cm) from CO or 4½" (11.5 cm) less than desired length to start of heel.

Work 51 rnds of leg-stripe patt (see Stitch Guide), reversing CC1 and CC2 for second sock—piece measures about 7¼ (7¼, 7½, 8, 8)" (18.5 [18.5, 19, 20.5 20.5] cm) from CO.

Heel

Use different markers for A, B, and C so you can identify each marker as you work. The heel is worked using MC and CC2 for first sock (MC and CC1 for second sock).

Set-up rnd: K33 (35, 37, 42, 47), place Marker A, k18 (20, 22, 24, 26), place Marker B, k5 (5, 5, 6, 7) to Marker C at end of rnd, slip marker (sl m), and knit the first 33 (35, 37, 42, 47) sts again to end at Marker A.

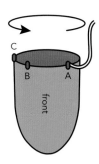

Marker positions for heel: Working yarn is at Marker A. First row of heel will be a WS row that is purled counterclockwise from Marker A, past Marker C, to end at Marker B.

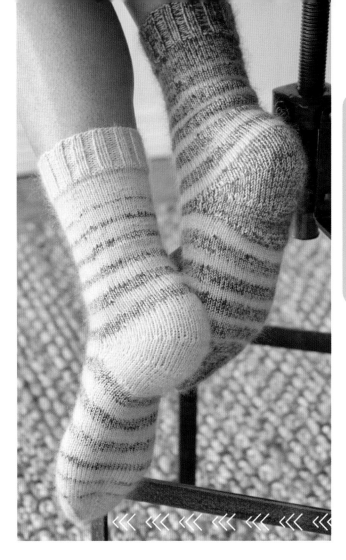

First Wedge

The 18 (20, 22, 24, 26) sts between Markers A and B are the instep sts. The heel is worked back and forth in rows on the rem 38 (40, 42, 48, 54) sts, beg with a WS row worked from Marker A, past Marker C, and ending at Marker B.

Marker C will rem in place to mark the original beg-of-rnd as you work the heel; slip Marker C as you come to it.

Note: Keep firm tension on the first few stitches of each short-row.

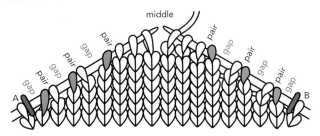

Wedge in process: Markers A and B mark the start and end of the heel. Slipped stitches (blue) begin each row. A pair of stitches (a slipped stitch followed by a knit stitch when viewed from the right side) is located above each gap.

19

Short-Row 1: (WS) Sl Marker A to right needle tip if it's not already on the right needle, sl 1 purlwise with yarn in front (pwise wyf), purl to Marker B, turn work.

Short-Row 2: (RS) Sl 1 pwise with yarn in back (wyb), knit to 2 sts before Marker A, turn work.

Short-Row 3: Sl 1 pwise wyf, purl to 2 sts before Marker B, turn work—1 st pair at each end of heel.

Short-Row 4: Sl 1 pwise wyb, knit to 2 sts before previous turning point, turn work.

Short-Row 5: Sl 1 pwise wyf, purl to 2 sts before previous turning point, turn work—1 more st pair at each end of heel.

Rep Short-Rows 4 and 5 only 6 (6, 7, 8, 10) more times—6 (8, 6, 8, 6) sts rem in center between turning gaps; 8 (8, 9, 10, 12) st pairs at each side.

Joining rnd: With RS facing, sl 1 pwise wyb, knit to 1 st before gap, work down the slope to Marker A, closing gaps as foll: *Lift the right leg of the st below the st on the left needle onto the left needle tip, k2tog (the lifted leg along with the next st), k1;* rep from * to * to Marker A. Knit across instep sts to Marker B. Work up the slope to center heel sts, closing gaps by rep from * to * until all gaps have been closed. Knit to Marker A.

Next rnd: Knit 1 rnd even, ending at Marker A.

Second Wedge

Work short-rows as for first wedge followed by the joining rnd, then work 1 rnd even.

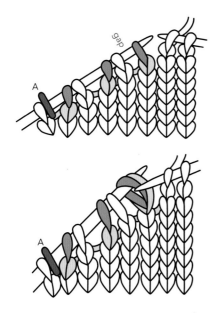

Lifted leg from row below to close gap: Lift the right leg of the stitch below the first stitch on the left needle onto the needle tip and work it together with that stitch as k2tog to close the gap.

Third Wedge

Work as for first wedge until Short-Rows 4 and 5 have been worked a total of 5 (5, 6, 7, 9) times—14 (16, 14, 16, 14) sts rem in center between turning gaps; 6 (6, 7, 8, 10) stitch pairs at each side.

Third wedge: Three wedges are sufficient if the top of the heel stitches is level with the top of the instep stitches.

Joining rnd: With RS facing, sl 1 pwise wyb, knit to 1 st before gap, work down the slope to Marker A, closing gaps as foll: *Lift the right leg of the st below the st on the left needle onto the left needle tip, k2tog (the lifted leg along with the next st), k1;* rep from * to * to Marker A. Remove Marker A. Knit across instep sts to Marker B, then remove Marker B. Work up the slope to center heel sts, closing gaps by rep from * to * until all gaps have been closed.

Next rnd: Knit across the rem heel and instep sts to Marker C—6 rnds of MC and CC2 on instep sts for first sock (6 rnds of MC and CC1 for second sock).

Foot

Work 51 rnds of foot-stripe patt (see Stitch Guide), reversing CC1 and CC2 for second sock. Change to MC and CC2 for remainder of first sock (MC and CC1 for second sock).

Next rnd: Dec 2 (0, 4, 0, 2) sts evenly spaced—54 (60, 60, 72, 78) sts rem.

Work even until foot measures 7¾ (7¾, 8¼, 8¼, 8½)" (19.5 [19.5, 21, 21, 21.5] cm) from center back heel or 1½ (1¾, 1¾, 2¼, 2½)" (3.8 [4.5, 4.5, 5.5, 6.5] cm) less than desired total sock foot length and *at the same time* in last rnd, pm after every 9 (10, 10, 12, 13) sts—6 marked sections.

Toe

Shape the toe differently for the two socks as foll:

First Sock

Dec rnd: *Knit to 2 sts before m, k2tog; rep from *—6 sts dec'd.

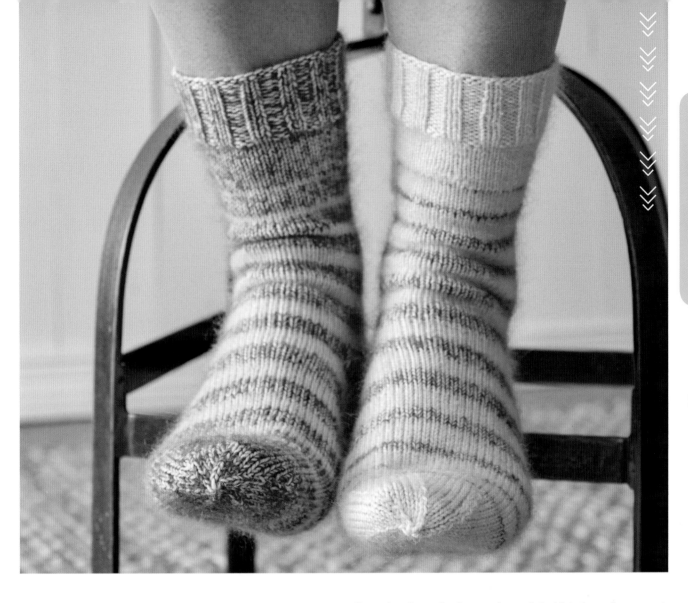

Second Sock

Dec rnd: *Ssk, knit to m; rep from *—6 sts dec'd.

Both Socks

[Knit 2 rnds even, then rep dec rnd] 3 (4, 4, 6, 7) times—30 sts rem for all sizes; 5 sts each marked section.

[Knit 1 rnd, then rep dec rnd] 2 times—18 sts rem; 3 sts each section.

Rep dec rnd—12 sts rem; 2 sts each section.

Next rnd: Removing markers as you come to them, work [k2tog] 6 times for first sock; work [ssk] 6 times for second sock—6 sts rem.

Cut yarn, leaving an 8" (20.5 cm) tail. Thread tail on tapestry needle, draw through rem sts, pull tight to close hole at tip of toe, and fasten off on WS.

Finishing

Weave in loose ends.

Block as desired.

CAT BORDHI is a creative, freethinking knitter, who delights in experimenting with technique and breaking the rules. She has shared her knowledge in her books *Socks Soar on Two Circular Needles, A Treasury of Magical Knitting, A Second Treasury of Magical Knitting, New Pathways for Sock Knitters, Personal Footprints, Cat's Sweet Tomato Heel Socks, The Art of Felts,* and *Versatildes: A New Landscape for Knitters,* as well as numerous YouTube knitting tutorials.

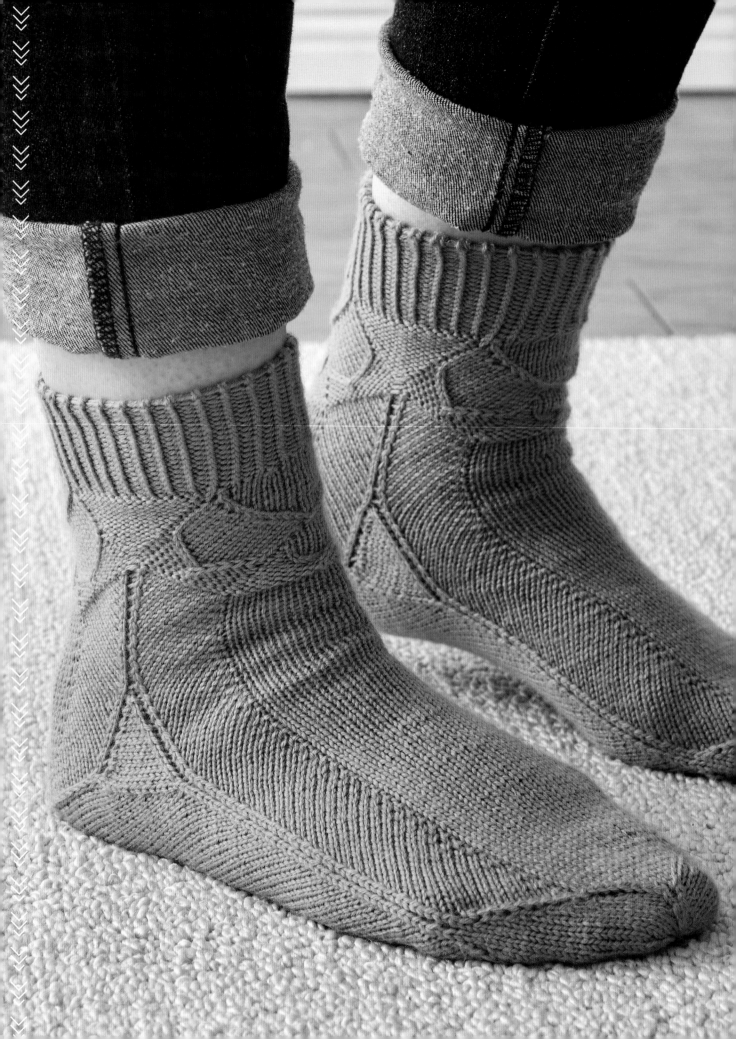

Crystalline

CARISSA BROWNING

Drawing inspiration from nature, this sock design is reminiscent of the faceted growth patterns of ice and mineral crystals. Each sock employs short-rows and multidirectional knitting to give it the appearance of a large crystal, with groupings of smaller crystals around the cuff. This pattern takes the idea of a traditional cuff-down sock and adds angles and textures for interest. It features a standard flap-and-gusset heel, but achieves it in a non-standard fashion. Even the toe decreases are worked in an unusual way to continue the crystalline illusion.

FINISHED SIZE

About 6½ (7½, 8¼)" (16.5, [19, 21] cm) foot circumference, 8 (9, 10)" (20.5 [23, 25.5] cm) foot length from back of heel to tip of toe (length is adjustable), and 5¼ (6, 6½)" (13.5 [15, 16.5] cm) leg length from top of cuff to start of heel turn (length is adjustable).

Socks shown measures 7½" (10 cm) foot circumference.

YARN

Fingering weight (#1 Super Fine).

Shown here: Cascade Yarns Heritage Silk (85% superwash merino wool, 15% silk; 437 yd [400 m]/100 g): #5658 Herb (green), 1 skein for all sizes.

NEEDLES

Size U.S. 1 (2.25 mm): set of 5 double-pointed (dpn) or 40" (100 cm) circular (cir) for magic-loop method.

Adjust needles size if necessary to obtain correct gauge.

NOTIONS

Cable needle (cn); stitch markers; tapestry needle.

GAUGE

18 sts and 21 rnds = 2" (5 cm) in St st worked in rnds, relaxed after blocking.

NOTES

- The leg and foot length are easily adjustable by working more or fewer rounds at the places indicated in the instructions. Choose a size with your preferred foot circumference, then adjust the lengths as desired.
- The foot consists of a 13 (15, 17)-stitch stockinette panel in the center of the instep and sole, and 21 (23, 25) stitches in a bias stockinette pattern at each side. The 26 (30, 34) total stockinette stitches measure about 2¾ (3¼, 3¾)" (7 [8.5, 9.5] cm) wide; the 42 (46, 50) total bias stitches measure about 3¾ (4¼, 4½)" (9.5 [11, 11.5] cm) wide.

STITCH GUIDE

LT: Sl 1 st onto cn and hold in front of work, k1, then k1 from cn.

LTP: Sl 1 st onto cn and hold in front of work, p1, then k1 from cn.

RT: Sl 1 st onto cn and hold in back of work, k1, then k1 from cn.

RTP: Sl 1 st onto cn and hold in back of work, k1, then p1 from cn.

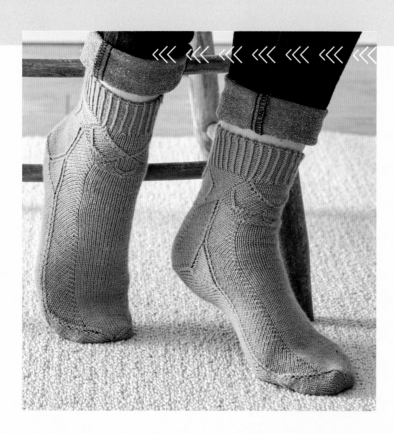

Leg
Cuff

Using the invisible k1, p1 rib method (see Glossary), CO 56 (64, 72) sts.

Rib rnd: *K1 through back loop (tbl), p1; rep from *.

Rep the last rnd 19 more times—20 twisted rib rnds completed; piece measures about 1½" (3.8 cm) from CO.

Leg Triangles

Note: Although the leg triangles involve short-rows, the stitches are not wrapped at the turning points because the turns occur at the sides of the triangle, along which stitches will be picked up later.

Set-up for first triangle: P7 (8, 9) and stop.

Work first triangle in short-rows over next 14 (16, 18) sts as foll, without wrappig at turning points.

Short-Row 1: (RS) K2 (1, 2), [k1f&b (see Glossary), k2 (3, 3)] 3 times, k1f&b, k2 (2, 3), turn work—4 triangle sts inc'd; 18 (20, 22) triangle sts; 35 (40, 45) unworked sts at end of rnd.

Short-Row 2: (WS) Sl 1 pwise with yarn in front (wyf), p17 (19, 21), turn work.

Short-Row 3: Sl 1 pwise with yarn in back (wyb), ssk, k12 (14, 16), k2tog, k1, turn work—16 (18, 20) triangle sts.

Short-Row 4: Sl 1 pwise wyf, p15 (17, 19), turn work.

Short-Row 5: Sl 1 pwise wyb, ssk, k10 (12, 14), k2tog, k1, turn work—14 (16, 18) triangle sts.

Short-Row 6: Sl 1 pwise wyf, p13 (15, 17), turn work.

Short-Row 7: Sl 1 pwise wyb, ssk, k8 (10, 12), k2tog, k1, turn work—12 (14, 16) triangle sts.

Short-Row 8: Sl 1 pwise wyf, p11 (13, 15), turn work.

Short-Row 9: Sl 1 pwise wyb, ssk, k6 (8, 10), k2tog, k1, turn work—10 (12, 14) triangle sts.

Short-Row 10: Sl 1 pwise wyf, p9 (11, 13), turn work.

Short-Row 11: Sl 1 pwise wyb, ssk, k4 (6, 8), k2tog, k1, turn work—8 (10, 12) triangle sts.

Short-Row 12: Sl 1 pwise wyf, p7 (9, 11), turn work.

Short-Row 13: Sl 1 pwise wyb, ssk, k2 (4, 6), k2tog, k1, turn work—6 (8, 10) triangle sts.

Short-Row 14: Sl 1 pwise wyf, p5 (7, 9), turn work.

Size 6½" (16.5 cm) is complete. Cont for other sizes as foll.

SIZES 7½ (8¼)" (19 [21] CM) ONLY

Short-Row 15: Sl 1 pwise wyb, ssk, k2 (4), k2tog, k1, turn work—6 (8) sts.

Short-Row 16: Sl 1 pwise wyf, p5 (7), turn work.

SIZE 8¼" (21 CM) ONLY

Short-Row 17: Sl 1 pwise wyb, ssk, k2, k2tog, k1, turn work—6 sts.

Short-Row 18: Sl 1 pwise wyf, p5, turn work.

ALL SIZES

Short-Row 15 (17, 19): (RS) Sl 1 pwise wyb, ssk, k2tog, k1, then pick up and knit 9 (10, 11) sts along left edge of first triangle (end of RS rows). Do not turn.

With RS facing and counting from beg of rnd, there will be 7 (8, 9) purled set-up sts, 4 sts at top of triangle, 9 (10, 11) sts picked-up sts from side of triangle, and 35 (40, 45) unworked sts.

Set-up for second triangle: With RS still facing, purl the next 14 (16, 18) sts and stop—21 (24, 27) unworked sts rem.

Work second triangle in short-rows over next 14 (16, 18) sts as foll.

Short-Row 1: (RS) K2 (1, 2), [k1f&b, k2 (3, 3)] 3 times, k1f&b, k2 (2, 3), turn work—4 triangle sts inc'd; 18 (20, 22) triangle sts; 7 (8, 9) unworked sts at end of rnd.

Short-Rows 2–14 (16, 18): Work as for first triangle—6 triangle sts rem.

Short-Row 15 (17, 19): Sl 1 pwise wyb, ssk, k2tog, k1, pick up and knit 9 (10, 11) sts along left edge of second triangle (end of RS rows), then purl rem 7 (8, 9) unworked sts to end of rnd. Do not turn.

With RS facing and counting from beg of rnd, there will be 7 (8, 9) purled first triangle set-up sts, a gap along right side of first triangle (beg of RS rows), 4 top triangle sts and 9 (10, 11) picked-up sts from first triangle, 14 (16, 18) purled second triangle set-up sts, a gap along right side of second triangle (beg of RS rows), 4 top triangle sts and 9 (10, 11) picked-up sts from second triangle, and 7 (8, 9) purled sts at end of rnd.

Leg Charts

With RS still facing, resume working in rnds as foll.

Set-up rnd: *P5 (6, 7), p2tog, pick up and knit 9 (10, 11) sts along right side (beg of RS rows) of first triangle; work 4 sts from top of triangle as k1, RT (see Stitch Guide), k1; k9 (10, 11) sts from side of triangle, p5 (6, 7), p2tog, place marker (pm) in center of rnd; rep from * once more—68

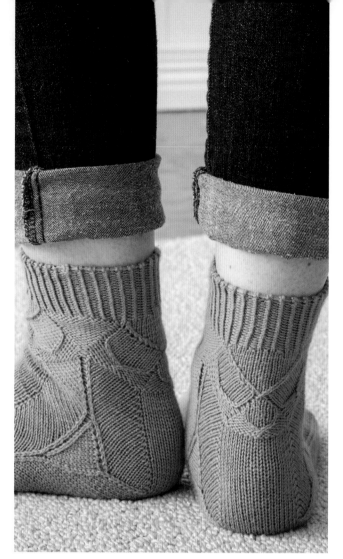

(76, 84) sts total; 34 (38, 42) sts each for front and back of leg; rnd beg at side of leg.

Work Rnds 1–13 (15, 17) of Leg chart for your size, removing m between chart reps in last rnd—piece measures about 2½ (2¾, 3)" (6.5 [7, 7.5] cm), measured at the sides of the leg.

Lower Leg

Cont as foll.

Rnd 1: *Ssk, k7 (8, 9), k1f&b, k13 (15, 17), k1f&b, k8 (9, 10), k2tog; rep from *.

Rnd 2: Knit.

Rep the last 2 rnds 7 (9, 11) more times, or to desired length (see Note below), ending with Rnd 2—16 (20, 24) lower leg rnds; piece measures about 4 (4¾, 5¼)" (10 [12, 13.5] cm) from CO, measured at the sides of the leg.

Note: To adjust leg length, work more or fewer repeats of the lower leg patt; every 6 rnds added or removed will lengthen or shorten the leg by about ½" (1.3 cm).

Heel

The heel is worked on the first 34 (38, 42) sts of the rnd; the rem 34 (38, 42) sts will be worked later for instep. Remove beg-of-rnd marker.

Heel Flap and Heel Turn

Work 34 (38, 42) heel sts back and forth in rows as foll.

Row 1: (RS) LT (see Stitch Guide), k7 (8, 9), k1f&b, k13 (15, 17), k1f&b, k8 (9, 10), RT—36 (40, 44) sts.

Row 2: (WS) Sl 1 wyf, p35 (39, 43).

Row 3: Sl 1 pwise wyb, ssk, k7 (8, 9), k1f&b, k13 (15, 17), k1f&b, k8 (9, 10), k2tog, k1.

Row 4: Sl 1 pwise wyf, p35 (39, 43).

Rows 5–12: Rep Rows 3 and 4 four more times—12 rows total; heel flap measures 1¼" (3.2 cm); piece measures 5¼ (6, 6½)" (13.5 [15, 16.5] cm) from CO, measured at the sides of the leg.

Change to working in short-rows for heel turn as foll, without wrapping any sts at turning points.

Short-Row 13: Sl 1 pwise wyb, ssk, k7 (8, 9), k1f&b, k13 (15, 17), k1f&b, ssk, turn work.

Note: In the next section, 1 st is dec'd in each WS row, and 1 st is inc'd in each RS row, so that the stitch count is restored to 36 (40, 44) sts after completing each RS row.

Short-Row 14: Sl 1 pwise wyf, p16 (18, 20), p2tog, turn work.

Short-Row 15: Sl 1 pwise wyb, k1f&b, k13 (15, 17), k1f&b, k1, ssk (1 st each side of gap), turn work.

Short-Row 16: Sl 1 pwise wyf, p18 (20, 22), p2tog (1 st each side of gap), turn work.

Short-Row 17: Sl 1 pwise wyb, k1, k1f&b, k13 (15, 17), k1f&b, k2, ssk (1 st each side of gap), turn work.

Short-Row 18: Sl 1 pwise wyf, p20 (22, 24), p2tog (1 st each side of gap), turn work.

Short-Row 19: Sl 1 pwise wyb, k2, k1f&b, k13 (15, 17), k1f&b, k3, ssk (1 st each side of gap), turn work.

Short-Row 20: Sl 1 pwise wyf, p22 (24, 26), p2tog (1 st each side of gap), turn work.

Short-Row 21: Sl 1 pwise wyb, k3, k1f&b, k13 (15, 17), k1f&b, k4, ssk (1 st each side of gap), turn work.

Short-Row 22: Sl 1 pwise wyf, p24 (26, 28), p2tog (1 st each side of gap), turn work.

Short-Row 23: Sl 1 pwise wyb, k4, k1f&b, k13 (15, 17), k1f&b, k5, ssk (1 st each side of gap), turn work.

Legend:

- ☐ knit
- · purl
- k1tbl
- p1tbl
- ○ yo
- ⟋ p2tog
- ☐ pattern repeat
- RTP (see Stitch Guide)
- LTP (see Stitch Guide)

LEG SIZE 6½" (16.5 CM)

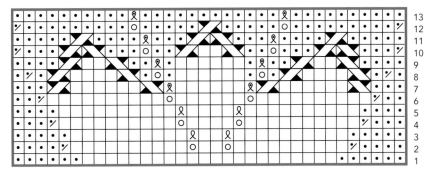

34-st repeat
work 2 times

LEG SIZE 7½" (19 CM)

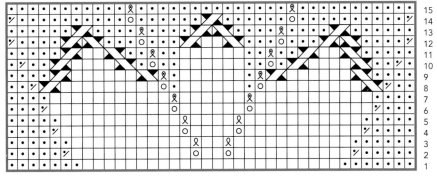

38-st repeat
work 2 times

LEG SIZE 8¼" (21 CM)

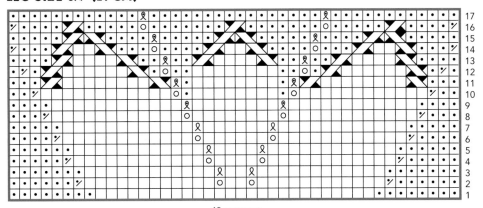

42-st repeat
work 2 times

Short-Row 24: Sl 1 pwise wyf, p26 (28, 30), p2tog (1 st each side of gap), turn work.

Short-Row 25: Sl 1 pwise wyb, k5, k1f&b, k13 (15, 17), k1f&b, k6, ssk (1 st each side of gap), turn work.

Short-Row 26: Sl 1 pwise wyf, p28 (30, 32), p2tog (1 st each side of gap), turn work—35 (39, 43) sts rem; 2 (3, 4) unworked sts at end of this row, and 3 (4, 5) unworked sts at beg of this row.

Size 6½" (16.5 cm) is complete; cont for the other sizes as foll.

SIZES 7½ (8¼)" (19 [21] CM) ONLY

Short-Row 27: Sl 1 pwise wyb, k6, k1f&b, k15 (17), k1f&b, k7, ssk (1 st each side of gap), turn work—40 (44) sts; 3 (4) unworked sts each end of row.

Short-Row 28: Sl 1 pwise wyf, p32 (34), p2tog (1 st each side of gap), turn work—39 (43) sts rem; 2 (3) unworked sts at end of this row, and 3 (4) unworked st at beg of this row.

SIZE 8¼" (21 CM) ONLY

Short-Row 29: Sl 1 pwise wyb, k7, k1f&b, k17, k1f&b, k8, ssk (1 st each side of gap), turn work—44 sts; 3 unworked sts each end of row.

Short-Row 30: Sl 1 pwise wyf, p36, p2tog (1 st each side of gap), turn work—43 sts rem; 2 unworked sts at end of this row, and 3 unworked st at beg of this row.

ALL SIZES

Short-Row 27 (29, 31): Sl 1 pwise wyb, k6 (7, 8), k1f&b, k13 (15, 17), k1f&b, k6 (7, 8), sl 1 kwise wyb, k2tog (1 st each side of gap), psso, turn work—still 35 (39, 43) sts; 2 unworked sts each side.

Short-Row 28 (30, 32): Sl 1 pwise wyf, p29 (33, 37), p2tog, turn work—34 (38, 42) sts rem; 1 unworked st at end of this row, and 2 unworked sts at beg of this row.

Gussets

Resume working across all sts in rnds as foll.

Rnd 1: With RS facing and leaving 1 heel st unworked at beg of row, work 33 (37, 41) heel sts as sl 1 pwise wyb, k7 (8, 9), k1f&b, k13 (15, 17), k1f&b, k10 (11, 12); pick up and knit 13 sts along left side of heel flap; work 34 (38, 42) held instep sts in patt as ssk, k7 (8, 9), k1f&b, k13 (15, 17), k1f&b, k8 (9, 10), k2tog; pick up and knit 13 sts along right side of heel flap, k1 unworked st from beg of heel—96 (104, 112) sts; pm for beg-of-rnd.

Rnd 2: K46 (50, 54), k2tog; for instep, k34 (38, 42); ssk, k12—2 sts dec'd, 1 st on each side of instep.

Rnd 3: Ssk, k7 (8, 9), k1f&b, k13 (15, 17), k1f&b, k8 (9, 10), k2tog, k11, k2tog; for instep, ssk, k7 (8, 9), k1f&b, k13 (15, 17), k1f&b, k8 (9, 10), k2tog; then ssk, k11—2 sts dec'd.

Rnd 4: K44 (48, 52), k2tog; for instep, k34 (38, 42); then ssk, k10—2 sts dec'd.

Rnd 5: Ssk, k7 (8, 9), k1f&b, k13 (15, 17), k1f&b, k8 (9, 10), k2tog, k9, k2tog; for instep, ssk, k7 (8, 9), k1f&b, k13 (15, 17), k1f&b, k8 (9, 10), k2tog; then ssk, k9—2 sts dec'd.

Rnd 6: K42 (46, 50), k2tog; for instep, k34 (38, 42); then ssk, k8—2 sts dec'd.

Rnd 7: Ssk, k7 (8, 9), k1f&b, k13 (15, 17), k1f&b, k8 (9, 10), k2tog, k7, k2tog; for instep ssk, k7 (8, 9), k1f&b, k13 (15, 17), k1f&b, k8 (9, 10), k2tog; then ssk, k7—2 sts dec'd.

Rnd 8: K40 (44, 48), k2tog; for instep k34 (38, 42); then ssk, k6—2 sts dec'd.

Rnd 9: Ssk, k7 (8, 9), k1f&b, k13 (15, 17), k1f&b, k8 (9, 10), k2tog, k5, k2tog; for instep ssk, k7 (8, 9), k1f&b, k13 (15, 17), k1f&b, k8 (9, 10), k2tog; then ssk, k5—2 sts dec'd.

Rnd 10: K38 (42, 46), k2tog; for instep k34 (38, 42); then ssk, k4—2 sts dec'd.

Rnd 11: Ssk, k7 (8, 9), k1f&b, k13 (15, 17), k1f&b, k8 (9, 10), k2tog, k3, k2tog; for instep, ssk, k7 (8, 9), k1f&b, k13 (15, 17), k1f&b, k8 (9, 10), k2tog; then ssk, k3—2 sts dec'd.

Rnd 12: K36 (40, 44), k2tog; for instep, k34 (38, 42); then ssk, k2—2 sts dec'd.

Rnd 13: Ssk, k7 (8, 9), k1f&b, k13 (15, 17), k1f&b, k8 (9, 10), k2tog, k1, k2tog; for instep, ssk, k7 (8, 9), k1f&b, k13 (15, 17), k1f&b, k8 (9, 10), k2tog; then ssk, k1—2 sts dec'd.

Rnd 14: K34 (38, 42), k2tog; for instep, k34 (38, 42); then ssk—70 (78, 86) sts rem.

Rnd 15: *Ssk, k7 (8, 9), k1f&b, k13 (15, 17), k1f&b, k8 (9, 10), sssk (see Glossary); rep from *—68 (76, 84) sts rem.

Rnd 16: Knit.

Foot

Notes: Because the stockinette panel on the back of the leg continues uninterrupted down the back of the heel, under the ball of the heel, and along the sole to the toe, there's no definite demarcation for the center back heel. The foot rounds are also not straight across but undulate in "peaks" and "valleys" because of the bias stockinette panels at each side. Therefore, determining foot length is approximate. Try the sock on and stop the foot pattern when the sock measures 1 (1¼, 1½)" (2.5 [3.2, 3.8] cm) from the tips of your toes, ending with a plain knit round. To adjust foot length, work more or fewer repeats of the foot patt; every 6 rnds added or removed will lengthen or shorten the foot by about ½" (1.3 cm).

Cont on 68 (76, 84) sts as foll.

Rnd 1: *Ssk, k7 (8, 9), k1f&b, k13 (15, 17), k1f&b, k8 (9, 10), k2tog; rep from *.

Rnd 2: Knit.

Rep these 2 rnds 16 (21, 26) more times, or to desired length.

Foot Triangles

Note: In this section, you'll work short-rows to fill in the "valleys" of the bias stockinette panels and even out the end of the foot. The first set of short-rows is worked back and forth across the 10 sts on each side of the beg-of-rnd marker and will dec them to 6 sts each side of marker; slip the marker when you come to it.

Short-Row 1: (RS) K1, ssk, turn work.

Short-Row 2: (WS) Sl 1 pwise wyf, p2, p2tog, turn work.

Short-Row 3: Sl 1 pwise wyb, yo, k2, yo, ssk (1 st each side of gap), turn work.

Short-Row 4: Sl 1 pwise wyf, p1 through back loop (tbl), p2, p1tbl, p2tog (1 st each side of gap), turn work.

Short-Row 5: Sl 1 pwise wyb, k4, ssk (1 st each side of gap), turn work.

Short-Row 6: Sl 1 pwise wyf, p4, p2tog (1 st each side of gap), turn work.

Short-Row 7: Sl 1 pwise wyb, yo, k4, yo, ssk (1 st each side of gap), turn work.

Short-Row 8: Sl 1 pwise wyf, p1tbl, p4, p1tbl, p2tog (1 st each side of gap), turn work.

Short-Row 9: Sl 1 pwise wyb, k6, ssk (1 st each side of gap), turn work.

Short-Row 10: Sl 1 pwise wyf, p6, p2tog (1 st each side of gap), turn work.

Short-Row 11: Sl 1 pwise wyb, yo, k6, yo, ssk (1 st each side of gap), turn work.

Short-Row 12: Sl 1 pwise wyf, p1tbl, p6, p1tbl, p2tog (1 st each side of gap), turn work.

Short-Row 13: Sl 1 pwise wyb, k8, ssk (1 st each side of gap), turn work.

Short-Row 14: Sl 1 pwise wyf, p8, p2tog (1 st each side of gap), turn work.

Short-Row 15: Sl 1 pwise wyb, yo, k8, yo, ssk (1 st each side of gap), turn work.

Short-Row 16: Sl 1 pwise wyf, p1tbl, p8, p1tbl, p2tog (1 st each side of gap), turn work—60 (68, 76) rem; 6 sts worked on each side of marker; 48 (56, 64) unworked sts.

Cont for your size as foll.

SIZE 6½" (16.5 CM) ONLY

Next short-row: (RS) Sl 1 pwise wyb, k35 to end at halfway point of rnd, do not turn work.

Work the second set of short-rows over the next 20 sts, dec them to 12 sts, by rep Short-Rows 1–16 once more—52 sts rem.

Next short-row: (RS) Sl 1 pwise wyf, k31 to end marker, do not turn work.

Skip to Toe.

SIZE 7½" (19 CM) ONLY

Short-Row 17: Sl 1 pwise wyb, k10, ssk (1 st each side of gap), turn work.

Short-Row 18: Sl 1 pwise wyf, p10, p2tog (1 st each side of gap), turn work—66 sts rem.

Short-Row 19: Sl 1 pwise wyb, yo, k10, yo, k1, do not turn work—68 sts; 7 sts worked on each side of marker; 54 unworked sts.

Next short-row: (RS) With RS still facing, k27 more sts to halfway point of rnd.

Work the second set of short-rows over the next 22 sts, dec them to 12 sts, by rep Short-Rows 1–18 once more, ending with a WS row—58 sts rem.

Short-Row 19: (RS) S1 pwise wyb, yo, k10, yo, k1, do not turn work—60 sts.

Next short-row: (RS) With RS still facing, k17, k1tbl, k5 to end at marker, do not turn work.

Skip to Toe.

SIZE 8¼" (21 CM) ONLY

Short-Row 17: Sl 1 pwise wyb, k10, ssk (1 st each side of gap), turn work.

Short-Row 18: Sl 1 pwise wyf, p10, p2tog (1 st each side of gap), turn work.

Short-Row 19: Sl 1 pwise wyb, yo, k10, yo, ssk (1 st each side of gap), turn work.

Short-Row 20: Sl 1 pwise wyf, p1tbl, p10, p1tbl, p2tog (1 st each side of gap), turn work—74 sts rem; 7 sts worked on each side of marker; 60 unworked sts.

Next short-row: (RS) Sl 1 pwise wyb, k43 to halfway point of rnd, do not turn work.

Work the second set of short-rows over the next 24 sts, dec them to 14 sts, by rep Short-Rows 1–20 once more, ending with a WS row—64 sts rem.

Next short-row: (RS) Sl 1 pwise wyf, k38 to end at marker, do not turn work.

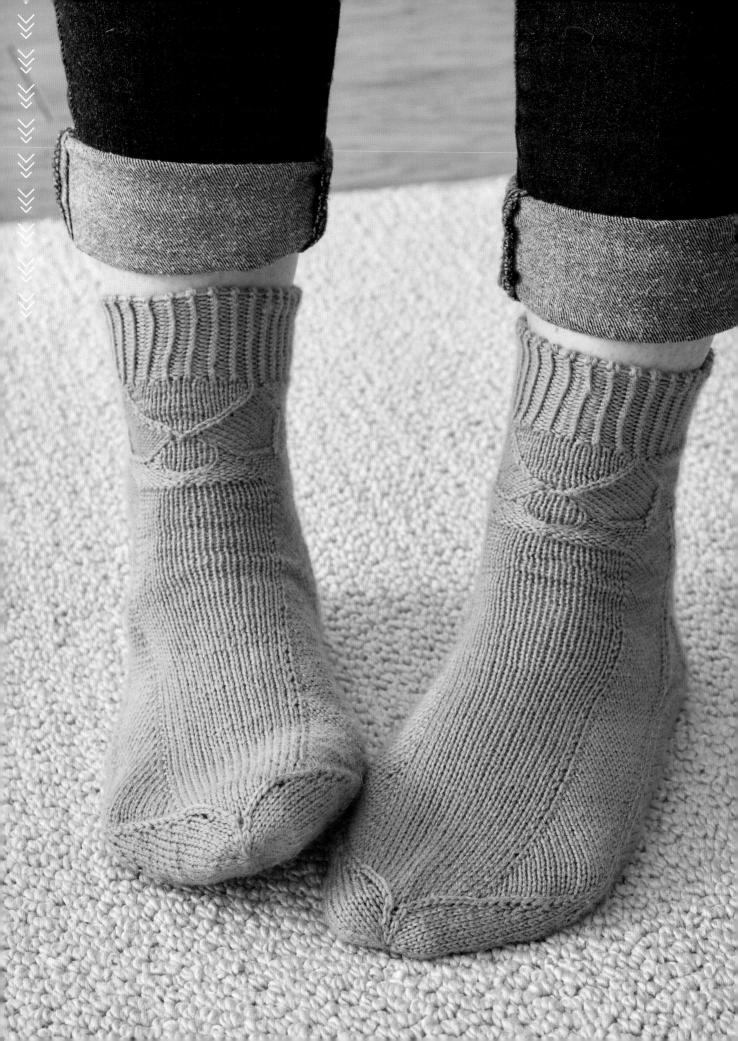

Toe

Work for your size as foll.

SIZE 6½" (16.5 CM) ONLY

Rnd 1: K5, ssk, k12, k2tog, k10, ssk, k12, k2tog, k1f&b, k4—49 sts rem.

Rnd 2: K4, k1f&b, ssk, k10, k2tog, k1f&b, k8, k1f&b, ssk, k10, k2tog, k6—48 sts rem.

Rnd 3: *K6, ssk, k8, k2tog, k6; rep from *—44 sts rem.

Rnd 4: *K6, ssk, k6, k2tog, k6; rep from *—40 sts rem.

Rnd 5: *K6, ssk, k4, k2tog, k6; rep from *—36 sts rem.

Rnd 6: *K6, ssk, k2, k2tog, k6; rep from *—32 sts rem.

Rnd 7: *K6, ssk, k2tog, k6; rep from *—28 sts rem.

Skip to All sizes.

SIZE 7½" (19 CM) ONLY

Rnd 1: K5, k1tbl, ssk, k14, k2tog, k1tbl, k10, k1tbl, ssk, k14, k2tog, k6—56 sts rem.

Rnd 2: *K6, ssk, k12, k2tog, k6; rep from *—52 sts rem.

Rnd 3: K6, ssk, k10, k2tog, k12, ssk, k10, k2tog, yo, k6—49 sts rem.

Rnd 4: K6, yo, ssk, k8, k2tog, yo, k12, yo, ssk, k8, k2tog, k1tbl, k6—48 sts rem.

Rnd 5: K6, k1tbl, ssk, k6, k2tog, k1tbl, k12, k1tbl, ssk, k6, k2tog, k7—44 sts rem.

Rnd 6: *K7, ssk, k4, k2tog, k7; rep from *—40 sts rem.

Rnd 7: *K7, ssk, k2, k2tog, k7; rep from *—36 sts rem.

Rnd 8: *K7, ssk, k2tog, k7; rep from *—32 sts rem.

Skip to All sizes.

SIZE 8¼" (21 CM) ONLY

Rnd 1: K6, ssk, k16, k2tog, k12, ssk, k16, k2tog, k1f&b, k5—61 sts rem.

Rnd 2: K5, k1f&b, ssk, k14, k2tog, k1f&b, k10, k1f&b, ssk, k14, k2tog, k7—60 sts rem.

Rnd 3: K7, ssk, k12, k2tog, k14, ssk, k12, k2tog, k7—56 sts rem.

Rnd 4: K7, ssk, k10, k2tog, k14, ssk, k10, k2tog, k7—52 sts rem.

Rnd 5: K7, ssk, k8, k2tog, k14, ssk, k8, k2tog, k1f&b, k6—49 sts rem.

Rnd 6: K6, k1f&b, ssk, k6, k2tog, k1f&b, k12, k1f&b, ssk, k6, k2tog, k8—48 sts rem.

Rnd 7: *K8, ssk, k4, k2tog, k8; rep from *—44 sts rem.

Rnd 8: *K8, ssk, k2, k2tog, k8; rep from *—40 sts rem.

Rnd 9: *K8, ssk, k2tog, k8; rep from *—36 sts rem.

ALL SIZES

Rnd 8 (9, 10): *Ssk, k3 (4, 5), k2tog; rep from *—20 (24, 28) sts rem.

Rnd 9 (10, 11): Knit.

Rnd 10 (11, 12): *Ssk, k1 (2, 3), k2tog; rep from *—12 (16, 20) sts rem.

Rnd 11 (12, 13): Knit—toe measures about 1 (1¼, 1¼)" (2.5 [3.2, 3.2] cm) from end of foot.

SIZE 8¼" (21 CM) ONLY

Rnd 14: *Ssk, k1, k2tog; rep from *—12 sts rem.

Rnd 15: Knit—toe measures about 1½" (3.8 cm) from end of foot.

Finishing

Cut yarn, leaving a 10" (25.5 cm) tail. Thread tail on a tapestry needle, draw through rem sts, pull tight to close hole, and fasten off on WS.

Weave in loose ends.

Block lightly.

CARISSA BROWNING lives and knits in Dallas, Texas, where she has accepted the futility of stitching cozy woolen sweaters and has perhaps overcompensated with an abundance of handknitted socks. She can now last almost three months without wearing the same pair twice. More of her work can be found at CarissaKnits.com.

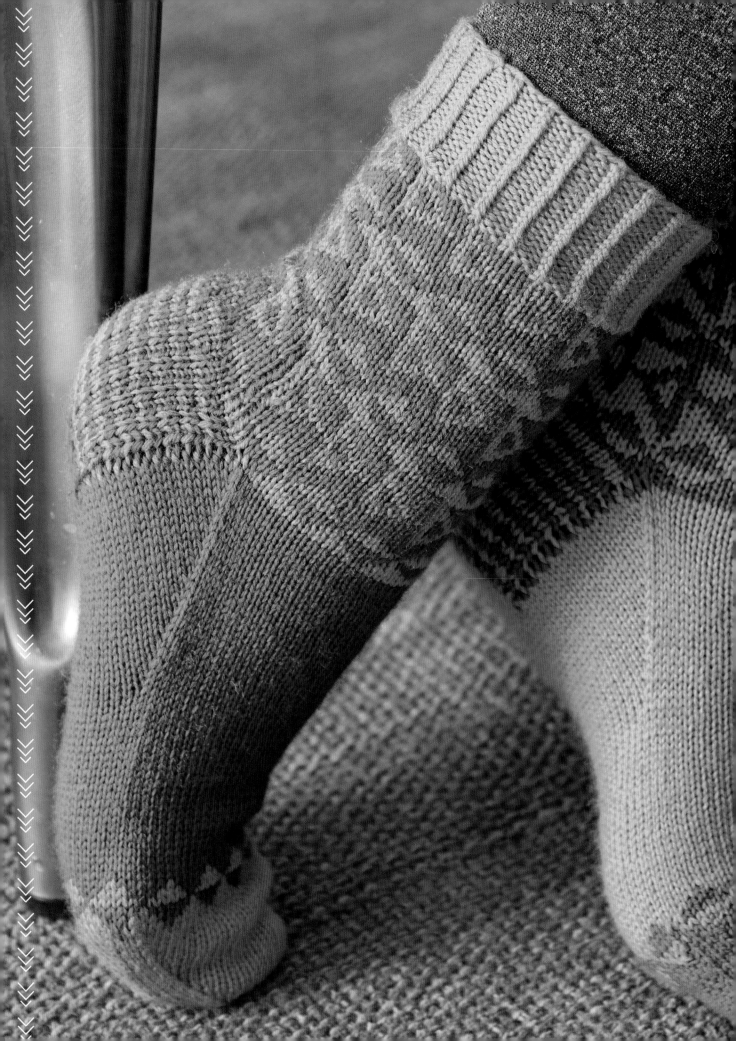

Bertha

RACHEL COOPEY

These coordinating, but not identical, socks follow traditional top-down sock construction, but nontraditional colors are used to form "fraternal twins." Not only are the colorwork patterns mirrored between the socks, but the colors are reversed as well, and the heel flaps are worked in narrow horizontal stripes. The result is not-quite-odd socks that are lots of fun to knit and wear. Bright colors are recommended—bright, happy socks can cheer up even the dullest day!

FINISHED SIZE

About 8¼ (9, 9¾)" (21 [23, 25] cm) foot circumference, 9 (9½, 10)" (23 [24, 25.5] cm) foot length from back of heel to tip of toe (length is adjustable), and 8¾" (22 cm) leg length from top of leg to base of heel.

Socks shown measure 8¼" (21 cm) foot circumference.

YARN

Fingering weight (#1 Super Fine).

Shown here: Brown Sheep Company Wildfoote Luxury Sock (75% washable wool, 25% nylon; 215 yd [197 m]/50 g): #SY53 Bluebird (A) and #SY45 Goldenrod (B), 1 (1, 2) skein(s) each.

NEEDLES

Size U.S. 1.5 (2.5 mm): set of 4 or 5 double-pointed (dpn) or preferred method of working a small circumference in the round (see page 6).

Adjust needle size if necessary to obtain the correct gauge.

NOTIONS

Marker (m); tapestry needle.

GAUGE

16 sts and 22 rnds = 2" (5 cm) in both solid-color and stranded-colorwork St st, worked in rnds, relaxed after blocking.

NOTES

- The geometric elements in these charts were deliberately chosen because they minimize the "jog" that can occur at start of the round in stranded-colorwork, particularly when working stripes. To make the "jog" even less obvious, the start of the round is adjusted when necessary so the chart pattern begins on the inner side of the leg and foot in both socks.

- When you work stranded-colorwork patterns, be sure to carry the unused yarn loosely across the back of the work to ensure that the fabric will have sufficient stretch and does not pucker. Use Joyce Williams's method of knitting on the far side (see sidebar on page 35) if necessary.

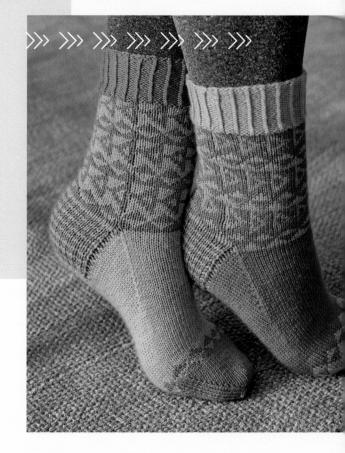

Left Sock

With A, use a flexible method (see Glossary) to CO 66 (72, 78) sts. Divide sts as necessary for your method of working in rnds, place marker (pm), and join, being careful not to twist sts. Rnds beg at start of front-of-leg sts.

Cuff

Set-up rnd: *P2, k1 through back loop (tbl); rep from *.

Cont in rib patt as established for 19 more rnds—20 rnds total; cuff measures 1¾" (4.5 cm) from CO.

Leg

Work Rows 1–16 of Left Sock chart (see page 36) 3 times—48 rnds total; piece measures 6¼" (16 cm) from CO.

Heel Flap

Set-up: With B, knit 1 rnd.

The heel flap is worked back and forth in rows on the 33 (36, 39) sts at the end of the rnd; rem 33 (36, 39) sts will be worked later for instep.

Row 1: (WS) With B, sl 1 purlwise with yarn in front (pwise wyf), p32 (35, 38).

Row 2: (RS) With B, [sl 1 pwise with yarn in back (wyb), k1] 16 (18, 19) times, k1 (0, 1).

Row 3: With A, sl 1 pwise wyf, p32 (35, 38).

Row 4: With A, [sl 1 pwise wyb, k1] 16 (18, 19) times, k1 (0, 1).

Rep these 4 rows 7 more times, then work WS Row 1 once more—33 heel flap rows total; flap measures 2½" (6.5 cm) from end of chart patt, including set-up rnd.

Heel Turn

With B, work short-rows as foll.

Short-Row 1: (RS) Sl 1 pwise wyb, k17 (20, 21), ssk, k1, turn work.

Short-Row 2: (WS) Sl 1 pwise wyf, p4 (7, 6), p2tog, p1, turn work.

Short-Row 3: Sl 1 pwise wyb, knit to 1 st before gap formed on previous RS row, ssk (1 st on each side of gap), k1, turn work.

Short-Row 4: Sl 1 pwise wyf, purl to 1 st before gap formed on previous WS row, p2tog (1 st on each side of gap), p1, turn work.

Rep the last 2 rows 5 (5, 6) more times, ending with a WS row—19 (22, 23) heel sts rem.

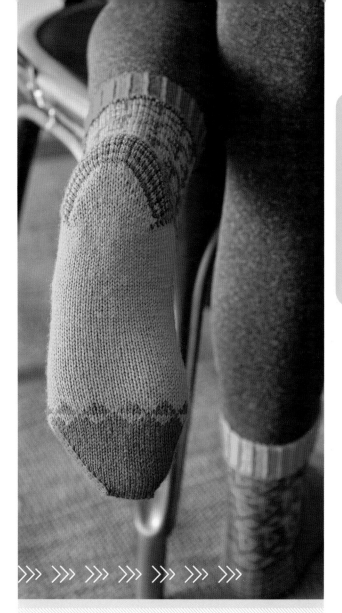

>>> >>> >>> >>> >>> >>> >>>

KNITTING ON THE FAR SIDE

To ensure that floats are long enough to allow the fabric to stretch fully, turn the sock inside out so that the wrong side faces outward and the right side (the "public" side) is on the inside of the sock tube. Doing so forces the floats to travel a greater distance along the outside circumference of the knitted tube.

Shape Gussets

Set-up rnd: With B, sl 1 pwise wyb, k18 (21, 22) to end of heel sts, pick up and knit 16 sts along edge of heel flap (1 st in each chain selvedge st), k33 (36, 39) instep sts, pick up and knit 16 sts along other edge of heel flap, then knit across 19 (22, 23) heel sts and first 16 picked-up sts again—84 (90, 94) sts total.

Rnds beg at start of instep.

Rnd 1: K33 (36, 39) instep sts, ssk, knit to last 2 sts, k2tog—2 sts dec'd.

Rnd 2: Knit.

Rep the last 2 rnds 8 (8, 7) more times—66 (72, 78) sts rem; 33 (36, 39) sts each for instep and sole.

Foot

With B, work even in St st until foot measures 6¼ (6½, 6¾)" (16 [16.5, 17] cm) from center back heel or 2¾ (3, 3¼)" (7 [7.5, 8.5] cm) less than desired finished sock foot length.

Work Rnds 10–16 of Left Sock chart—foot measures 7 (7¼, 7½)" (18 [18.5, 19] cm) or 2 (2¼, 2½)" (5 [5.5, 6.5] cm) less than desired finished sock foot length.

Toe

With A, dec as foll.

Rnd 1: For instep, k1, ssk knit to last 3 instep sts, k2tog, k1; for sole, k1, ssk, knit to last 3 sts of rnd, k2tog, k1—4 sts dec'd; 2 sts dec'd each from instep and sole.

Rnd 2: Knit.

Rep these 2 rnds 10 (11, 12) more times—22 (24, 26) sts rem; toe measures about 2 (2¼, 2½)" (5 [5.5, 6.5] cm) from end of chart patt.

Cut yarn, leaving a 12" (30.5 cm) tail.

Finishing

Thread tail on a tapestry needle and use the Kitchener st (see Glossary) to graft rem sts tog.

Weave in loose ends. Block as desired.

Right Sock

With B, use a flexible method as before to CO 66 (72, 78) sts. Divide sts as necessary for your method of working in rnds, pm, and join for working in rnds, being careful not to twist sts. Rnd begs at start of back-of-leg sts.

■ A
□ B
□ pattern repeat

LEFT SOCK

6-st repeat

RIGHT SOCK

6-st repeat

Cuff

With B, work as for left sock—20 rib rnds total; cuff measures 1¾" (4.5 cm) from CO.

Leg

Work Rows 1–16 of Right Sock chart 3 times—48 rnds total; piece measures 6¼" (16 cm) from CO.

Heel Flap

Set-up: With A, k33 (36, 39) back-of-leg sts, turn work.

The heel flap is worked back and forth in rows on the 33 (36, 39) sts at the start of the round; rem 33 (36, 39) sts will be worked later for instep.

Row 1: (WS) With A, sl 1 pwise wyf, p32 (35, 38).

Row 2: (RS) With A, [sl 1 pwise wyb, k1] 16 (18, 19) times, k1 (0, 1).

Row 3: With B, sl 1 pwise wyf, p32 (35, 38).

Row 4: With B, [sl 1 pwise wyb, k1] 16 (18, 19) times, k1 (0, 1).

Rep these 4 rows 7 more times, then work WS Row 1 once more—33 heel flap rows total; flap measures 2½" (6.5 cm) from end of chart patt, including set-up rnd.

Heel Turn

With A, work short-rows as foll.

Short-Row 1: (RS) Sl 1 pwise wyb, k17 (20, 21), ssk, k1, turn work.

Short-Row 2: (WS) Sl 1 pwise wyf, p4 (7, 6), p2tog, p1, turn work.

Short-Row 3: Sl 1 pwise wyb, knit to 1 st before gap formed on previous RS row, ssk (1 st on each side of gap), k1, turn work.

Short-Row 4: Sl 1 pwise wyf, purl to 1 st before gap formed on previous WS row, p2tog (1 st on each side of gap), p1, turn work.

Rep the last 2 rows 5 (5, 6) more times, ending with a WS row—19 (22, 23) heel sts rem.

Shape Gussets

Set-up rnd: With A, sl 1 pwise wyb, k18 (21, 22) to end of heel sts, pick up and knit 16 sts along edge of heel flap (1 st in each chain selvedge st), k33 (36, 39) instep sts, pick up and knit 16 sts along other edge of heel flap, then knit across 19 (22, 23) heel sts and first 16 picked-up sts again—84 (90, 94) sts total.

Rnd begs at start of instep.

Rnd 1: K33 (36, 39) instep sts, ssk, knit to last 2 sts, k2tog—2 sts dec'd.

Rnd 2: Knit.

Rep the last 2 rnds 8 (8, 7) more times—66 (72, 78) sts rem; 33 (36, 39) sts each for instep and sole.

Foot

With A, work even in St st until foot measures 6¼ (6½, 6¾)" (16 [16.5, 17] cm) from center back heel or 2¾ (3, 3¼)" (7 [7.5, 8.5] cm) less than desired finished sock foot length.

Set-up: Remove beg-of-rnd m, with A, k33 (36, 39) instep sts, pm for new beg-of-rnd at start of sole sts.

Work Rnds 10–16 of Right Sock chart—foot measures 7 (7¼, 7½)" (18 [18.5, 19] cm) or 2 (2¼, 2½)" (5 [5.5, 6.5] cm) less than desired finished sock foot length.

Toe

With B, dec as foll.

Rnd 1: For sole, k1, ssk knit to last 3 sole sts, k2tog, k1; for instep, k1, ssk, knit to last 3 sts of rnd, k2tog, k1—4 sts dec'd; 2 dec'd sts each from sole and instep.

Rnd 2: Knit.

Rep these 2 rnds 10 (11, 12) more times—22 (24, 26) sts rem; toe measures about 2 (2¼, 2½)" (5 [5.5, 6.5] cm) from end of chart patt.

Cut yarn, leaving a 12" (30.5 cm) tail.

Finishing

Work as for left sock.

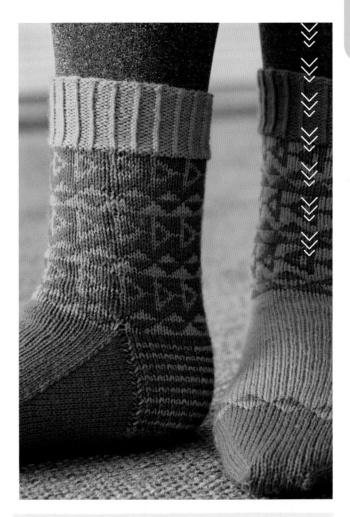

As a child **RACHEL COOPEY** was taught to knit by her mother and grandmother, and she has a very long garter-stitch scarf to prove it! She was drawn to sock knitting when she bought three beautiful skeins of hand-dyed sock yarn that compelled her to give it a try. She has published two books of sock designs as well as patterns for *Knitty.com, Interweave,* and *Twist Collective.* Visit Rachel online at coopknits.co.uk.

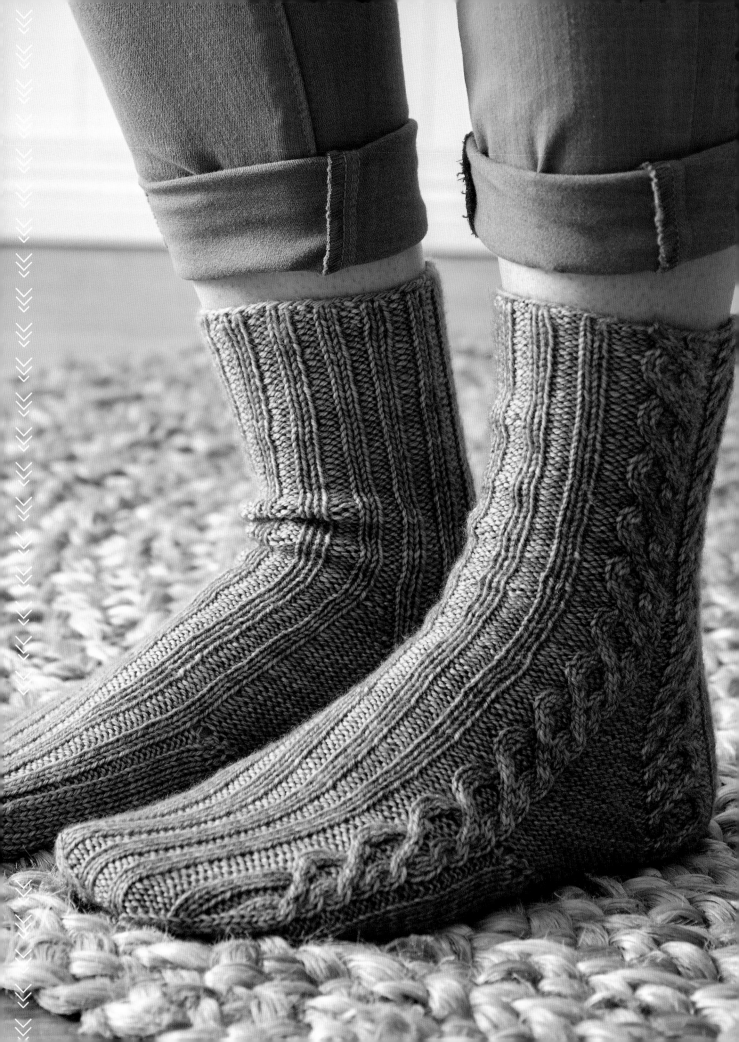

Cleave

HUNTER HAMMERSEN

These socks start out like a standard top-down sock, but things take a little twist when you get to the heel. Instead of setting half the stitches aside and working a heel flap on the other half, you'll keep working in the round, increasing at the beginning and midpoint of the round to form the heel flap and gusset. Then you'll switch to working in rows to turn the heel and work a bit of the sole. Finally, you'll resume working in the round again to finish off the foot.

This construction is comfy and looks great, but it also eliminates the need to pick up stitches along the sides of the heel flap (a process that many knitters dislike). Also, if your socks tend to wear out under the heel (as mine so often do), you can easily carry a reinforcing thread along with your yarn when working the section in rows for added durability. If you've only ever made top-down socks with heel flaps in the past, this approach is a simple, nonthreatening way to branch out into another type of construction.

FINISHED SIZE

About 6½ (7½, 8½, 9½, 10¼)" (16.5 [19, 21.5, 24, 26] cm) foot circumference, 9 (9¼, 9¾, 10, 10½)" (23 [23.5, 25, 25.5, 26.5] cm) foot length from back of heel to tip of toe (length is adjustable), and 7¾ (8¼, 8¾, 9, 9½)" (19.5 [21, 22, 23, 24] cm) leg length from top of cuff to start of heel turn.

Socks shown measure 7½" (19 cm) foot circumference.

YARN

Fingering weight (#1 Super Fine).

Shown here: String Theory Caper Sock (80% merino, 10% cashmere, 10% nylon; 400 yd [365 m]/4 oz [113.5 g]): Light Teal, 1 (1, 1, 2, 2) skein(s).

NEEDLES

Size U.S. 1 (2.25 mm): needles for working in rounds as you prefer (see page 6).

Adjust needle size if necessary to obtain the correct gauge.

NOTIONS

Markers (m); cable needle (cn); tapestry needle.

GAUGE

17 sts and 20 rnds = 2" (5 cm) in St st worked in rnds, relaxed after blocking.

NOTE

- The cable patterns are different for the right and left socks. The double-cable pattern in each leg chart runs along the outside of the leg, then divides at the top of the gusset. One half of the split cable continues to the bottom of the heel flap; the other half continues along the outside of the foot to the toe.

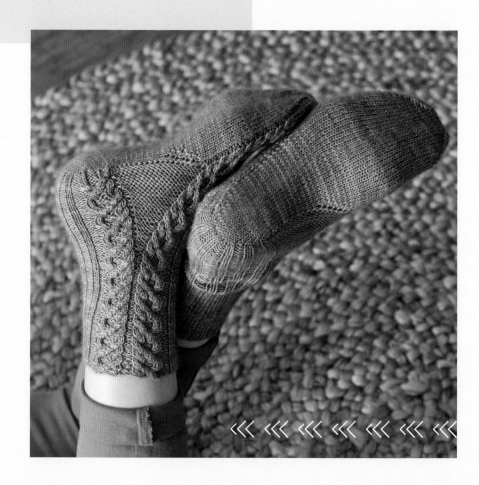

Left Sock

Leg

CO 56 (64, 72, 80, 88) sts. Arrange sts on needles as preferred (see page 6), place marker (pm), and join for working in rnds, being careful not to twist sts. Rnd begins on inside of leg at start of front-of-leg sts.

Work Rnds 1–8 of Left Leg chart (see page 43) 6 times, ending with Rnd 8—48 chart rnds completed; piece measures 4¾" (12 cm) from CO.

To prepare for heel incs, place two markers (A and B) after the 28th (32nd, 36th, 40th, 44th) st, then place an additional marker after the last st of the rnd, next to the end-of-rnd m (C and D)—2 markers next to each other at the mid-point and end-of-rnd.

Heel Flap and Gusset

Set-up rnd: Work Rnd 1 of Left Leg chart as established over 28 (32, 36, 40, 44) sts, sl Marker A, M1P (see Glossary), sl Marker B, work Rnd 1 of Left Heel chart over 28 (32, 36, 40, 44) sts, sl Marker C, M1P, sl Marker D—58 (66, 74, 82, 90) sts total; 1 gusset st between each pair of markers.

Note: The gussets are shaped over the following 30 (34, 38, 42, 46) rounds. For the stitches of the Left Leg chart, continue the established pattern. For the sts of the Left Heel chart, continue in pattern until Rnds 1–8 have been worked 2 (3, 3, 4, 4) times, then work Rnds 9–16 once, then work the stitches as they appear in Rnd 16 (knit the knits and purl the purls) for 7 (3, 7, 3, 7) rnds. Work all gusset stitches in reverse stockinette (purl RS rows; knit WS rows).

Next rnd: Keeping in patts as set, work to Marker A, sl Marker A, purl to Marker B, sl Marker B, work to Marker C, sl Marker C, purl to Marker D, sl Marker D.

Inc rnd: Keeping in patts as set, work in patt to Marker A, sl Marker A, p1, M1P, purl to Marker B, sl Marker B, work in patt to Marker C, sl Marker C, purl to 1 st before Marker D, M1P, p1, sl Marker D—2 sts inc'd.

Rep the last 2 rnds 14 (16, 18, 20, 22) more times—88 (100, 112, 124, 136) sts total; 16 (18, 20, 22, 24) gusset sts between each pair of markers; heel flap measures about 3 (3½, 4, 4¼, 4¾)" (7.5 [9, 10, 11, 12] cm) from set-up rnd; piece measures about 7¾ (8¼, 8¾, 9, 9½)" (19.5 [21, 22, 23, 24] cm) from CO.

Make a note of the last Left Leg chart rnd completed so you can resume working in patt with the correct rnd later.

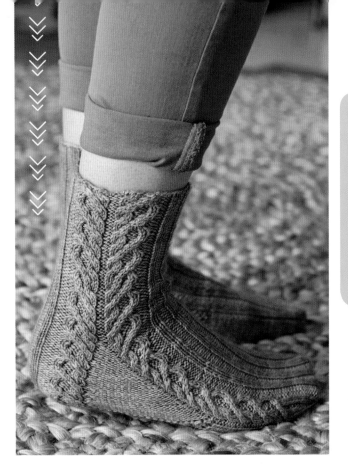

Heel Turn

Set-up: Work instep sts in patt to Marker A, sl Marker A, purl to Marker B, sl Marker B, knit to Marker C, then stop.

The heel turn is worked over the 28 (32, 36, 40, 44) back-of-leg sts between Markers B and C. Rearrange the sts as necessary to isolate these sts on a single needle; the rem 60 (68, 76, 84, 92) sts will be worked later for gusset decs and instep.

Work 28 (32, 36, 40, 44) heel sts back and forth in short-rows as foll.

Short-Row 1: (WS) Sl 1, p16 (18, 20, 22, 24), p2tog, p1.

Short-Row 2: (RS) Sl 1, k7, ssk, k1.

Short-Row 3: Sl 1, p8, p2tog, p1.

Short-Row 4: Sl 1, k9, ssk, k1.

Short-Row 5: Sl 1, p10, p2tog, p1.

Short-Row 6: Sl 1, k11, ssk, k1.

Short-Row 7: Sl 1, p12, p2tog, p1.

Short-Row 8: Sl 1, k13, ssk, k1.

Short-Row 9: Sl 1, p14, p2tog, p1.

Short-Row 10: Sl 1, k15, ssk, k1.

Size 6½" (16.5 cm) is complete—18 heel sts rem; 78 sts total.

Skip to Bottom of Heel.

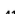

SIZES 7½, (8½, 9½, 10¼)" (19 [21.5, 24, 26] CM) ONLY

Short-Row 11: (WS) Sl 1, p16, p2tog, p1.

Short-Row 12: (RS) Sl 1, k17, ssk, k1.

Size 7½" (19 cm) is complete—20 heel sts rem; 88 sts total.

Skip to Bottom of Heel.

SIZES 8½ (9½, 10¼)" (21.5 [24, 26] CM) ONLY

Short-Row 13: (WS) Sl 1, p18, p2tog, p1.

Short-Row 14: (RS) Sl 1, k19, ssk, k1.

Size 8½" (21.5 cm) is complete—22 heel sts rem; 98 sts total.

Skip to Bottom of Heel.

SIZES 9½ (10¼)" (24 [26] CM) ONLY

Short-Row 15: (WS) Sl 1, p20, p2tog, p1.

Short-Row 16: (RS) Sl 1, k21, ssk, k1.

Size 9½" (24 cm) is complete—24 heel sts rem; 108 sts total.

Skip to Bottom of Heel.

SIZE 10¼" (26 CM) ONLY

Short-Row 17: (WS) Sl 1, p22, p2tog, p1.

Short-Row 18: (RS) Sl 1, k23, ssk, k1.

Size 10¼" (26 cm) is complete—26 sts rem; 118 sts total.

Bottom of Heel

Remove markers B and C between heel and gusset sts as you come to them to accommodate the decs. Cont working heel sts in rows, dec 1 gusset st at end of each heel row as foll.

Row 1: (WS) Purl to last heel st, p2tog (1 heel st tog with 1 gusset st)—1 gusset st dec'd.

Row 2: (RS) Knit to last heel st, ssk (1 heel st tog with 1 gusset st)—1 gusset st dec'd.

Rep these 2 rows 10 (11, 12, 13, 14) more times—56 (64, 72, 80, 88) sts rem; 18 (20, 22, 24, 26) heel sts; 5 (6, 7, 8, 9) sts each gusset; 28 (32, 36, 40, 44) instep sts.

Cont working back and forth in rows, inc 1 heel/sole st and dec 1 gusset st every row as foll.

Row 3: (WS) Purl to last sole st, M1P, p2tog (1 heel st tog with 1 gusset st)—no change to st count; 1 sole st inc'd, 1 gusset st dec'd.

Row 4: (RS) Knit to last sole st, M1, ssk (1 heel st tog with 1 gusset st)—no change to st count; 1 sole st inc'd, 1 gusset st dec'd.

Rep these 2 rows 3 (4, 5, 6, 7) more times, ending with a RS row—still 56 (64, 72, 80, 88) sts; 26 (30, 34, 38, 42) heel sts; 1 st each gusset; 28 (32, 36, 40, 44) instep sts.

Foot

Joining rnd: With RS still facing, p1, sl Marker D, work 28 (32, 36, 40, 44) instep sts in patt, sl Marker A, p1, knit across heel/sole sts to 1 st before Marker D, p1, sl Marker D—28 (32, 36, 40, 44) sts each for instep and sole; rnd begins at Marker D on inner edge of foot, at start of instep sts.

Keeping sole sts in St st with p1 at each side, cont instep patt as set until foot measures 6½ (6½, 6¾, 6¾, 7)" (16.5 [16.5, 17, 17, 18] cm) from center back heel, or 2½ (2¾, 3, 3¼, 3½)" (6.5 [7, 7.5, 8.5, 9] cm) less than desired finished sock foot length, ending with Rnd 8 of Left Leg chart. Do not work any partial reps of the leg chart; if ending with Rnd 8 leaves you short of the target length, change to working the instep sts in patt from Left Toe chart, beg with Rnd 1.

Toe

Change to working 28 (32, 36, 40, 44) instep sts in patt from Left Toe chart if you have not already done so. Cont until Rnds 1–8 of toe chart have been worked once, then work the sts as they appear in Rnd 8 of chart until foot measures 8 (8, 8¼, 8, 8¼)" (20.5 [20.5, 21, 20.5, 21] cm) from center back heel, or 1 (1¼, 1½, 2, 2¼)" (2.5 [3.2, 3.8, 5, 5.5] cm) less than desired finished sock foot length.

42

☐ knit

· purl

☐ pattern repeat

⟍⟋ sl 2 sts onto cn and hold in back of work, k2, then k2 from cn

⟋⟍ sl 2 sts onto cn and hold in front of work, k2, then k2 from cn

◣⟍ sl 2 sts onto cn and hold in back of work, k2, then p2 from cn

◣⟋ sl 2 sts onto cn and hold in front of work, p2, then k2 from cn

LEFT LEG

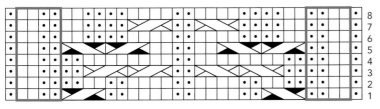

4-st rep;
work
4 (5, 6, 7, 8)
times

4-st rep;
work
4 (5, 6, 7, 8)
times

LEFT TOE

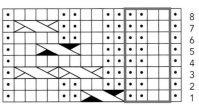

4-st rep;
work
4 (5, 6, 7, 8)
times

LEFT HEEL

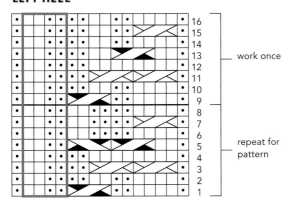

work once

repeat for
pattern

4-st rep;
work
4 (5, 6, 7, 8)
times

Dec rnd: K1, ssk, work sts as they appear to 3 sts before Marker A, k2tog, k1, sl Marker A, p1, ssk, knit to 3 sts before Marker D, k2tog, p1, sl Marker D—4 sts dec'd.

Next rnd: Work sts as they appear to Marker A, sl Marker A, p1, knit to 1 st before Marker D, p1, sl Marker D.

Rep the last 2 rnds 1 (2, 3, 4, 5) more time(s)—48 (52, 56, 60, 64) sts rem.

Rep dec rnd every rnd 6 (7, 8, 9, 10) times—24 sts rem for all sizes.

Finishing

Removing markers, arrange sts so that 12 top-of-foot sts are on one needle and 12 bottom-of-foot sts are on a second needle. Cut yarn, leaving a 12" (30.5 cm) tail. Thread tail on a tapestry needle and use the Kitchener st (see Glossary) to graft the sts tog.

Weave in loose ends.

Block lightly.

43

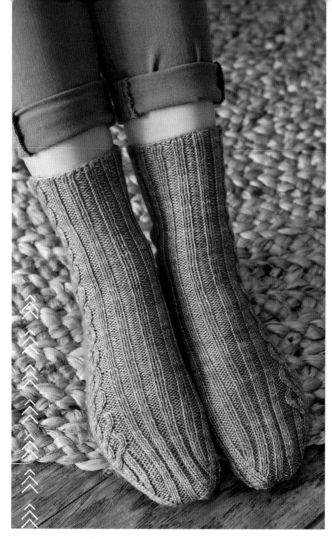

Right Sock

Leg

CO 56 (64, 72, 80, 88) sts. Arrange sts on needles as preferred, pm, and join for working in rnds, being careful not to twist sts. Rnd begins on outside of leg at start of front-of-leg sts.

Work Rnds 1–8 of Right Leg chart 6 times, ending with Rnd 8—48 chart rnds completed; piece measures 4¾" (12 cm) from CO.

Place Markers A, B, C, and D as for left sock—2 markers next to each other at the mid-point and end-of-rnd.

Heel Flap and Gusset

Set-up rnd: Work Rnd 1 of Right Leg chart as established over 28 (32, 36, 40, 44) sts, sl Marker A, M1P, sl Marker B, work Rnd 1 of Right Heel chart over 28 (32, 36, 40, 44) sts, sl Marker C, M1P, sl Marker D—58 (66, 74, 82, 90) sts total; 1 gusset st between each pair of markers.

Note: The gussets are shaped over 30 (34, 38, 42, 46) rounds in the same manner as the left sock, substituting the charts for the right sock. For the stitches of the Right Leg chart, continue the established pattern. For the sts of the Right Heel chart, continue in pattern until Rnds 1–8 have been worked 2 (3, 3, 4, 4) times, then work Rnds 9–16 once, then work the stitches as they appear in Rnd 16 for 7 (3, 7, 3, 7) rnds. Work all gusset stitches in reverse stockinette.

Complete heel flap and gusset as for left sock—88 (100, 112, 124, 136) sts total; 16 (18, 20, 22, 24) gusset sts between each pair of markers; heel flap measures about 3 (3½, 4, 4¼, 4¾)" (7.5 [9, 10, 11, 12] cm) from set-up rnd; piece measures about 7¾ (8¼, 8¾, 9, 9½)" (19.5 [21, 22, 23, 24] cm) from CO.

Make a note of the last Right Leg chart rnd completed so you can resume working in patt with the correct rnd later.

Heel Turn

Work as for left sock—78 (88, 98, 108, 118) sts total; 18 (20, 22, 24, 26) heel sts.

Bottom of Heel

Work as for left sock—56 (64, 72, 80, 88) sts rem; 26 (30, 34, 38, 42) heel sts; 1 st each gusset; 28 (32, 36, 40, 44) instep sts.

Foot

Joining rnd: With RS still facing, p1, sl Marker D, work 28 (32, 36, 40, 44) instep sts in patt, sl Marker A, p1, knit across heel/sole sts to 1 st before Marker D, p1, sl Marker D—28 (32, 36, 40, 44) sts each for instep and sole; rnd begins at Marker D on outer edge of foot, at start of instep sts.

Keeping sole sts in St st with p1 at each side, cont instep patt as set until foot measures 6½ (6½, 6¾, 6¾, 7)" (16.5 [16.5, 17, 17, 18] cm) from center back heel, or 2½ (2¾, 3, 3¼, 3½)" (6.5 [7, 7.5, 8.5, 9] cm) less than desired total length, ending with Rnd 8 of Right Leg chart. Do not work any partial reps of the leg chart; if ending with Rnd 8 leaves you short of the target length, change to working the instep sts in patt from Right Toe chart, beg with Rnd 1.

Toe

Change to working 28 (32, 36, 40, 44) instep sts in patt from Right Toe chart if you have not already done so. Complete toe as for left sock—24 sts rem for all sizes.

Finishing

Work as for left sock.

☐ knit

· purl

☐ pattern repeat

sl 2 sts onto cn and hold in back of work, k2, then k2 from cn

sl 2 sts onto cn and hold in front of work, k2, then k2 from cn

sl 2 sts onto cn and hold in back of work, k2, then p2 from cn

sl 2 sts onto cn and hold in front of work, p2, then k2 from cn

RIGHT LEG

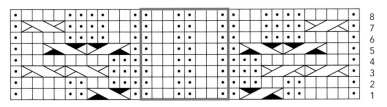

8-st rep;
work
4 (5, 6, 7, 8)
times

RIGHT TOE

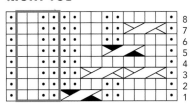

4-st rep;
work
4 (5, 6, 7, 8)
times

RIGHT HEEL

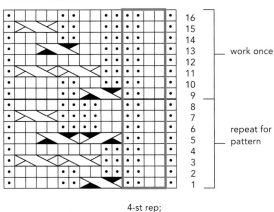

work once

repeat for
pattern

4-st rep;
work
4 (5, 6, 7, 8)
times

HUNTER HAMMERSEN didn't really like knitting the first time she tried it. She didn't much care for it the second time either. It wasn't till the third time, and the discovery of knitted socks, that she was properly smitten. Once she realized she could make up her own patterns, her fate was sealed. She's been busy designing ever since. You can find her work at ViolentlyDomestic.com.

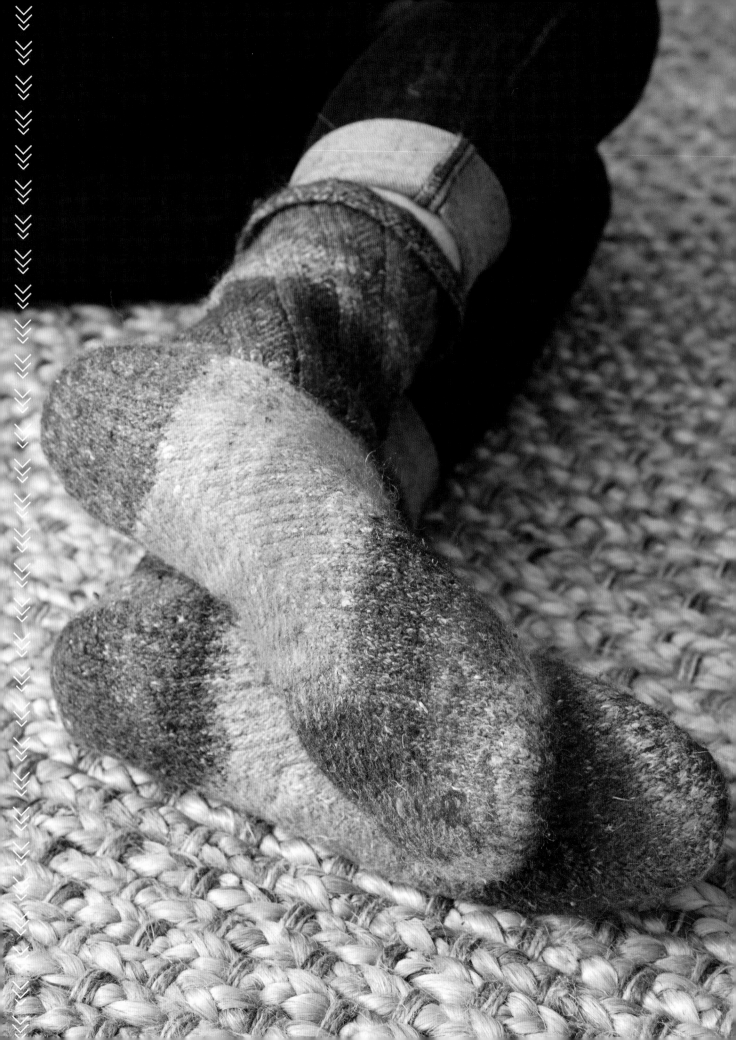

Tilt-A-Whirl

JENNIFER LEIGH

Beginning with Elizabeth Zimmermann's arch-shaped foot, with a dash of inspiration and guidance from Cat Bordhi's unusual constructions, I conceived these socks for active feet. Yarnovers provide ventilation and stretch in the leg, and a thick, reinforced fabric provides support and cushioning for the foot. The dense foot will withstand the most punishing wear and tear. Although the construction is novel, these socks are easy to work and will provide an enjoyable knitting adventure for first-time sock knitters as well as lifelong sock-knitting fanatics.

FINISHED SIZE

About 6¼ (7, 7¾, 8½, 9, 9¾)" (16 [18, 19.5, 21.5, 23, 25] cm) foot circumference, 8½ (9, 9½, 10¼, 10¾, 11¼)" (21.5 [23, 24, 26, 27.5, 28.5] cm) foot length from back of heel to tip of toe (adjustable), and 6½ (6½, 7, 7, 8, 8)" (16.5 [16.5, 18, 18, 20.5, 20.5] cm) leg length from top of leg to start of heel turn (adjustable).

Socks shown measure 7¾" (19.5 cm) foot circumference.

YARN

Fingering weight (#1 Super Fine).

Shown here: Noro Silk Garden Sock (40% wool, 25% silk, 25% nylon, 10% mohair; 328 yd [300 m]/100 g): #289 Purple, Blue, Green, Brown: 1 (1, 2, 2, 2, 2) ball(s).

NEEDLES

Size U.S. 1.5 (2.5 mm): two 16" or 24" (40 or 60 cm) circular (cir).

Adjust needle size if necessary to obtain the correct gauge.

NOTIONS

Removable stitch markers; regular markers (m); tapestry needle.

GAUGE

30 sts and 45 rnds = 4" (10 cm) in leg patts worked in rnds, relaxed after blocking.

34 sts and 58 rows/rnds = 4" (10 cm) in twisted heel stitch patts, relaxed after blocking.

23 sts = 2" (5 cm) in twisted heel stitch patts for foot, measured at a 45-degree angle to the bias stitch columns, with the ruler laid perpendicular to the center instep and sole sts.

NOTES

- The leg and heel patterns are worked on the bias, with the stitch columns tilted on a 45-degree angle. This requires more stitches than "normal" patterns in which the stitch columns are vertical. The bias-stitch patterns used here have less stretch than regular stockinette, so select a size with a relatively small amount of negative ease—¼" to ½" (6 mm to 1.3 cm) for the foot circumference and ½" to 1" (1.3 to 2.5 cm) for the calf circumference. If in doubt, choose the larger size.

- In the twisted heel stitch worked in rounds, the first round alternates a knit stitch with a slip stitch. In the second round, the stitches that were knitted in the first round are knitted again, but the slipped stitches are knitted through their back loops. This creates single-stitch columns of plain stockinette that alternate with single-stitch columns of slipped and twisted stitches. When working back and forth in rows, on WS rows the stockinette columns are purled, and the slip stitches are purled through their back loops. During shaping, maintain the pattern by knitting each stockinette column, being careful to keep the correct alternation of slipped and twisted stitches in the other columns.

- This pattern is written for working one sock at a time on two circular needles, but can also be worked on double-pointed needles or with single long circular needle using the magic-loop technique (see page 6).

STITCH GUIDE

Left-Leg Pattern (multiple of 8 sts)

Rnd 1: *K2, yo, k4, k2tog; rep from *.

Rnd 2: Knit.

Rep Rnds 1 and 2 for patt.

Right-Leg Pattern (multiple of 8 sts)

Rnd 1: *K2, ssk, k4, yo; rep from *.

Rnd 2: Knit.

Rep Rnds 1 and 2 for patt. Take care not to drop any yarnovers at the ends of the needles.

Twisted Heel Stitch Worked in Rounds (even number of sts)

Rnd 1: *K1, sl 1 purlwise with yarn in back (pwise wyb); rep from *.

Rnd 2: *K1, k1 through back loop (tbl); rep from *.

Rep Rnds 1 and 2 for patt.

Twisted Heel Stitch Worked in Rows (even number of sts)

Row 1: (RS) *K1, sl 1 purlwise with yarn in back (pwise wyb); rep from *.

Row 2: (WS) *P1 through back loop (tbl), p1; rep from *.

Rep Rows 1 and 2 for patt.

Leg

Using the Old Norwegian method (see Glossary), CO 42 (49, 56, 63, 63, 70) sts. Arrange sts as evenly as possible on two cir needles, place marker (pm), and join for working in rnds, being careful not to twists sts.

[Purl 1 rnd, then knit 1 rnd] 2 times—2 garter ridges.

Work the left and right socks differently as foll.

Left sock

Set-up Rnd 1: K2, *yo, k7; rep from * to last 5 sts, yo, k5—48 (56, 64, 72, 72, 80) sts.

Set-up Rnd 2: Knit.

Right sock

Set-up Rnd 1: *K7, yo; rep from *—48 (56, 64, 72, 72, 80) sts.

Set-up Rnd 2: Knit.

Both socks

Redistribute sts if necessary so there are 24 (28, 32, 36, 36, 40) sts on each needle.

Working left-leg patt (see Stitch Guide) on left sock, or right leg patt (see Stitch Guide) on right sock, cont in patt until piece measures 4¼ (4¼, 4½, 4½, 5¼, 5)" (11 [11, 11.5, 11.5, 13.5, 12.5] cm) from CO, ending with Rnd 1.

Note: To lengthen or shorten the leg, work more or fewer pattern repeats, ending with Rnd 1, until leg measures about 2¼ (2¼, 2½, 2½, 2¾, 3)" (5.5 [5.5, 6.5, 6.5, 7, 7.5] cm) less than desired length to start of heel turn.

Gusset Increases

Notes: The gusset stitches are increased on each side of a center back heel panel. They're worked in the twisted heel stitch given below. Slip stitches as if to purl with yarn in back (pwise wyb).

Work the left and right socks differently as foll.

Left sock

Set-up rnd: (counts as Rnd 2 of leg patt) K2, pm, k5, pm, knit to end of rnd—5 sts between gusset markers.

Rnd 1: K2, slip marker (sl m), yo, k1tbl, *k1, k1tbl; rep from * to next m, yo, sl m, k1, work Rnd 1 of left leg patt to end of rnd—2 sts inc'd between gusset markers.

Rnd 2: K2, sl m, k1, *sl 1, k1; rep from * to next m, sl m, k1, work Rnd 2 of left leg patt to end of rnd.

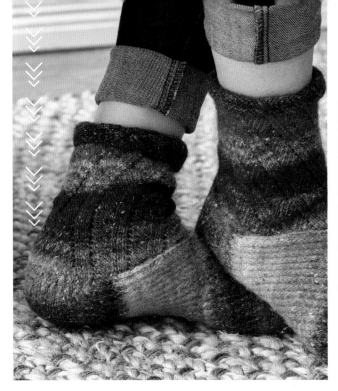

Rnd 3: K2, sl m, yo, k1, *k1tbl, k1; rep from * to next m, yo, sl m, k1, work Rnd 1 of left leg patt to end of rnd—2 sts inc'd between gusset markers.

Rnd 4: K2, sl m, k2, sl 1, *k1, sl 1; rep from * to 2 sts before marker, k2, sl m, k1, work Rnd 2 of left leg patt to end of rnd.

Right sock

Set-up rnd: (counts as Rnd 2 of leg patt) K3, pm, k5, pm, knit to end of rnd—5 sts between gusset markers.

Rnd 1: K3, sl m, yo, k1tbl, *k1, k1tbl; rep from * to next m, yo, sl m, work Rnd 1 of right leg patt to end of rnd—2 sts inc'd between gusset markers.

Rnd 2: K3, sl m, k1, *sl 1, k1; rep from * to next m, sl m, work Rnd 2 of right leg patt to end of rnd.

Rnd 3: K3, sl m, yo, k1, *k1tbl, k1; rep from * to next m, yo, sl m, work Rnd 1 of right leg patt to end of rnd—2 sts inc'd between gusset markers.

Rnd 4: K3, sl m, k2, sl 1, *k1, sl 1; rep from * to 2 sts before next m, k2, sl m, work Rnd 2 of right leg patt to end of rnd.

Both socks

Work Rnds 1–4 (do not rep the set-up rnd) 4 (4, 5, 5, 6, 6) more times, then work Rnds 1–3 (Rnds 1–3, Rnd 1, Rnd 1, Rnd 1, Rnds 1–3) once more—72 (80, 90, 98, 102, 112) sts total; 29 (29, 31, 31, 35, 37) sts between gusset markers; 24 (24, 26, 26, 30, 32) gusset rnds completed, including set-up rnd; gusset measures about 2¼ (2¼, 2½, 2½, 2¾, 3)" (5.5 [5.5, 6.5, 6.5, 7, 7.5] cm); piece measures about 6½ (6½, 7, 7, 8, 8)" (16.5 [16.5, 18, 18, 20.5, 20.5] cm) from CO.

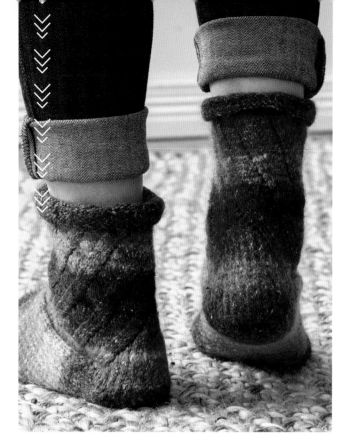

Heel Turn

Remove end-of-rnd marker, knit the sts before the first gusset marker (first 2 leg sts for left sock, first 3 leg sts for right sock) onto the end of the second cir needle, then transfer all the leg sts after the second gusset m onto the beg of the same needle—29 (29, 31, 31, 35, 37) gusset sts on one cir needle for heel; 43 (51, 59, 67, 67, 75) leg sts on other cir needle to be worked later for instep.

Mark the center heel st (should be a slip/twist column) by placing a locking marker in the stitch itself, not on the needle between sts—14 (14, 15, 15, 17, 18) sts each side of marked heel st. Move this marker up as you work so you can easily identify the center st.

Maintaining the established twisted heel patt (see Notes), work heel sts back and forth in rows as foll.

Row 1: (RS) K1 (yo of last gusset inc row), work in established twisted heel st patt to last st, k1 (yo of gusset inc row), turn work.

Row 2: (WS) Sl 1 pwise with yarn in front (wyf), work in patt to last st, p1, turn work.

Row 3: Sl 1 pwise wyb, work in patt to last st, turn work, yo—1 heel st rem unworked.

Row 4: Sl 1 pwise wyf, work in patt to last st, turn work, yo—1 unworked heel st and 1 yo in turning gap at each end of needle.

Row 5: Sl 1 pwise wyb, work in patt to 2 sts before yo in previous turning gap, k1, turn, yo.

Row 6: Sl 1 pwise wyb, work in patt to 2 sts before yo in previous turning gap, p1, turn, yo.

Rep Rows 5 and 6 only 8 (8, 9, 9, 10, 10) more times, ending with a WS row—10 (10, 11, 11, 12, 12) unworked heel sts and turning gap yo's at each end of needle; 9 (9, 9, 9, 11, 13) center sts between last 2 turning gap yo's.

Next row: (RS) Sl 1 pwise wyb, work in patt to first turning gap yo, [work yo tog with st after it as k2tog] 10 (10, 11, 11, 12, 12) times, place a locking marker in the last k2tog to mark it as the "RS turning st," turn work.

Next row: (WS) Re-establishing twisted heel st patt over the k2tog sts worked in previous row, sl 1 pwise wyf, work in patt to first turning gap yo, [work yo tog with st after it as ssp (see Glossary)] 10 (10, 11, 11, 12, 12) times, place a locking marker in the last ssp to mark it as the "WS turning st," turn work—29 (29, 31, 31, 35, 37) heel sts.

Foot

Notes: The heel stitches now become the foot stitches; the marked stitch in the center of the heel becomes the center sole stitch. The foot stitches are worked back and forth in rows, increasing on each side of the center sole stitch, and joined to the leg stitches by working a marked turning stitch together with 1 leg stitch at the end of each row. Continue to move the locking markers up as you work to identify the center sole and turning stitches.

Row 1: (RS) Sl 1 pwise wyb, work in patt to marked center st, M1R (see Glossary), k1 (center st), M1L (see Glossary), work in patt to RS turning st, ssk (turning st tog with 1 leg st), turn work—2 foot sts inc'd; 1 leg st joined.

Row 2: (WS) Working new sts on each side of center st into established patt, sl 1 pwise wyf, work in patt to marked center st, p1 (center st), work in patt to WS turning st, p2tog (turning st tog with 1 leg st), turn work—1 leg st joined.

Rep the last 2 rows 20 (24, 28, 32, 32, 36) more times—72 (80, 90, 98, 102, 112) sts total; 1 unjoined leg st rem between turning sts, 71 (79, 89, 97, 101, 111) foot sts arranged as 1 marked center st and 35 (39, 44, 48, 50, 55) sts in twisted heel st patt at each side.

Remove markers from turning sts, leaving marker in center sole st in place. Resume working in rnds as foll, working new sole sts into established patt on each side of center st.

Next rnd: With RS facing, sl 1 st from right needle to left needle, and pm for new end-of-rnd. Sl 2 sts as if to k2tog (slipped st and rem leg st after it), k1, pass 2 slipped sts over (p2sso), and place a locking marker in this st to indicate the center instep st. Work in patt to marked

center sole st, M1R, k1 (center st), M1L, work in patt to end of rnd—still 72 (80, 90, 98, 102, 112) sts; 1 marked st center of instep and sole, 35 (39, 44, 48, 50, 55) sts in twisted heel st patt on each side.

Work even as foll.

Rnd 1: K1 (center instep st), work in patt to center sole st, k1, work in patt to last st, sl last st to right needle, remove end-of-rnd m, return slipped to left needle, replace end-of-rnd m.

Rnd 2: Sl 2 as if to k2tog (slipped st and center instep st), k1, p2sso, work in patt to center sole st, M1R, k1 (center st), M1L, work in patt to last st.

Rep the last 2 rnds until foot measures 9 (9½, 10, 10¾, 11¼, 11¾)" (23 [24, 25.5, 27.5, 28.5, 30] cm), measured along the underside of the foot and straight up along the center sole st column from the end of the heel turn to the needle, or about ½" (1.3 cm) longer than total foot length.

Note: The sock foot is worked longer than the wearer's foot because the star toe will draw the foot fabric up around the tips of the toes and back toward the ankle; the center of the star will sit on top of the foot, near the base of the toes.

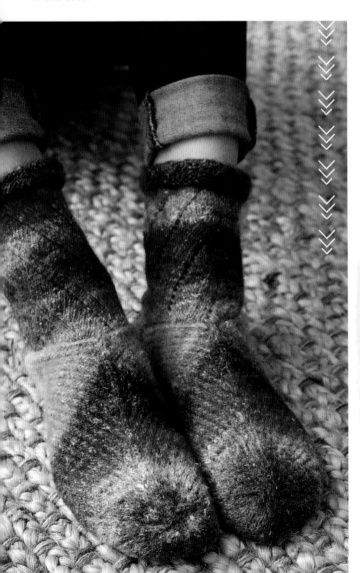

Toe

Next rnd: Removing locking marker in center sole st, knit and *at the same time* dec 0 (dec 0, dec 2, dec 2, inc 2, dec 0) sts evenly spaced—72 (80, 88, 96, 104, 112) sts.

Next rnd: *K9 (10, 11, 12, 13, 14), place a regular marker on the needle; rep from * to end, omitting the last marker placement because end-of-rnd marker is already in position—8 marked sections of 9 (10, 11, 12, 13, 14) sts each.

Work the left and right socks differently as foll.

Left sock

Dec rnd: *Ssk, work in patt to m, sl m; rep from * 8 times—8 sts dec'd.

Right sock

Dec rnd: *Work in patt to 2 sts before m, k2tog, sl m; rep from * 8 times—8 sts dec'd.

Both socks

[Knit 3 rnds, then rep dec rnd] 0 (0, 0, 0, 0, 2) times—64 (72, 80, 88, 96, 88) sts rem.

[Knit 1 rnd, then rep dec rnd] 3 (3, 3, 3, 4, 3) times—40 (48, 56, 64, 64, 64) sts rem.

Rep the dec rnd on the next 4 (5, 6, 7, 7, 7) rnds—8 sts rem for all sizes.

Cut yarn, leaving a 10" (25.5 cm) tail. Thread tail on a tapestry needle, draw through rem sts twice, pull tight to close hole, and fasten off on WS.

Finishing

Weave in loose ends.

Block if desired.

JENNIFER "JENNIGMA" LEIGH has been knitting since she was three, when her grandmother taught her one summer while sitting on the beach. She lives in Seattle, Washington, with dogs, cats, her sweetheart, her son, and an occasional visiting cow from the farm across the street. In addition to knitting, she works a project she calls Hack Your Clothes, the goal of which is to help people reclaim the skills needed to make off-the-shelf clothes fit their bodies and personalities, or perhaps to make new things from scratch. See her blog at Jennigma.net and her project website at HackYourClothes.com.

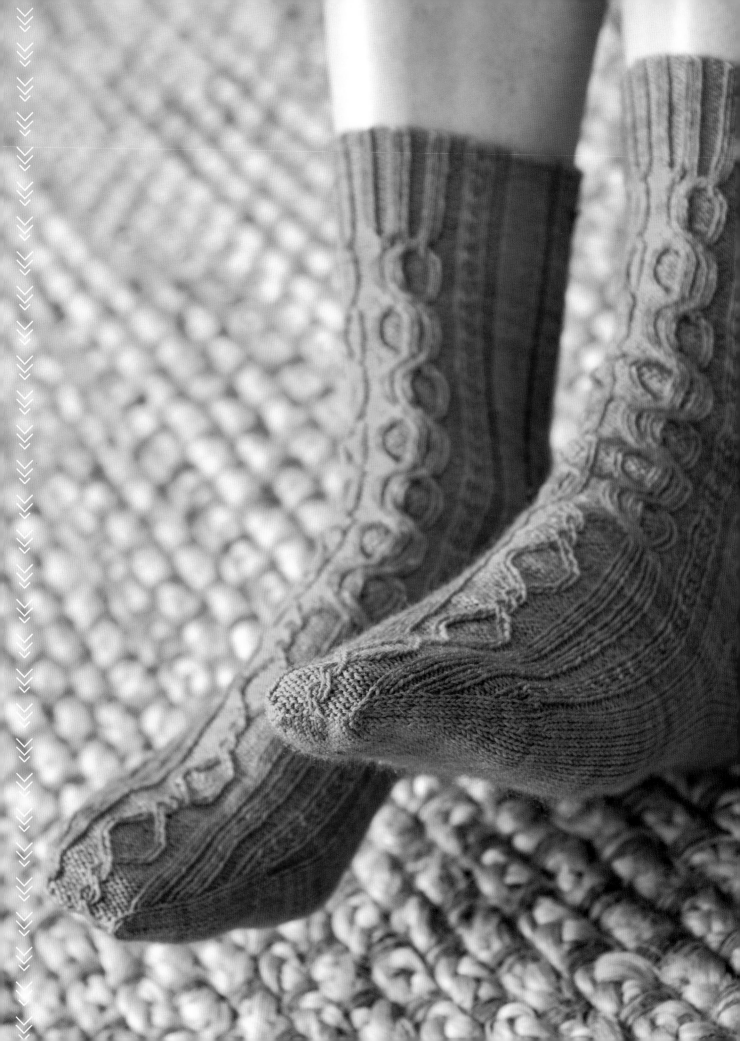

Gold Digger

HEIDI NICK

I love how an asymmetrical cable forms a symmetrical design when paired with its mirror image. If you haven't tried a Fleegle heel (first engineered by Susan Glinert Stevens) before, you're in for a treat—it's easy and fun, with no picking up stitches, and, best of all, no holes. This sock is deceptively easy, with plenty of "rest" rows between the cable twists. Stockinette-stitch panels along the sides allow for adjustable sizing.

FINISHED SIZE

About 7 (7¼, 7¾, 8¼, 8½)" (18 [18.5, 19.5, 21, 21.5] cm) foot circumference, relaxed, will stretch to fit up to 7¾ (8, 8½, 9, 9½)" (19.5 [20.5, 21.5, 23, 24] cm) foot circumference; 9 (9½, 10, 10¼, 10½)" (23 [24, 25.5, 26, 26.5] cm) foot length from back of heel to tip of toe (length is adjustable); and 8" (20.5 cm) leg length from top of cuff to start of heel turn.

Socks shown measure 7¼" (18.5 cm) foot circumference, relaxed.

YARN

Fingering weight (#1 Super Fine).

Shown here: Lola-Doodles Buff Sock (75% superwash Bluefaced Leicester, 25% nylon; 464 yd [424 m]/100 g): Gold Digger, 1 (1, 1, 1, 2) skein(s).

NEEDLES

Size U.S. 1 (2.25 mm): two 24" (60 cm) circular (cir).

Adjust needle size if necessary to obtain the correct gauge.

NOTIONS

Markers (m); cable needle (cn); tapestry needle.

GAUGE

19 sts and 26 rnds = 2" (5 cm) in St st worked in rnds, relaxed after blocking.

26 center cable sts of Front chart measure about 2" (5 cm) wide, slightly stretched after blocking.

12 center cable sts of Back and Instep charts measure about 1" (5 cm) wide, slightly stretched after blocking.

NOTES

- Instructions are for working with two circular needles; see page 6 for substituting other needle configurations.
- Needle 1 holds the front-of-leg and instep stitches; Needle 2 holds the back-of-leg, heel, and sole stitches.

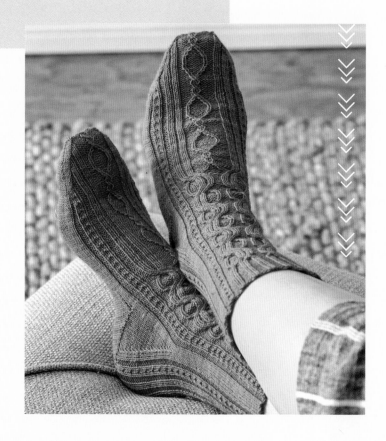

Leg

Using a flexible method (see Glossary), CO 68 (72, 76, 80, 84) sts. Arrange sts so that there are 34 (36, 38, 40, 42) sts on each cir needle, place marker (pm), and join for working in rnds, being careful not to twist sts.

Next rnd: Beg and end as indicated for your size, on Needle 1 work Rib Rnd 1 of Front chart (see page 56) over 34 (36, 38, 40, 42) sts; on Needle 2, work Rib Rnd 1 of Back chart (see page 57) over 34 (36, 38, 40, 42) sts.

Cont in patts as set, work Rib Rnds 2–4 once, then rep Rib Rnds 1–4 four more times—20 rnds completed; piece measures about 1½" (3.8 cm) from CO.

Next rnd: Beg and end as indicated for your size, on Needle 1 work Set-up Rnd 1 of Front chart over 34 (36, 38, 40, 42) sts; on Needle 2, work Set-up Rnd 1 of Back chart over 34 (36, 38, 40, 42) sts.

Cont in patts as set, work Set-up Rnds 2–4 once, then work Rnds 1–24 of charts 2 times—piece measures about 5½" (14 cm) from CO.

Gussets

Rnd 1: On Needle 1, cont in patt; on Needle 2, M1R (see Glossary), work Rnd 1 of Back chart, M1L (see Glossary)—2 sts inc'd on Needle 2.

Rnd 2: On Needle 1, cont in patt; on Needle 2, k1, work Rnd 2 of Back chart, k1.

Rnd 3: On Needle 1, cont in patt; on Needle 2, k1, M1R, cont in patt to last st, M1L, k1—2 sts inc'd on Needle 2.

Rnd 4: On Needle 1, cont in patt; on Needle 2, k2, cont in patt to last 2 sts, k2.

Rnd 5: On Needle 1, cont in patt; on Needle 2, k1, M1R, k1, pm, cont in patt to last 2 sts, pm, k1, M1L, k1—2 sts inc'd on Needle 2.

Rnd 6: On Needle 1, cont in patt; on Needle 2, k3, slip marker (sl m), cont in patt to next m, sl m, k3.

Rnd 7: On Needle 1, cont in patt; on Needle 2, knit to 1 st before m, M1R, k1, sl m, cont in patt to next m, sl m, k1, M1L, knit to end—2 sts inc'd on Needle 2.

Rnd 8: On Needle 1, cont in patt; on Needle 2, knit to m, sl m, cont in patt to m, sl m, knit to end.

Rnds 9–30: Cont in patt, rep the shaping of Rnds 7 and 8 eleven more times, ending with Rnd 6 of both charts—98 (102, 106, 110, 114) sts total; 34 (36, 38, 40, 42) sts on Needle 1; 64 (66, 68, 70, 72) sts on Needle 2.

Rnd 31: On Needle 1, work Rnd 7 of chart; on Needle 2, knit to 1 st before m, M1R, k1, sl m, work first 17 (18, 19,

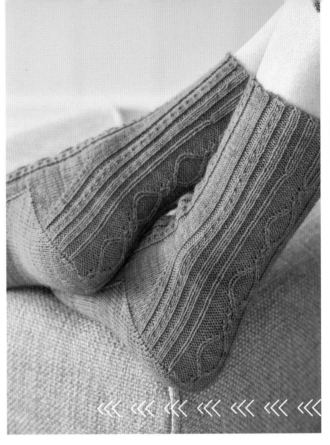

20, 21) sts from Rnd 7 of Back chart, pm at center back, work second 17 (18, 19, 20, 21) sts from Rnd 7 of Back chart, sl m, k1, M1L, knit to end—100 (104, 108, 112, 116) sts total; 34 (36, 38, 40, 42) sts on Needle 1; 66 (68, 70, 72, 74) sts on Needle 2 with 33 (34, 35, 36, 37) sts on each side of center m; piece measures 8" (20.5 cm) from CO.

Heel

Turn Heel

Set-up: On Needle 1, work Rnd 8 of Front chart and stop.

The heel turn is worked back and forth in rows on the 66 (68, 70, 72, 74) heel sts on Needle 2; the sts on Needle 1 will be worked later for instep.

Cont on heel sts as foll:

Row 1: (RS) K37 (38, 39, 40, 41) sts to 4 sts past center m, ssk, k1, turn work.

Remove all markers from heel needle as you come to them on the foll rows.

Row 2: (WS) Sl 1 purlwise with yarn in front (pwise wyf), p9, p2tog, p1, turn work.

Row 3: Sl 1 purlwise wyb (pwise wyb), knit to 1 st before gap formed on previous RS row, ssk (1 st on each side of gap), k1, turn work.

Row 4: Sl 1 pwise wyf, purl to 1 st before gap formed on previous WS row, p2tog (1 st on each side of gap), p1, turn work.

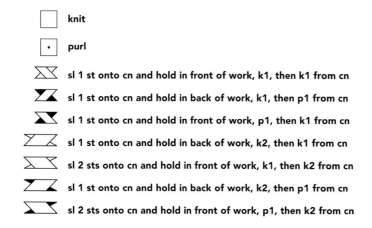

☐ knit

· purl

⟋⟍ sl 1 st onto cn and hold in front of work, k1, then k1 from cn

⟋◣ sl 1 st onto cn and hold in back of work, k1, then p1 from cn

◢⟍ sl 1 st onto cn and hold in front of work, p1, then k1 from cn

⟋⟍ sl 1 st onto cn and hold in back of work, k2, then k1 from cn

⟋⟍ sl 2 sts onto cn and hold in front of work, k1, then k2 from cn

◢⟍ sl 1 st onto cn and hold in back of work, k2, then p1 from cn

◢⟍ sl 2 sts onto cn and hold in front of work, p1, then k2 from cn

FRONT

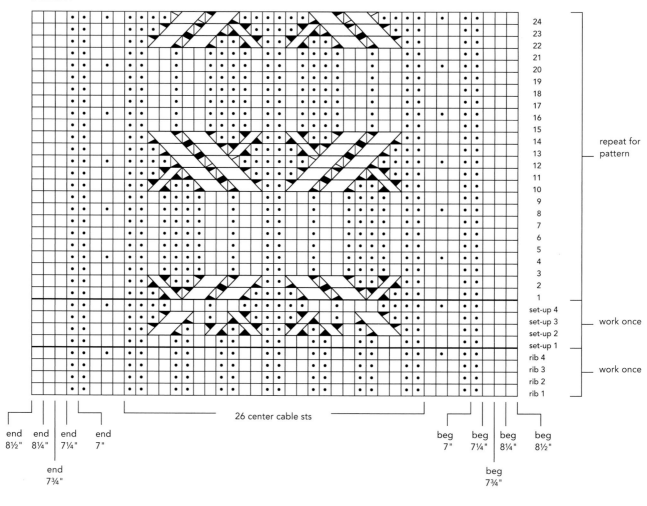

24
23
22
21
20
19
18
17
16
15 — repeat for pattern
14
13
12
11
10
9
8
7
6
5
4
3
2
1

set-up 4
set-up 3 — work once
set-up 2
set-up 1
rib 4
rib 3 — work once
rib 2
rib 1

26 center cable sts

end 8½" end 8¼" end 7¼" end 7"

end 7¾"

beg 7" beg 7¼" beg 8¼" beg 8½"

beg 7¾"

BACK

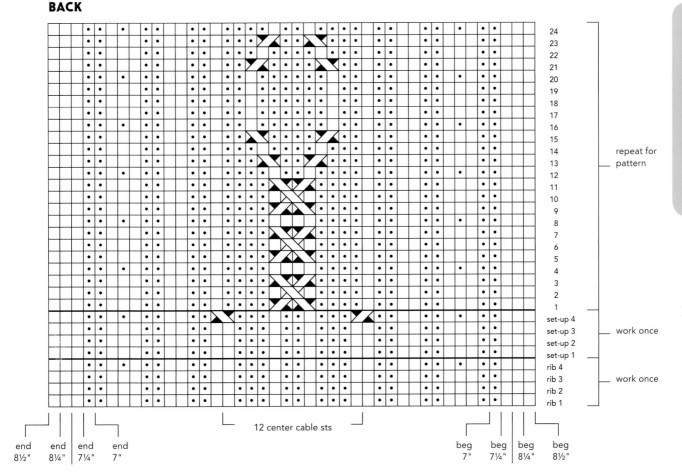

24
23
22
21
20
19
18
17
16
15
14
13
12
11
10
9
8
7
6
5
4
3
2
1

repeat for pattern

set-up 4
set-up 3
set-up 2
set-up 1

work once

rib 4
rib 3
rib 2
rib 1

work once

12 center cable sts

end 8½" end 8¼" end 7¼" end 7"

beg 7" beg 7¼" beg 8¼" beg 8½"

INSTEP

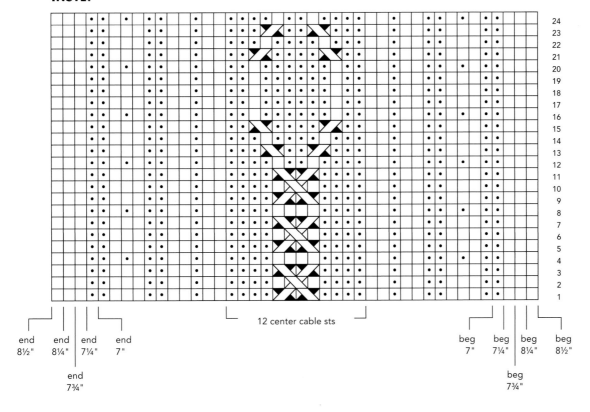

24
23
22
21
20
19
18
17
16
15
14
13
12
11
10
9
8
7
6
5
4
3
2
1

12 center cable sts

end 8½" end 8¼" end 7¼" end 7"

beg 7" beg 7¼" beg 8¼" beg 8½"

end 7¾"

beg 7¾"

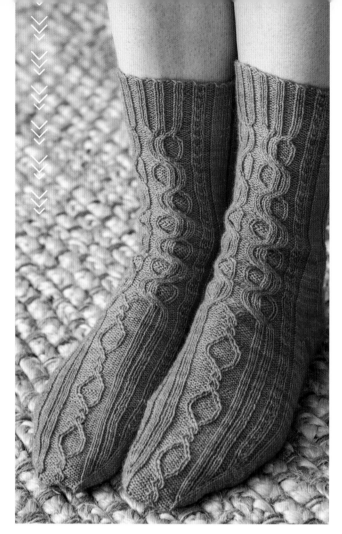

Rep Rows 3 and 4 only 11 (12, 12, 13, 13) more times—40 (40, 42, 42, 44) heel sts rem; 2 (1, 2, 1, 2) unworked st(s) at each end of needle outside the k1 or p1 after the last dec.

Next row: (RS) Knit to last 2 sts, k2tog—39 (39, 41, 41, 43) heel sts rem.

Foot

Resume working in rnds with instep sts on Needle 1 and sole sts on Needle 2.

Joining rnd: On Needle 1, work Rnd 9 of Front chart over 34 (36, 38, 40, 42) sts; on Needle 2, ssk, knit to end—38 (38, 40, 40, 42) sole sts rem on Needle 2.

SIZES 7 (7¼, 7¾)" (18 [18.5, 19.5] CM) ONLY

Next rnd: On Needle 1, cont in patt; on Needle 2, knit.

Next rnd: On Needle 1, cont in patt; on Needle 2, k1, ssk, knit to last 3 sts, k2tog, k1—36 (36, 38) sts on Needle 2.

Rep the last 2 rnds 1 (0, 0) more time—34 (36, 38) sts on Needle 2.

ALL SIZES

There are now 68 (72, 76, 80, 84) sts total; 34 (36, 38, 40, 42) sts on each needle.

Cont est patt on Needle 1 and work sts on Needle 2 in St st, for 3 (5, 5, 7, 7) more rnds, ending with Rnd 16 of Front chart.

Next rnd: Beg and end as indicated for your size, on Needle 1 work Rnd 1 of Instep chart over 34 (36, 38, 40, 42) sts; on Needle 2, knit.

Cont in patt as set until foot measures 7 (7¼, 7¾, 7¾, 8)" (18 [18.5, 19.5, 19.5, 20.5] cm) from center back heel or 2 (2¼, 2¼, 2½, 2½)" (5 [5.5, 5.5, 6.5, 6.5] cm) less than desired finished sock length.

Toe

Note: During the following shaping, cont the Instep chart on Needle 1 until the next Rnd 24 has been completed, then repeat only Rnds 1–4 of chart to end of toe.

Rnd 1: On Needle 1, k1, ssk, work in patt to last 3 sts, k2tog, k1; on Needle 2, k1, ssk, knit to last 3 sts, k2tog, k1—4 sts dec'd.

Rnds 2–4: Work 3 rnds even in patt.

Rnds 5–8: Rep Rnds 1–4 once more—4 sts dec'd.

Rnd 9: Rep Rnd 1—4 sts dec'd.

Rnds 10 and 11: Work 2 rnds even in patt.

Rnds 12–14: Rep Rnds 9–11 once more—4 sts dec'd.

Rnd 15: Rep Rnd 1—4 sts dec'd.

Rnd 16: Work 1 rnd even in patt.

Rep Rnds 15 and 16 only 5 (6, 7, 8, 9) more times—28 sts rem for all sizes; 14 sts on each needle.

Cut yarn, leaving a 20" (51 cm) tail.

Finishing

Thread tail on tapestry needle and use the Kitchener st (see Glossary) to graft the rem sts tog. Weave in loose ends. Block lightly, if desired.

HEIDI NICK, a lifelong resident of upstate New York and mom to two girls (who also knit), learned to knit from her Grandmummy when she was a teenager. Her patterns are available on *Ravelry* (Ravelry.com).

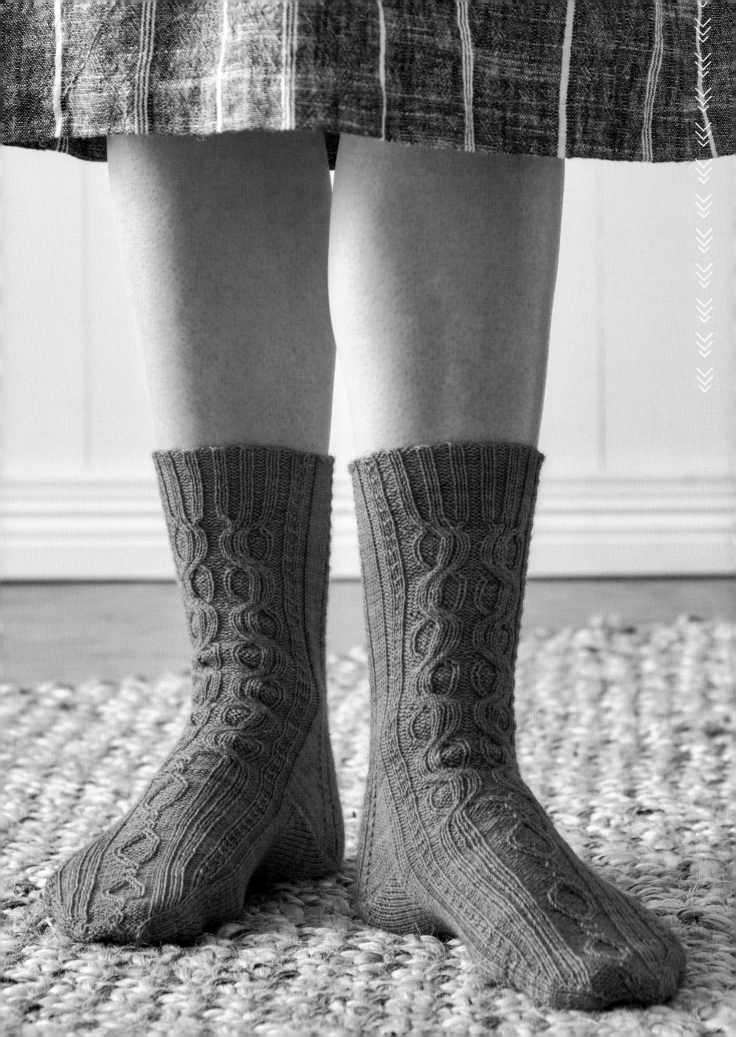

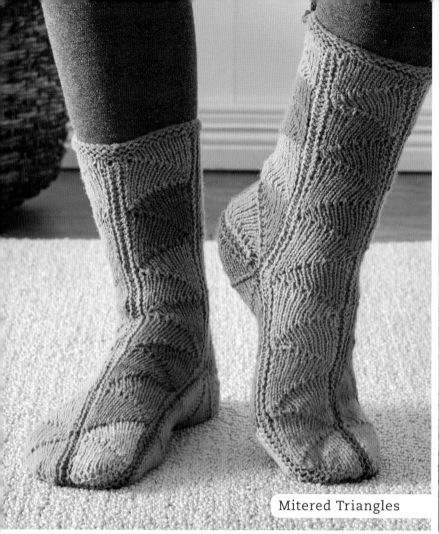

Mitered Triangles

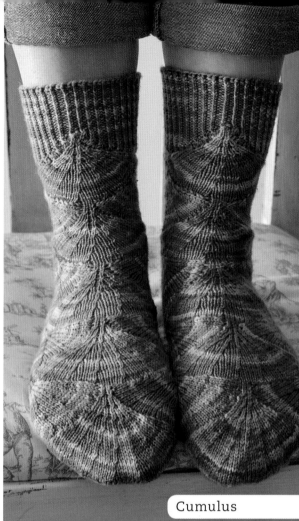

Cumulus

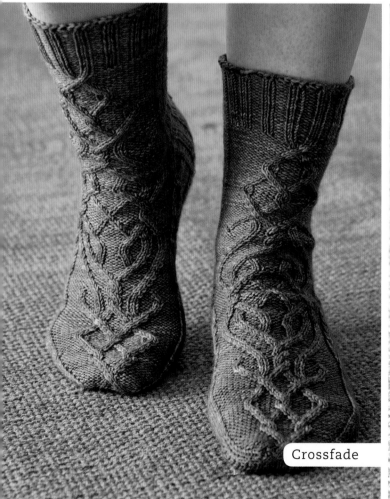

Crossfade

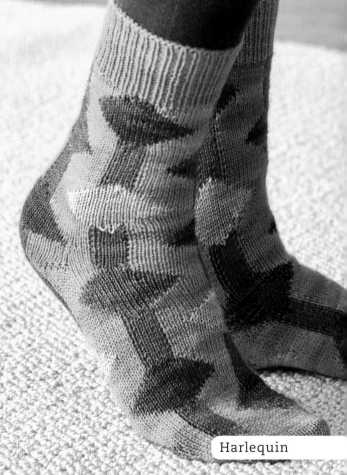

Harlequin

CHAPTER 2
TOE-UP CONSTRUCTION

Toe-up construction typically begins with a type of circular cast-on that mimics the Kitchener stitch used for top-down socks. Stitches are increased to create the toe box, then the foot is worked even to the beginning of the gusset increases. The heel is usually shaped with short-rows as the gusset stitches are decreased. The leg is worked to the desired length, then bound off with a flexible method that allows sufficient stretch to pull on and off a foot.

Four of the designs in this book are worked from the toe up. But each one offers a new technique that expands the realm of toe-up knitting.

True to her signature use of shapes and color, Kathryn Alexander worked her **Mitered Triangles** (page 62) in four panels of mitered triangles such that each panel is worked lengthwise from the toe to the cuff, then joined with a three-needle bind-off. The toe and heel are formed by variations of the mitered triangles used throughout the foot and leg. Kathryn added a garter-stitch cuff topped off with a twisted I-cord loop at the back of the leg.

Anne Berk's **Harlequin** socks (page 70) follow standard toe-up construction with a short-row heel and wedge toe. The difference arises in the intarsia colorwork pattern that's worked in rounds, which produces isolated and vertical stripes of color. To achieve this effect, Anne uses her "Annetarsia" method of alternating between knit and purl rows that are joined by an ingenious method that gives the appearance of having been worked in rounds.

For **Cumulus** (page 78), Carissa Browning worked a series of individual short-row scallops that build one upon another in a circular pattern from the toe to the cuff. The heels are shaped with larger scallops along the way. These socks are ideal for hand-dyed yarn.

Marjan Hammink followed traditional toe-up construction for **Crossfade** (page 86), but she started the cable pattern at the top of the toe instead of waiting until the toe had been fully shaped. She worked the gusset stitches in a cable pattern in which the cables are turned without the aid of a cable needle.

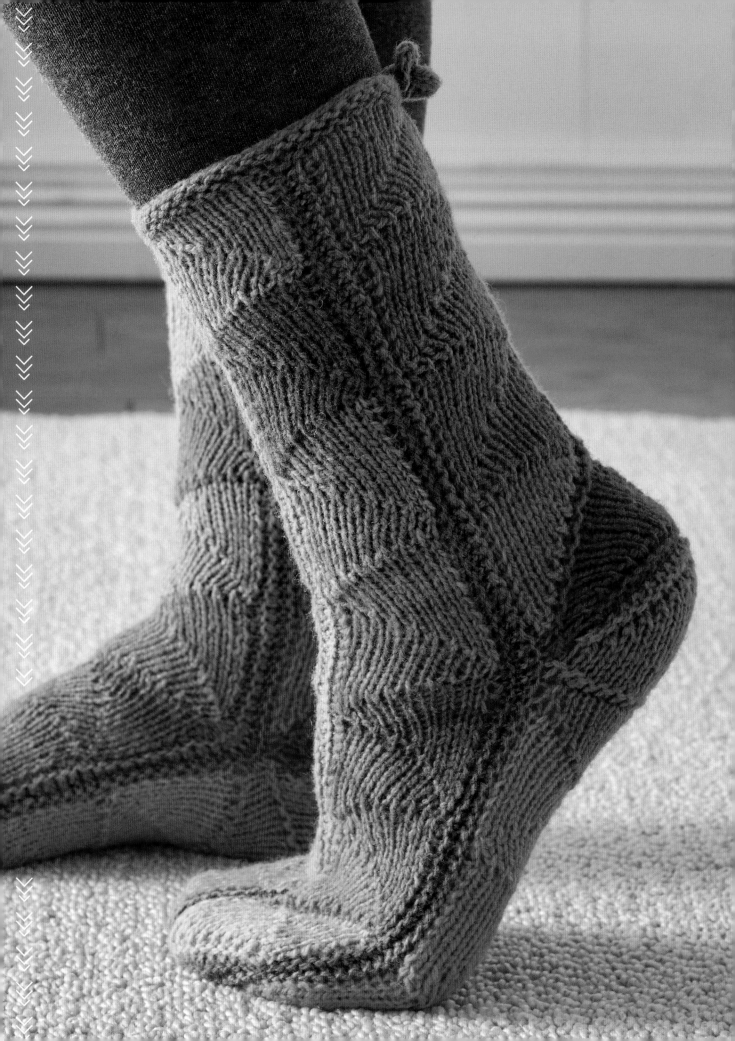

Mitered Triangles

KATHRYN ALEXANDER

Whenever Ann Budd invites me to join one of her projects, I say "yes" even before I know what she has in mind. Ann's vision *du jour* always coaxes me to conjure up something out of the ordinary. Her current sock collection is no different because it directed my focus toward a new way to knit and assemble a sock. I wanted to construct the familiar sock shape without having to decrease for a toe, without having to turn a heel, without having to knit in the round, and without having to do any of the things "traditional" sock patterns require. Then, I thought of tempting knitters with color and introducing them to toes and heels shaped with triangles.

FINISHED SIZE

About 8" (20.5 cm) foot circumference, 9¼" (23.5 cm) foot length from back of heel to tip of toe, and 9½" (24 cm) leg length from upper edge to base of heel.

See Notes (below) for adjusting the size.

YARN

Sportweight (#2 Fine).

Shown here: Kathryn Alexander Designs Light 2-Ply Hand-Dyed Sport (100% wool; 22 yd [20 m]/5 g): 22 yd (20 m) each of 18 colors.

Note: The yarn for these socks is available in kit form at kathrynalexander.net.

NEEDLES

Sock: size U.S. 2 (2.75 mm): set of 4 or 5 double-pointed and two 16" (40 cm) circular (cir).

Three-Needle Bind-Off: size U.S. 5 (3.75 mm): 1 dpn.

Adjust needle size if necessary to obtain the correct gauge.

NOTIONS

Stitch holders; tapestry needle.

GAUGE

13 sts and 18 rows = 2" (5 cm) in St st, relaxed after blocking.

10 panel sts measure about 1¾" (4.5 cm) wide, relaxed after blocking.

17 rows of 10-st left- or right-leaning triangles measure about 1¾" (4.5 cm) high, relaxed after blocking.

11 garter sts = 2" (5 cm), and 4 garter rows (2 garter ridges) between panels measure about ¼" (6 mm) high.

NOTES

- Each sock is made up of panels joined with garter ridges connected by a three-needle bind-off. Each panel is made up of a series of left- and right-leaning triangles.

- Two continuous panels form the front leg, instep, and top of the toe; two panels form the sole and underside of the toe; two panels form the back leg. The heel cup is a four-triangle pyramid shape joined to the sock between the sole and back leg.

- Each 10-stitch triangle requires about 56" (142 cm) of yarn.

- The width of the panels can be adjusted by changing the number of stitches in the basic triangle by a small amount—1 or 2 stitches at the most. Each stitch added to or removed from all four 10-stitch panels will increase or decrease the total circumference of the sock by about ½" (1.3 cm). Be aware that each stitch added to or removed from the basic triangle will require working 2 more or 2 fewer rows in the triangle, which will change its height by about ¼" (6 mm) and affect the length of each piece.

- If you do not need to change the sock circumference, you can still lengthen the foot by working an extra pair of left- and right-leaning triangles in all four panels. Because of the way the triangles fit together, each extra pair will lengthen the foot by about 1¾" (4.5 cm).

- Unless otherwise noted, use any cast-on you desire, just be careful that it's not too tight.

- You do not have to break the yarn when working two successive triangles using the same color.

- The directions are written for turning the work after each short-row. To make it easier to work back and forth on a small number of stitches, use the knitting-in-reverse method (shown at bottom of page 65) to avoid having to turn the work at the end of each row.

- The 17 rows in each triangle create 8 "knots" along the triangle selvedge that will help with perfectly placed pick-up stitches. When picking up 10 stitches along the edge of a triangle, pick up 1 stitch in each knot, plus 1 stitch in the bar of the first and last rows of the triangle. When picking up 9 stitches from a triangle in preparation for working a garter ridge, omit the first bar at the beginning, pick up 1 stitch in each of the 8 knots, then 1 stitch in the ending bar.

- To reduce the number of ends to weave in, avoid cutting the yarn until it's absolutely necessary. Work from the inside and outside of a single ball of yarn so you can use each color twice before cutting it. Use the working yarn attached to the end of a panel or the cast-on tails for three-needle bind-offs or garter ridges. If the color you want to use is at the opposite end of the needle, just work an extra row to bring the color into the position where it's needed.

STITCH GUIDE

Left-Leaning Triangle (LLT)

CO 10 sts. For the very first triangle of the panel, knit 1 WS row to create a garter ridge. For all other left-leaning triangles that start with live sts from a previous right-leaning triangle, beg with Short-Row 1. Work short-rows, turning at the end of each row, as foll (see Notes).

Short-Row 1: (RS) K2.

Short-Row 2: (WS) P2.

Short-Row 3: K3.

Short-Row 4: P3.

Short-Row 5: K4.

Short-Row 6: P4.

Short-Row 7: K5.

Short-Row 8: P5.

Short-Row 9: K6.

Short-Row 10: P6.

Short-Row 11: K7.

Short-Row 12: P7.

Short-Row 13: K8.

Short-Row 14: P8.

Short-Row 15: K9.

Short-Row 16: P9.

Short-Row 17: K10—all sts have been worked.

Right-Leaning Triangle (RLT)

Leaving a 24" (61 cm) tail, CO 10 sts. For the very first triangle of the panel, use the tail to knit 1 WS row and create a garter ridge, then with the WS still facing, slide the sts back to the beg of the needle and pick up the working yarn, in preparation for working Row 1 as a WS row. For all other right-leaning triangles that start with live sts from a previous left-leaning triangle, beg with Short-Row 1. Work short-rows, turning at the end of each row, as foll (see Notes).

Short-Row 1: (WS) P2.

Short-Row 2: (RS) K2.

Short-Row 3: P3.

Short-Row 4: K3.

Short-Row 5: P4.

Short-Row 6: K4.

Short-Row 7: P5.

Short-Row 8: K5.

Short-Row 9: P6.

Short-Row 10: K6.

Short-Row 11: P7.

Short-Row 12: K7.

Short-Row 13: P8.

Short-Row 14: K8.

Short-Row 15: P9.

Short-Row 16: K9.

Short-Row 17: P10—all sts have been worked.

Color List

The socks shown used the foll 18 colors: Mustard, Pale Gold, Melon, Rosy Pink, Dusty Violet, Purple Rose, Fuchsia, Mint, Gray Mint, Green, Yellow Green, Faded Denim, Smoky Teal, Gray Blue, Rusty Rose, Yellow Gold, Gray Violet, and Taupe Green.

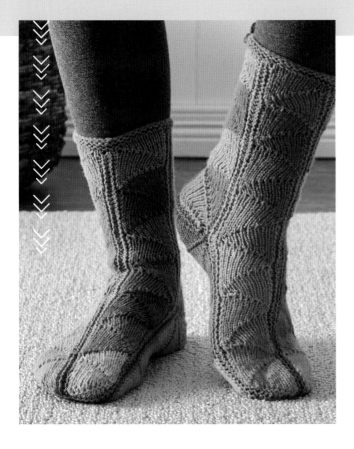

KNITTING MITERED TRIANGLES IN REVERSE

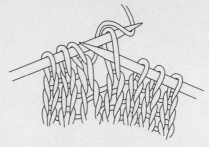

To create a standard knit stitch in reverse, enter the stitch with the left needle tip from left to right behind the right needle tip, wrap the yarn from back to front, coming up and over the left needle tip, then pull the yarn wrap through the loop to form a new stitch on the left needle, letting the loop drop from the right needle.

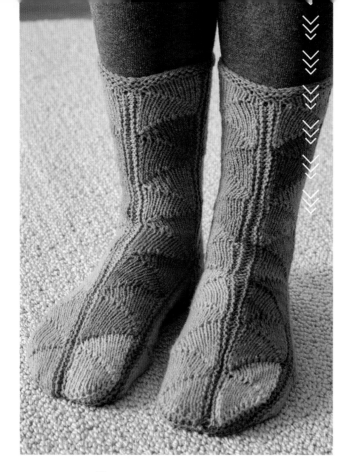

Top of Foot and Front Leg

First Front Panel

Looking down on the sock from above as it's worn, this panel will be on the right-hand side of the foot and front leg.

With smaller needles and Mustard, use the long-tail method (see Glossary) to CO 10 sts.

Triangle 1: With Mustard, work LLT (see Stitch Guide) for first triangle of the panel, ending with a RS row.

Triangle 2: With Mustard, work RLT (see Stitch Guide), ending with a WS row.

Triangle 3: With Pale Gold, purl 1 WS row for color change, then work LLT, ending with a RS row.

Triangle 4: With Pale Gold, work RLT, ending with a WS row.

Triangles 5 and 6: With Melon, rep Triangles 3 and 4.

Triangles 7 and 8: With Rosy Pink, rep Triangles 3 and 4.

Triangles 9 and 10: With Dusty Violet, rep Triangles 3 and 4.

Triangles 11 and 12: With Purple Rose, rep Triangles 3 and 4.

Triangles 13 and 14: With Fuchsia, rep Triangles 3 and 4,

ending with a WS row; do not cut yarn—piece measures about 12¼" (31 cm) from CO along each edge. Place 10 panel sts onto holder.

Garter ridge: See Notes on page 64 for tips on picking up evenly spaced stitches.

Pick-up row: (WS) With attached strand of Fuchsia and WS of panel facing, pick up and purl (see Glossary) 9 sts along selvedge of Fuchsia triangle, then 10 sts each along Purple Rose, Dusty Violet, Rosy Pink, Melon, Pale Gold, and Mustard triangles—69 sts total.

Next row: (RS) With Fuchsia, purl—1 garter ridge on RS. Place sts onto holder. Cut yarn.

Second Front Panel

Looking down on the sock from above as it's worn, this panel will be on the left-hand side of the foot and front leg.

With smaller needles and Mint, CO 10 sts.

Triangle 1: With Mint, work RLT for first triangle of the panel, ending with a WS row.

Triangle 2: With Mint, work LLT, ending with a RS row.

Triangle 3: With Gray Mint, knit 1 RS row for color change, then work RLT, ending with a WS row.

Triangle 4: With Gray Mint, work LLT, ending with a RS row.

Triangles 5 and 6: With Green, rep Triangles 3 and 4.

Triangles 7 and 8: With Yellow Green, rep Triangles 3 and 4.

Triangles 9 and 10: With Faded Denim, rep Triangles 3 and 4.

Triangles 11 and 12: With Smokey Teal, rep Triangles 3 and 4.

Triangles 13 and 14: With Gray Blue, rep Triangles 3 and 4, ending with a RS row; do not cut yarn—piece measures about 12¼" (31 cm) from CO along each edge. Place 10 panel sts onto holder.

Garter ridge: Work as foll.

Pick-up row: (RS) With attached strand of Gray Blue and RS of panel facing, pick up and knit (see Glossary) 9 sts along selvedge of Gray Blue triangle, then 10 sts each along Smoky Teal, Faded Denim, Yellow Green, Green, Gray Mint, and Mint triangles—69 sts total.

Next row: (WS) With Gray Blue, knit—1 garter ridge on RS. Leave sts on needles; do not cut yarn.

Join Front Panels

Place 69 held sts from garter ridge of first front panel on

dpn or cir needle in smaller size. Hold the two panels tog with RS facing tog and WS facing out. With Gray Blue and single dpn in larger size as the working needle, use the three-needle method (see Glossary) to BO all sts tog.

Sole

First Sole Panel

Looking down on the sock from above as it's worn, this panel will be on the left-hand side, under the foot.

With smaller needles and Mustard, CO 10 sts. Work as for first front panel until Triangle 7 has been completed, ending with a RS row of Rosy Pink—piece measures about 7" (18 cm) from CO along edge at beg of RS rows. Leave sts on needle; do not cut yarn.

Garter ridge: With Rosy Pink, purl 1 WS row, then place 10 sts at end of panel onto holder.

Pick-up row: (WS) With attached strand of Rosy Pink and WS of panel facing, pick up and knit 9 sts along selvedge of Rosy Pink triangle, then 10 sts each along Melon, Pale Gold, and Mustard triangles—39 sts total.

Next row: (RS) With Rosy Pink, purl—1 garter ridge on RS. Place sts onto holder; do not cut yarn.

Second Sole Panel

Looking down on the sock from above as it's worn, this panel will be on the right-hand side, under the foot.

With smaller needles and Mint, CO 10 sts. Work as for second front panel until Triangle 7 has been completed, ending with a WS row of Yellow Green—piece measures about 7" (18 cm) from CO along edge at end of RS rows. Leave sts on needle; do not cut yarn.

Garter ridge: With Yellow Green, knit 1 RS row, then place 10 sts at end of panel onto holder.

Pick-up row: (RS) With attached strand of Yellow Green and RS of panel facing, pick up knit 9 sts along selvedge of Yellow Green triangle, then 10 sts each along Green, Gray Mint, and Mint triangles—39 sts total.

Next row: (WS) With Yellow Green, knit—1 garter ridge on RS. Leave sts on needle. Cut yarn.

Join Sole Panels

Place 39 held sts from garter ridge of first sole panel on dpn or cir needle in smaller size. Hold the two panels tog with RS facing tog and WS facing out. With Rosy Pink attached to first sole panel and single dpn in larger size as the working needle, use the three-needle method to BO all sts tog.

Heel

The heel is made up of four 12-st triangles, a right- and left-leaning joined pair for the bottom of the heel, and a right- and left-leaning joined pair for the back of the heel.

First Heel Triangle

With smaller needles, Yellow Gold, and leaving a 30" (76 cm) tail, use the long-tail method (see Glossary) to loosely CO 12 sts. Use the tail to knit 1 RS row, then knit 1 WS row to create a garter ridge. With WS still facing, slide the sts back to the beg of the needle and pick up the working yarn. Beg with WS Row 3 worked as p3, work Rows 3–17 of RLT, ending with WS Row 17 worked as p10.

Next row: (RS) K10.

Next row: (WS) P11.

Next row: K11.

Next row: P12—all sts have been worked.

Purl 1 RS row for garter ridge. Place sts onto holder. Cut working yarn from last row and weave in its end.

Second Heel Triangle

With smaller needles, Rusty Rose, and leaving a 30" (76 cm) tail, use the long-tail method to loosely CO 12 sts, leaving a 30" (76 cm) tail. Use the tail to knit 1 RS row, then use the working yarn to knit 1 WS row to create a garter ridge.

JOIN FIRST AND SECOND HEEL TRIANGLES

The second heel triangle joins to the first heel triangle at the start of RS rows. Because the join happens every other row, skip 1 row between picked-up sts along the edge of the first heel triangle. Work a left-leaning triangle while joining as foll.

Row 1: (RS) Insert the left needle tip from front to back into first triangle edge st in the row just above its starting garter ridge, and pick up a loop on left needle (just placed on needle; not picked up and knitted), work the lifted loop with the triangle st next to it as k2tog, then k2.

Row 2: (WS) P3.

Row 3: Work a lifted loop tog with 1 triangle st as k2tog, k3.

Row 4: P4.

Row 5: Work a lifted loop tog with 1 triangle st as k2tog, k4.

Row 6: P5.

Row 7: Work a lifted loop tog with 1 triangle st as k2tog, k5.

Row 8: P6.

Row 9: Work a lifted loop tog with 1 triangle st as k2tog, k6.

Row 10: P7.

Row 11: Work a lifted loop tog with 1 triangle st as k2tog, k7.

Row 12: P8.

Row 13: Work a lifted loop tog with 1 triangle st as k2tog, k8.

Row 14: P9.

Row 15: Work a lifted loop tog with 1 triangle st as k2tog, k9.

Row 16: P10.

Row 17: Work a lifted loop tog with 1 triangle st as k2tog, k10.

Row 18: P11.

Row 19: Work a lifted loop tog with 1 triangle st as k2tog, k11—all 12 second heel triangle sts have been worked.

Knit 1 WS row for garter ridge—joined heel pair measures about 2¼" (5.5 cm) high in center.

Place sts onto holder. Cut working yarn from last row and weave in its end along the middle of the joined triangles.

Third and Fourth Heel Triangles

Work as for the first and second triangles, using Yellow Gold for the third triangle and Rusty Rose for the fourth triangle.

Join Triangle Pairs

Slip a smaller dpn into the sts along the base of each triangle's CO; these st loops are just placed on the needle, not picked up and knitted. Hold the two triangle pairs tog with RS facing tog and WS facing out. With the single dpn in larger size as the working needle and available yarn tails, use the three-needle method to BO all sts tog.

Join Heel and Sole

With RS facing, place 10 Rosy Pink sts from end of first sole panel and 10 Yellow Green sts from end of second sole panel on the same smaller dpn—20 sole sts; 10 sts each color. Place 12 Rusty Rose sts and 12 Yellow Gold sts from second and first heel triangles on a separate smaller needle, then place 1 st at each end of needle onto small holder—22 heel sts; 11 sts each color. Hold the two needles with RS facing tog and WS facing out. Because there are 2 more sts on the heel needle than the sole needle, pick up 2 extra sole sts as you work the three-needle BO by picking up 1 st from each of the 2 garter ridges that join the center of the sole. With the tails available and the single dpn in larger size as the working needle, use the three-needle method to BO all sts tog.

Back Leg

First Back Leg Panel

Looking down on the sock from above as it's worn, this panel will be on the right-hand side of the back leg. Return 10 center sts of Yellow Gold third heel triangle to smaller needle, placing 1 st at each side onto small holders.

With WS facing, join Yellow Green and purl 1 WS row. Work as for second front panel Triangles 8–14, ending with a RS row of Gray Blue; do not cut yarn—piece measures about 7" (18 cm) from top of heel at beg of RS rows. Place 10 panel sts onto holder.

Garter ridge: Work as foll.

Pick-up row: (RS) With attached strand of Gray Blue and RS of panel facing, pick up and knit 9 sts along selvedge of Gray Blue triangle, then 10 sts each along Smoky Teal and Faded Denim triangles, then knit 1 Yellow Gold heel st from holder—30 sts total. Next row: (WS) With Gray Blue, knit—1 garter ridge on RS. Leave sts on needles. Cut yarn.

Second Back Leg Panel

Looking down on the sock from above as it's worn, this panel will be on the left-hand side of the back leg. Return 10 center sts of Rusty Rose fourth heel triangle to smaller needle, placing 1 st at each side onto small holders.

With RS facing, join Rosy Pink and knit 1 RS row. Work as for first front panel Triangles 8–14, ending with a WS row of Fuchsia; do not cut yarn—piece measures about 7" (18 cm) from top of heel at end of RS rows. Place 10 panel sts onto holder.

Garter ridge: Work as foll.

Pick-up row: (WS) With attached strand of Fuchsia and WS of panel facing, pick up and purl 9 sts along selvedge of Fuchsia triangle, then 10 sts each along Purple Rose and Dusty Violet panels, then knit 1 Rusty Rose heel st from holder—30 sts total.

Next row: (RS) With Fuchsia, purl—1 garter ridge on RS. Leave sts on needle; do not cut yarn.

Join Back Panels

Place 30 held sts from garter ridge of first back panel on dpn or cir needle in smaller size. Hold the two panels tog with RS facing tog and WS facing out. With Fuchsia and single dpn in larger size as the working needle, use the three-needle method to BO all sts tog.

Join Sides of Sock

Left Side

With RS facing, join Purple Rose to the top of the second back leg panel, at the end with the Fuchsia triangle.

Pick-up row: (RS) With a 16" (40 cm) cir needle, pick up and knit 9 sts along Fuchsia triangle, then 10 sts each along Purple Rose, Dusty Violet, and Rosy Pink triangles; k1 held Rusty Rose heel st, k1 held Yellow Gold Heel st, pick up and knit 10 sts along Melon, Pale Gold, and Mustard triangles, then pick up and knit 10 sts from Mustard CO edge of toe—81 sts total.

Next row: (WS) With Purple Rose, knit—1 garter ridge on RS. Leave sts on needle. Cut yarn.

With RS facing, join Gray Mint in center of top of foot at start of the Mint triangle.

Pick-up row: (RS) Using the other 16" (40 cm) cir needle, pick up and knit 10 sts across the Mint CO edge of toe, then 10 sts each along Mint, Gray Mint, and Green triangles, pick up 2 sts between Green and Yellow Green triangles at corner of heel, pick up and knit 10 sts each along Yellow Green, Faded Denim, and Smoky Teal triangles, then 9 sts along Gray Blue triangle—81 sts total.

Next row: (WS) With Gray Mint, knit—1 garter ridge on RS. Leave sts on needle; do not cut yarn.

Hold two 16" (40 cm) cir needles tog with RS facing tog and WS facing out. With Gray Mint and single dpn in larger size as the working needle, use the three-needle method to BO all sts tog.

Right Side

With RS facing, join Dusty Violet to the top of the first front leg panel, at the end with the Fuchsia triangle.

Pick-up row: (RS) Using a 16" (40 cm) cir needle, pick up and knit 9 sts along Fuchsia triangle, then 10 sts each along Purple Rose, Dusty Violet, and Rosy Pink triangles; pick up and knit 2 sts between Rosy Pink and Melon triangles at corner of heel; pick up and knit 10 sts each along Melon, Pale Gold, and Mustard triangles, then pick up and knit 10 sts from Mustard CO edge of toe—81 sts total.

Next row: (WS), with Dusty Violet, knit—1 garter ridge on RS. Leave sts on needle.

Cut yarn.

With RS facing, join Green in center of bottom of foot at start of the Mint triangle.

Pick-up row: (RS) Using the other 16" (40 cm) cir needle, pick up and knit 10 sts across the Mint CO edge of toe, then 10 sts each along Mint, Gray Mint, and Green triangles, k1 held Rusty Rose heel st, k1 held Yellow Gold Heel st, pick up and knit 10 sts each along Yellow Green, Faded Denim, and Smoky Teal triangles, then 9 sts along Gray Blue triangle—81 sts total.

Next row: (WS) With Green, knit—1 garter ridge on RS. Leave sts on needle; do not cut yarn.

Hold two 16" (40 cm) cir tog with RS facing tog and WS facing out. With Green and single dpn in larger size as the working needle, use the three-needle method to BO all sts tog.

Cuff

Return 10 held sts at top of two front leg panels and two back leg panels to dpn. Join Gray Violet to top of center back leg—40 sts total.

Pick-up rnd: Pick up and knit 1 st in garter ridge, [knit across 10 sts, pick up and knit 1 st in each of next 2 garter ridges] 3 times, knit across 10 sts, pick up and knit 1 st in garter ridge, pm, and join for working in rnds—48 sts total.

Rnds 1 and 2: With Gray Violet, knit 1 rnd, then purl 1 rnd; do not cut yarn.

Rnds 3 and 4: With Taupe Green, knit 1 rnd, then purl 1 rnd. With Taupe Green and single dpn in larger size, BO all sts—1 st rem on right needle; do not cut yarn.

I-Cord Knot

With Taupe Green, pick up and knit 2 more sts at top of BO edge—3 sts total. Work 3-st I-cord (see Glossary) for 12 rows total. BO all sts. Cut yarn and pull tail through rem st to secure. Sew end of I-cord to its base, forming a loop. With attached Gray Violet yarn, pick up and knit 3 sts from Gray Violet garter ridge at center back leg. Work 12 rows of I-cord as before, then cut yarn and pull tail through rem st to secure. Thread Gray Violet I-cord through Taupe Green loop, then sew end of I-cord to its base so the knot looks like two clasped loops.

Weave in loose ends, using yarn tails to close up and neaten any gaps between pieces. Block lightly.

KATHRYN ALEXANDER learned to knit some thirty-five years ago from the only other female member of the crew planting trees for Scott Paper Company in northwest Washington State. She now lives on a small farm in upstate New York with her husband and horses. Kathryn spends her time riding, gardening, cooking, knitting, dyeing, and weaving. Visit Kathryn at kathrynalexander.net, where you can find a kit of the yarn used for these socks.

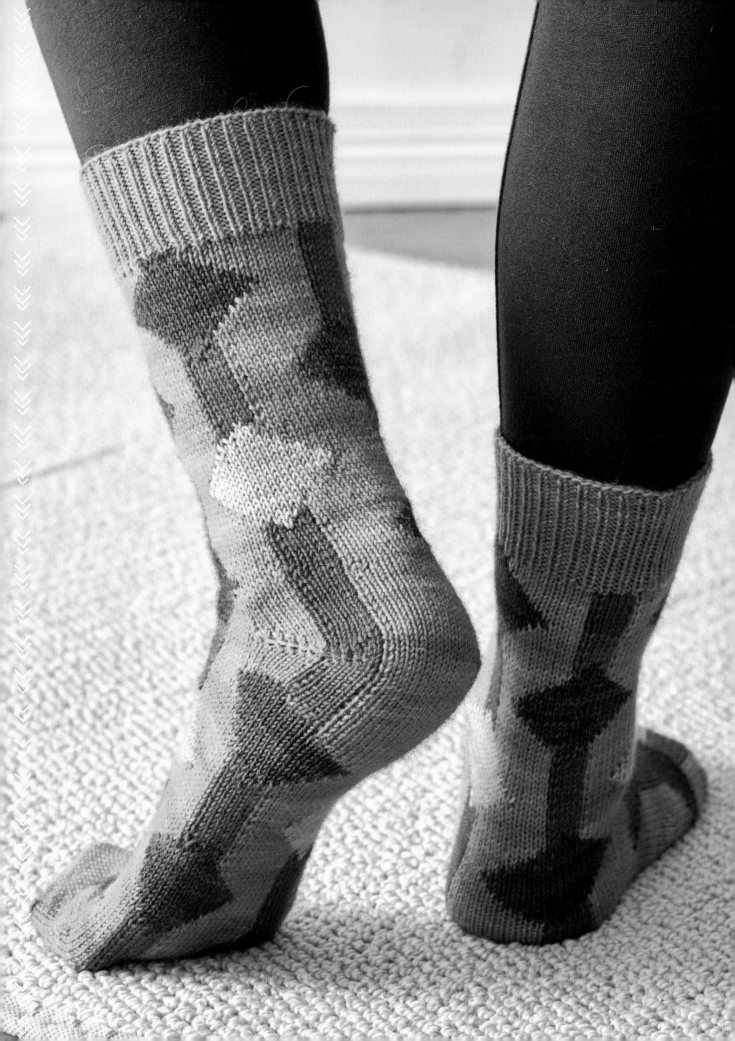

Harlequin

ANNE BERK

Harlequin checkered patterns are a variation of the classic argyle motif. I added vertical lines to create a fun and flattering look that is easy to knit and provides an exciting opportunity to play with color. Separate the bars farther or snug them closer together to customize the size. These toe-up socks are easy to execute once you master the trick of working my method of intarsia in-the-round (ITR), in which right-side rows are followed by wrong-side rows to give the appearance of knitting in rounds. The small areas of different colors offer an opportunity for creative stash-busting. Change the colors as desired to make the most of your stash.

FINISHED SIZE

About 7 (8)" (18 [20.5] cm) foot circumference, 8½ (8¾)" (21.5 [22 cm]) foot length from back of heel to tip of toe (length is adjustable), and 9 (9¼)" (23 [23.5] cm) leg length from top of cuff to base of heel (length is adjustable).

Socks shown measure 8" (20.5 cm) foot circumference.

YARN

Fingering weight (#1 Super Fine).

Shown here: Plucky Knitter Plucky Feet (90% superwash merino, 10% nylon; 425 yd [389 m]/4 oz [113.4 g]): Belgian Wit (gold; MC), 1 skein; Sticky Toffee (brown; A), Faded Grandeur (dark green; B), Oatmeal (gray; C), and Maneater (burgundy; D), less than 60 yd (55 m) each (see sidebar on page 73).

NEEDLES

Size U.S. 1 (2.25 mm): 32" (80 cm) circular (cir) or set of 4 or 5 double-pointed (dpn).

Adjust needle size if necessary to obtain the correct gauge.

NOTIONS

Chenille (or other sharp-tipped needle) for weaving in ends.

GAUGE

18 sts and 24 rows = 2" (5 cm) in using the intarsia in the rnd technique (see Stitch Guide).

NOTES

- The foot and leg are planned to contain 131 chart rows for both sizes. The socks shown have 66 foot rows and 65 leg rows. If you work more or fewer rows for the foot, that will leave fewer or more rows in the leg, so a longer foot will result in a shorter leg, and vice versa. To add foot length, work more plain stockinette rounds with MC before beginning the chart; every 3 rounds will add about ¼" (6 mm). To increase leg length, work more rib rounds in the cuff.

- Although the socks look like they're knitted in rounds, they're actually knitted back and forth in rows, as for traditional intarsia. Unlike a flat piece of intarsia, where you work all the way to the edge of the fabric before turning the work, the work is turned at a specific color change between two sections. The edges of the sections that meet at the turning point are joined by linking the yarns, effectively producing a seamless tube.

- All links and loops are formed on the wrong side of the work, whether you're working a right- or wrong-side row.

- Always turn the work and make a loop (loop n' lock; see Stitch Guide) before setting aside your knitting. Otherwise, you may have trouble finding where to start when you pick up the knitting again. The loop marks the last section of a row. If the yarn you need to work the next section is at the far end of its color block, it's time to turn the work and loop n' lock.

- There should always be one, and only one, loop in each row. If you discover two loops, you probably forgot to drop the working yarn into the loop for the last section of the previous "round," and the first loop you come to is a false one. To remove it, simply pull on the loop to release the trapped strand (you may need to unwind its butterfly to pull the yarn all the way out) and continue working.

STITCH GUIDE

ITR (in the round): The method of working intarsia so that it appears as if knitted in rounds, when, in fact, it's knitted in rows. Unlike working intarsia in rows, the motifs at the beginning and end of the rows are linked so that the join is invisible and creates the effect of working in the round. The rows begin and end at the edge of a color block and may not correspond to the edge of the chart.

Turning point: The end of a right- or wrong-side series of color blocks. The turning point always corresponds to the edge of a color block, and it may shift to the left or right to follow the edge of the block, as with the diamond motifs used here.

Loop n' lock: When you have worked all the way around the piece, you'll come to a block where the strand of yarn needed to work it is at the far edge of the block. The loop moves the strand from the far edge to the point where you ended, and links the last section worked to the next one, creating the illusion of a piece worked in rounds. See sidebar on page 73 for details.

LOOP N' LOCK

To make the loop, turn the work so the wrong side is facing (**Figure 1**); the last stitches worked are shown in the light color (the illustration shows 1 light stitch slipped to produce a right-leaning diagonal when viewed from the right side of the work). Bring the yarn on the far side of the next section (shown as dark yarn) across the back of the work to where you ended and place it over the working yarn at the end of the last section to form a loop of yarn (**Figure 2**) temporarily stranded across the back of the work. Turn and work back in the direction you came from; the loop will lock the colors at the turning point; this completes the loop n' lock.

When you have worked around the piece and get to the loop again (**Figure 3**), drop the yarn butterfly for the yarn you were just using through the loop (**Figure 4**), then use the loop strand to work across the last section of the row to end at the turning point. At the end of the section, pull on the working end to remove any remaining slack from the loop (**Figure 5**).

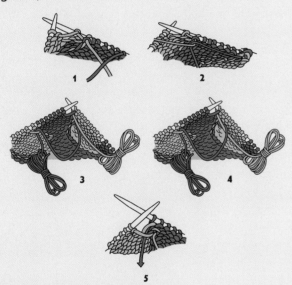

YARN PREPARATION

Intarsia requires a separate yarn source for each color block or motif, which is easier if you work with individual strands wound onto bobbins or into butterflies (see below). The lengths provided here will be sufficient for both socks. Divide the colors as follows, rounded up to the next whole yard (meter):

MC: 16 strands of 9 yd (8.2 m) each; 144 yd (132 m) total.

A: 36 strands of 1½ yd (1.4 m) each; 54 yd (51 m) total.

B: 12 strands of 3 yd (2.7 m) each; 36 yd (33 m) total.

C: 8 strands of 3 yd (2.7 m) each; 24 yd (22 m) total.

D: 12 strands of 3 yd (2.7 m) each; 36 yd (33 m) total.

The amounts above are based on each stitch using 0.39 inches (1 cm) of yarn. To determine your inches per stitch, knit a stockinette swatch of consisting of about 100 stitches—for example 10 stitches by 10 rows, or 20 stitches by 5 rows—then rip out the swatch and measure the length of yarn used. Count only the yarn in the knitted stitches and not the amount used in the cast-on. Divide the length by 100 to determine the number of inches (cm) of yarn in each stitch. For the socks shown, 39" (99 cm) of yarn was needed to knit 100 stitches.

WINDING YARN INTO BUTTERFLIES

Place a tail of yarn in the palm of one hand with the end near your wrist and hold it with your thumb. Wrap the yarn around the palm of your hand for the desired length, leaving a short tail. Remove the butterfly from your hand and hold it in the middle while you wrap the end firmly a few times around the bundle in the opposite direction (**Figure 1**), slip the end through the loop (**Figure 2**), and pull tight to secure. Pull the yarn from the center of the butterfly, beginning with the end that was held in the palm of your hand.

ANNETARSIA QUICK TIPS

- The last color section of every row is worked with the loop of yarn from the loop n' lock of the previous row.

- When you get to the loop, pull it out so you have a comfortable length of yarn to work the upcoming section, then drop the butterfly of the color just worked inside the loop to link these two colors, then work the next color section with the loop yarn.

- When you get to the end of the section worked with the loop, pull on the tail to remove the excess yarn, bring the yarn from the next color section to the left over the top of the yarn used for the previous section (the one worked with the loop), grab the current color from under this strand to loop n' lock the two yarns, turn the work (the loop is now to the right of the current section), then work in the opposite direction, working again with the color that was the loop yarn on the previous row. This will create a new loop that will signal the last color section of the next row.

73

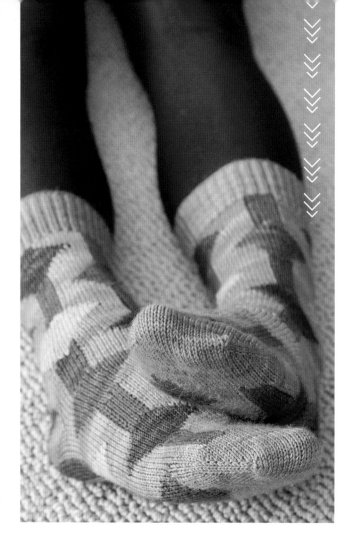

Toe

With MC, two cir needles or two dpn, and using Judy's Magic Cast-On (see Glossary), CO (32) 36 sts—16 (18) sole sts on one needle; 16 (18) instep sts on the other needle; rnd begins at start of sole.

Arrange sts as necessary for working in rnds (see page 6).

Next rnd: Knit.

Inc for toe as foll:

Rnd 1: K1, yo, knit to last sole st, yo, k1; k1, yo, knit to last instep st, yo, k1—4 sts inc'd; 2 instep sts and 2 sole sts.

Rnd 2: Knit, working all yarnovers through the back loop to twist the sts.

Rep the last 2 rnds 7 (8) more times—64 (72) sts total; 32 (36) sts each for sole and instep; toe measures slightly less than 1½" (3.8 cm) for 7" (18 cm) foot circumference, and slightly more for 8" (20.5 cm) foot circumference. See Notes on page 72 for adjusting foot length.

Foot

Wind 9 yd (8.2 m) of MC into yarn butterfly and cut from skein.

Joining a new strand of yarn for each color section (see Yarn Preparation on page 73), work ITR (see Stitch Guide) according to Harlequin chart for your size as foll.

Row 1: (RS) K6 with MC, *k2 with A, k1 with B, k2 with existing strand of A (stranded behind B), k11 (13) with new strand of MC, k5 with new strand of A*, k5 (7) with MC to end of chart; beg Row 1 of chart again by k6 with same strand of MC; then rep from * to * once more, ending k5 with A at turning point line. Do not work last 5 (7) MC sts at end of Row 1; the strand of yarn needed for those sts is at the far side of the next 11 (13) sts in the MC block. Turn work.

Row 2: (WS) With WS facing, the MC section to the right of where you ended has a working strand of MC at its right edge. Bring this MC strand across the MC section from right to left, and place it over the strand of A connected where you ended. Pick up the working strand of A from under this MC strand to loop n' lock the MC (see Stitch Guide). Work Row 2 of chart as *P5 A, p11 (13) MC, p1 A, p3 B, p1 A,* p6 MC to end of chart; beg at left-hand side of Row 2 work p5 (7) with same strand of MC; rep from * to * once more, then use the loop of MC locked to the final section to p6 MC to end of chart, then work p5 (7) at left-hand edge of Row 2 to end at turning point line. Drop the butterfly of the last color worked into that loop to lock those two colors. Turn work.

Row 3: (RS) Loop n' lock (make loop with A), *k11 (13) MC, k5 B, k11 (13) MC, k5 A; rep from * once more, knitting the last A section with the loop, and dropping the butterfly of the last color worked into the loop to lock those two colors. Turn work.

Cont as charted in this manner, forming a loop of A on RS rows and a loop of motif color on WS rows, until Row 66 of chart has been completed, or sock reaches to the wearer's anklebone when slightly stretched—foot measures about 7" (18 cm) from toe CO for both sizes.

Note: If you would prefer not to have a 2-row partial diamond on the underside of the foot, work the color D stitches in Rows 65 and 66 with color A. Make a note of the last row completed if you adjusted foot length.

Heel

The heel is worked back and forth in short-rows (see Glossary) on the 32 (36) sole sts; rem 32 (36) sts will be worked later for front of leg.

	MC
×	A
–	B
·	C
●	D

HARLEQUIN SIZE 7", ROWS 1 TO 67

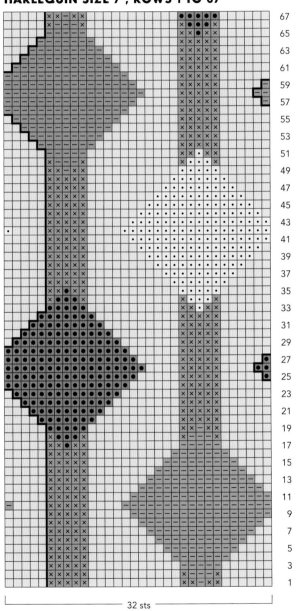

67
65
63
61
59
57
55
53
51
49
47
45
43
41
39
37
35
33
31
29
27
25
23
21
19
17
15
13
11
9
7
5
3
1

— 32 sts —

HARLEQUIN SIZE 7", ROWS 68 TO 131

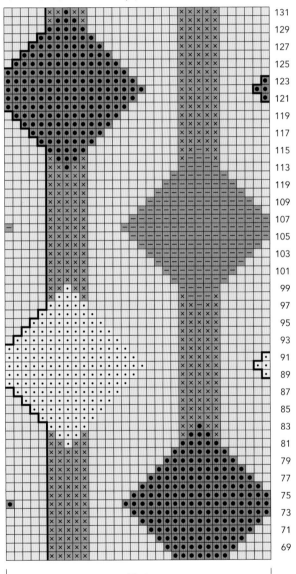

131
129
127
125
123
121
119
117
115
119
109
107
105
103
101
99
97
95
93
91
89
87
85
83
81
79
77
75
73
71
69

— 32 sts —

	MC
×	A
−	B
·	C
●	D

HARLEQUIN SIZE 8", ROWS 1 TO 67

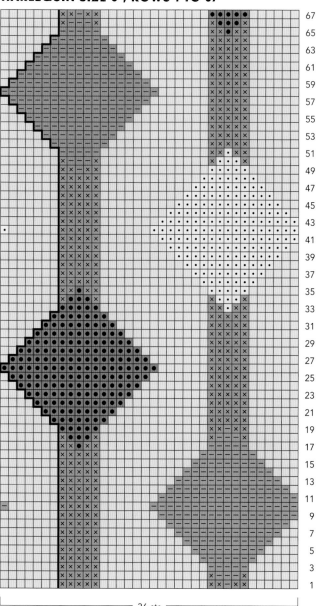

36 sts

HARLEQUIN SIZE 8", ROWS 68 TO 131

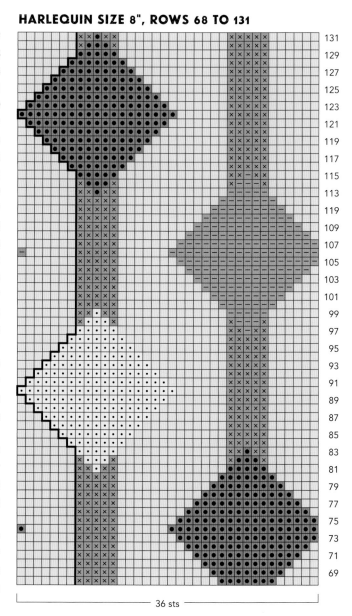

36 sts

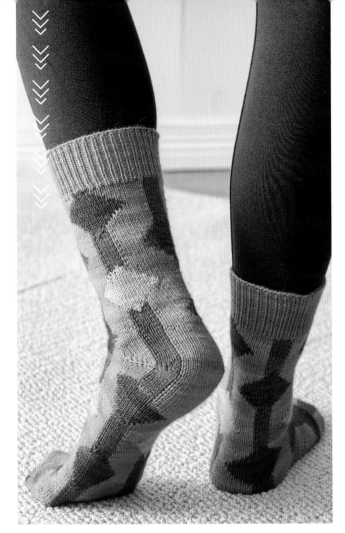

SECOND HALF

Cont with established colors as foll.

Short-Row 1: (RS) Knit to the first wrapped st, work wrap tog with wrapped st, wrap next st (now double-wrapped), turn work.

Short-Row 2: Sl 1 pwise (double-wrapped st), purl to first wrapped st, work wrap tog with wrapped st, wrap next st (now double-wrapped), turn work.

Rep Short-Rows 1 and 2 eight (ten) more times, working double wraps tog with wrapped sts, until all sts have been worked.

Note: If you would prefer to have a complete color D diamond at the start of the back of the leg, work the last 2 heel rows according to Rows 65 and 66 of the chart.

Leg

Resume working in patt with chart Row 67 across all 64 (72) sts, and work even until Row 131 has been completed—piece measures about 7 (7¼)" (18 [18.5] cm) from base of heel.

Next rnd: With MC, *k1, p1; rep from *.

Rep the last rnd until ribbing measures 2" (5 cm) or leg is desired length.

Using an elastic method (see Glossary), BO all sts.

Finishing

Use sharp-tip chenille or tapestry needle to weave in loose ends, splitting the plies of matching colors on WS to secure the ends.

Block lightly.

First Half

Short-Row 1: (RS) K6 MC, k5 A, k11 (13) MC; finish end of last color B diamond by working k2 A, k1 B, k2 A; k4 (6) MC, sl 1 pwise with yarn in front (wyf), turn work.

From here, work in MC with two 5-st vertical stripes of A.

Short-Row 2: (WS) Sl the unworked st pwise from left to right needle tip, bring yarn to front of work to wrap the slipped st, p30 (34), sl 1 pwise with yarn in back (wyb), turn work.

Short-Row 3: Sl 1 pwise wyb, knit to 1 st before unworked st, wrap next as before, turn work.

Short-Row 4: Sl 1 pwise wyf, purl to 1 st before unworked st, wrap next st as before, turn work.

Rep Short-Rows 3 and 4 only 7 (9) more times, ending with a WS row—9 (11) wrapped sts at each end of needle and 14 center sts between last pair of wrapped sts; heel measures 1½ (1¾)" (3.8 [4.5] cm).

ANNE BERK, a certified TKGA Master Knitter, teaches classes nationally and is author of *Annetarsia Knits,* a reference for knitting intarsia in rows or rounds. Anne also has published patterns and articles for many publications, including *PieceWork, Sockupied, ColorKnit,* and *Twist Collective,* as well as two DVDs on intarsia knitting—*Inside Intarsia* and *Intarsia In Depth,* both published by Interweave. During business hours, Anne is an optometrist in private practice in Portland, Oregon.

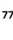

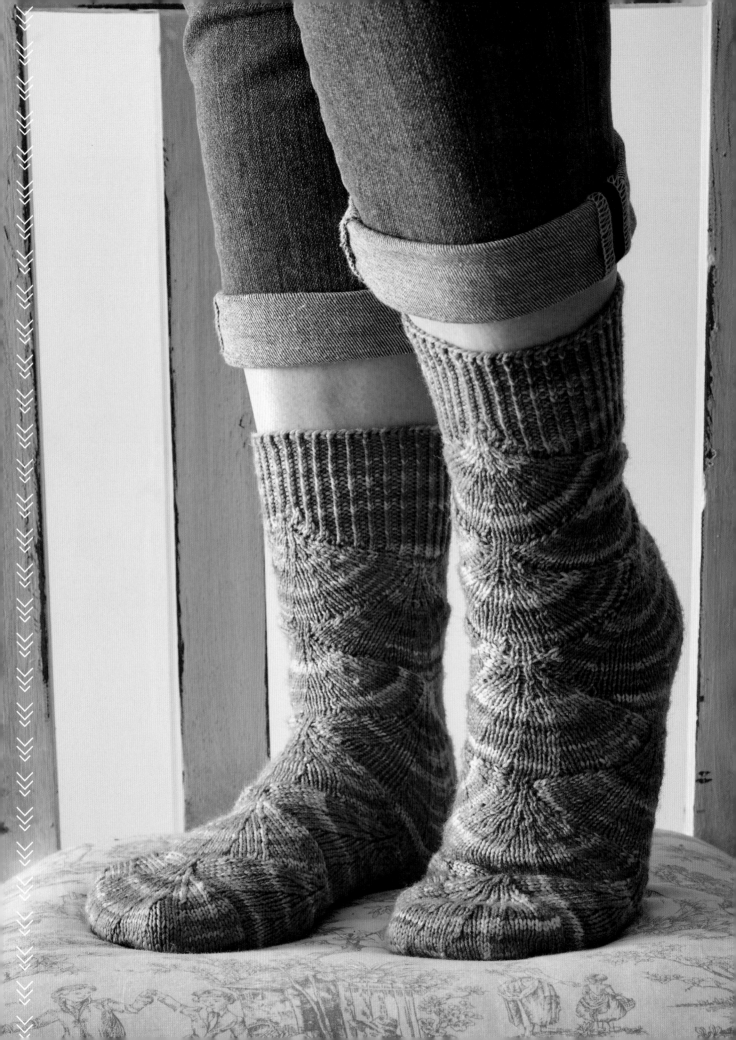

Cumulus

CARISSA BROWNING

Like billowing clouds, this sock design builds on itself, layer upon layer. Not your ordinary toe-up sock, this one begins with an overgrown Judy's Magic Cast-On from which two scallop shapes are formed. Each subsequent scallop is made from stitches picked up along the edges of previous ones. The heel construction is far from average, with two extra-large scallops emerging from a long, thin heel flap of sorts (the tail of the previous scallop from the bottom of the foot). Short-rows are employed to create the heel as well as to even out the curved top edge in preparation for the ribbed cuff. This pattern is ideal for hand-dyed yarns because the constantly changing stitch count minimizes the risk of striping or pooling colors.

FINISHED SIZE

About 6½ (7½, 8½)" (16.5 [19, 21.5] cm) foot circumference; 8 (9, 9¾)" (20.5 [23, 25] cm) foot length from back of heel to tip of toe, will stretch about ¾" to 1" (2 to 2.5 cm) longer; and 8¼ (8¾, 9¼)" (21 [22, 23.5] cm) leg length from top of cuff to base of heel.

Socks shown measure 7½" (19 cm) foot circumference.

YARN

Fingering weight (#1 Super Fine).

Shown here: Dream in Color Smooshy (100% superwash merino wool; 450 yd [411 m]/4 oz [113.4 g]): Some Summer Sky, 1 skein for all sizes.

NEEDLES

Size U.S. 1 (2.25 mm): set of 5 double-pointed (dpn) or 40" (100 cm) circular (cir) for magic-loop method.

Adjust needles size if necessary to obtain correct gauge.

NOTIONS

Markers (m), stitch holders; tapestry needle.

GAUGE

17 sts and 25 rnds = 2" (5 cm) in St st, worked in rnds, relaxed after blocking.

35 (42, 49) sts and 27 (31, 35) rows of each basic scallop measure about 3¼ (3¾, 4¼)" (8.5 [9.5, 11] cm) wide and 2¼ (2½, 2¾)" (5.5 [6.5, 7] cm), relaxed after blocking.

NOTE

- When the directions refer to the right and left sides of the foot, this is right or left as if you were looking down at the sock as it is worn.

STITCH GUIDE

Kw: Lift back strand of wrap and place on left needle tip, knit wrap together with wrapped stitch.

Kwt: Lift front strand of wrap and place on left needle tip, knit wrap together with wrapped stitch through the back loop.

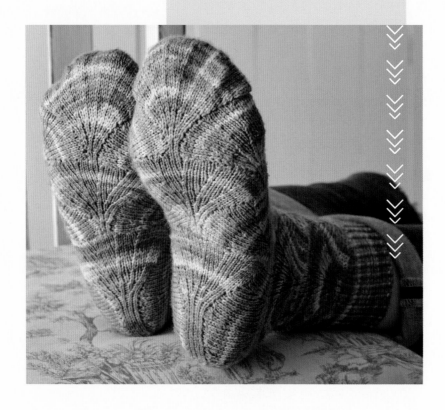

Toe

Using Judy's Magic Cast-On (see Glossary), CO 70 (84, 98) sts; 35 (42, 49) sts on each needle tip.

Scallop A (top of toe)

Work the first 35 (42, 49) sts as foll; the rem 35 (42, 49) sts will be worked later for bottom of toe.

Row 1: (RS) K35 (42, 49).

Row 2: (WS) Sl 1 purlwise with yarn in front (pwise wyf), p34 (41, 48).

Row 3: Sl 1 purlwise with yarn in back (pwise wyb), k2 (3, 4), k2tog, [k3 (4, 5), k2tog] 6 times—28 (35, 42) sts rem.

Rows 4 and 6: Sl 1 pwise wyf, p27 (34, 41).

Row 5: Sl 1 pwise wyb, k27 (34, 41).

Row 7: Sl 1 pwise wyb, k1 (2, 3), k2tog, [k2 (3, 4), k2tog] 6 times—21 (28, 35) sts rem.

Rows 8 and 10: Sl 1 pwise wyf, p20 (27, 34).

Row 9: Sl 1 pwise wyb, k20 (27, 34).

Row 11: Sl 1 pwise wyb, k0 (1, 2), k2tog, [k1 (2, 3), k2tog] 6 times—14 (21, 28) sts rem.

Size 6½" (16.5 cm) is complete; cont for other sizes as foll.

SIZES 7½ (8½)" (19 [21.5 CM]) ONLY

Rows 12 and 14: Sl 1 pwise wyf, p20 (27).

Row 13: Sl 1 pwise wyb, k20 (27).

Row 15: Sl 1 pwise wyb, k0 (1), k2tog, [k1 (2), k2tog] 6 times—14 (21) sts rem.

SIZE 8½" (21.5 CM) ONLY

Rows 16 and 18: Sl 1 pwise wyf, p20.

Row 17: Sl 1 pwise wyb, k20.

Row 19: Sl 1 pwise wyb, k2tog, [k1, k2tog] 6 times—14 sts rem.

ALL SIZES

Cont on 14 sts for all sizes as foll.

Row 12 (16, 20): Sl 1 pwise wyf, p13.

Row 13 (17, 21): Sl 1 pwise wyb, k13.

Row 14 (18, 22): Sl 1 pwise wyf, p13.

Row 15 (19, 23): Sl 1 pwise wyb, k1, [k2tog] 5 times, k2—9 sts rem.

Row 16 (20, 24): Sl 1 pwise wyf, p8.

Row 17 (21, 25): Sl 1 pwise wyb, k8.

Row 18 (22, 26): Sl 1 pwise wyf, p8.

Row 19 (23, 27): Sl 1 pwise wyb, [k2tog] 3 times, k2—6 sts rem.

Row 20 (24, 28): Sl 1 pwise wyf, p5.

Row 21 (25, 29): Sl 1 pwise wyb, k5.

Row 22 (26, 30): Sl 1 pwise wyf, p5.

Row 23 (27, 31): Sl 1 pwise wyb, [k2tog] 2 times, k1—4 sts rem.

Row 24 (28, 32): Sl 1 pwise wyf, p3.

Row 25 (29, 33): Sl 1 pwise wyb, k3.

Row 26 (30, 34): Sl 1 pwise wyf, p3.

Row 27 (31, 35): Sl 1 pwise wyb, k1, place marker (pm), k2, do not turn—piece measures 2¼ (2½, 2¾)" (5.5 [6.5, 7] cm) from CO, measured straight up in center of scallop.

With RS still facing, pick up and knit 17 (20, 24) sts evenly spaced (about 2 sts for every 3 rows) along left side of Scallop A (end of RS rows)—21 (24, 28) sts total. Place sts onto holder or spare needle while working Scallop B from the other side of the magic CO.

Scallop B (bottom of toe)

With RS facing, rotate piece to place 35 (42, 49) sts from other side of CO across the top of the work.

Row 1: (RS) Knit all sts through their back loops (tbl).

Rows 2–27 (31, 35): Work as for Scallop A—4 sts rem, with marker in center.

Do not break yarn.

Foot

Scallop C (left side of foot)

Row 1: (RS) With RS of Scallop B still facing, pick up and knit 16 (20, 24) sts along left side of Scallop B (end of RS rows), then 17 (20, 23) sts along right side of Scallop A (beg of RS rows), then k1 held st from top of Scallop A (ending 1 st before the marker)—37 (44, 51) sts between markers: 2 sts at top of Scallop B, 33 (40, 47) picked-up sts, and 2 sts at top of Scallop A.

Scallop C is worked on the center 35 (42, 49) sts between the markers, leaving the 1 st next to markers at top of Scallops A and B unworked.

Rows 2–27 (31, 35): Work as for Scallop A—4 sts rem for Scallop C, with marker in center.

With RS still facing, pick up and knit 15 (19, 23) sts evenly spaced along left side of Scallop C (end of RS rows), then k1 held st from top of Scallop A (ending at marker)—20 (24,

28) sts: 4 sts from Scallop C, 15 (19, 23) picked-up sts, and 1 st from Scallop A. Place sts onto holder or spare needle while working Scallop D along the rem sides of Scallops A and B. Do not break yarn.

Scallop D (right side of foot)

Row 1: (RS) With RS of Scallop C still facing, slip marker (sl m) at top of Scallop A, k2 held sts at top of Scallop A, then k17 (20, 24) held sts from left side of Scallop A; pick up and knit 16 (20, 23) from right side of Scallop B (beg of RS rows), then k1 from top of Scallop B (ending 1 st before the marker)—37 (44, 51) sts between markers: 2 sts at top of Scallop A, 33 (40, 47) picked-up sts, and 2 sts at top of Scallop B.

Scallop D is worked on the center 35 (42, 49) sts between the markers, leaving 1 st next to markers at top of Scallops A and B unworked.

Rows 2–27 (31, 35): Work as for Scallop A—4 sts rem for Scallop D, with marker in center.

Scallop E (bottom of foot)

Row 1: (RS) With RS of Scallop D still facing, pick up and knit 15 (19, 23) sts along left side of Scallop D (end of RS rows), k1 from top of Scallop B (ending at marker), remove marker, k1 rem st from top of Scallop B, pick up and knit 16 (19, 22) along right side of Scallop C (beg of RS rows), k1 held st from top of Scallop C (ending 1 st before marker)—37 (44, 51) sts between markers: 2 sts each at top of Scallops B, C, and D, and 31 (38, 45) picked-up sts.

Scallop E is worked on the center 35 (42, 49) sts between the markers, leaving 1 st next to markers at top of Scallops C and D unworked.

Rows 2–27 (31, 35): Work as for Scallop A—4 sts rem for Scallop E, with marker in center.

With RS still facing, pick up and knit 15 (19, 23) sts evenly spaced along left side of Scallop E (end of RS rows), then k1 held st from top of Scallop C (ending at marker)—20 (24, 28) sts: 4 sts from Scallop E, 15 (19, 23) picked-up sts, and 1 st from Scallop C. Place sts onto holder or spare needle while working Scallop F along the rem sides of Scallops C and D. Do not break yarn.

Scallop F (top of foot)

Row 1: (RS) With RS of Scallop E still facing, sl m at top of Scallop C, k2 held sts at top of Scallop C, then k15 (19, 23) held sts from left side of Scallop C, k1 held st from top of

Scallop A, remove marker, k1 rem st from top of Scallop A; pick up and knit 16 (19, 22) sts from right side of Scallop D (beg of RS rows), then k1 from top of Scallop D (ending 1 st before the marker)—37 (44, 51) sts between markers: 2 sts at top of Scallop A, 2 sts at top of Scallop C, 31 (40, 45) picked-up sts, and 2 sts at top of Scallop D.

Scallop F is worked on the center 35 (42, 49) sts between the markers, leaving 1 st next to markers at top of Scallops C and D unworked.

Rows 2–27 (31, 35): Work as for Scallop A—4 sts rem for Scallop F, with marker in center.

Scallop G (right side of foot)

Row 1: (RS) With RS of Scallop F still facing, pick up and knit 15 (19, 23) sts along left side of Scallop F (end of RS rows), k1 from top of Scallop D (ending at marker), remove marker, k1 rem st from top of Scallop D, pick up and knit 16 (19, 22) along right side of Scallop E (beg of RS rows), k1 held st from top of Scallop E (ending 1 st before marker)—37 (44, 51) sts between markers: 2 sts each at top of Scallops D, E, and F, and 31 (38, 45) picked-up sts.

Rows 2–27 (31, 35): Work as for Scallop A over the center 35 (42, 49) sts between markers, leaving 1 st next to markers at top of Scallops E and F unworked—4 sts rem for Scallop G, with marker in center.

With RS still facing, pick up and knit 15 (19, 23) sts evenly spaced along left side of Scallop G (end of RS rows), then knit 1 held st from top of Scallop E (ending at marker)—20 (24, 28) sts: 4 sts from Scallop G, 15 (19, 23) picked-up sts, and 1 st from Scallop E. Place sts onto holder or spare needle while working Scallop H along the rem sides of Scallops E and F. Do not break yarn.

Scallop H (left side of foot)

Row 1: (RS) With RS of Scallop G still facing, sl m at top of Scallop E, k2 held sts at top of Scallop E, then k15 (19, 23) held sts from left side of Scallop E, k1 held st from top of Scallop C, remove marker, k1 rem st from top of Scallop C; pick up and knit 16 (19, 22) sts from right side of Scallop F (beg of RS rows), then k1 from top of Scallop F (ending 1 st before the marker)—37 (44, 51) sts between markers: 2 sts each at top of Scallops C, E, and F, and 31 (38, 45) picked-up sts.

Rows 2–27 (31, 35): Work as for Scallop A over the center 35 (42, 49) sts between markers, leaving 1 st next to markers at top of Scallop E and F unworked—4 sts rem for Scallop H, with marker in center.

Instep and Heel

Scallop I (instep)

Row 1: (RS) With RS of Scallop H still facing, pick up and knit 15 (19, 23) sts along left side of Scallop H (end of RS rows), k1 from top of Scallop F (ending at marker), remove marker, k1 rem st from top of Scallop F, pick up and knit 16 (19, 22) along right side of Scallop G (beg of RS rows), k1 held st from top of Scallop G (ending 1 st before marker)—37 (44, 51) sts between markers: 2 sts each at top of Scallops F, G, and H, and 31 (38, 45) picked-up sts.

Rows 2–27 (31, 35): Work as for Scallop A over the center 35 (42, 49) sts between markers, leaving 1 st next to markers at top of Scallops G and H unworked—4 sts rem for Scallop I, with marker in center.

With RS still facing, pick up and knit 15 (19, 23) sts evenly spaced along left side of Scallop I (end of RS rows), then k1 held st from top of Scallop G (ending at marker)—20 (24, 28) sts: 4 sts from Scallop I, 15 (19, 23) picked-up sts, and 1 st from Scallop G. Place sts onto holder or spare needle. Do not break yarn.

Scallop J (bottom of heel and heel flap)

Row 1: (RS) With RS of Scallop I still facing, sl m at top of Scallop G, knit 2 held sts at top of Scallop G, then knit 15 (19, 23) held sts from left side of Scallop G, knit 1 held st from top of Scallop E, remove marker, knit 1 rem st from top of Scallop E; pick up and knit 16 (19, 22) sts from right side of Scallop H (beg of RS rows), then k1 from top of Scallop H (ending 1 st before the marker)—37 (44, 51) sts between markers: 2 sts each at top of Scallops E, G, and H, and 31 (38, 45) picked-up sts.

Rows 2–19 (23, 27): Work as for Scallop A over the center 35 (42, 49) sts between markers, leaving 1 st next to markers at top of Scallops G and H unworked—6 sts rem for Scallop J.

Work even for underside of heel flap as foll.

Even-numbered Rows 20–42 (24–46, 28–50): Sl 1 pwise wyf, p5.

Odd-numbered Rows 21–43 (25–47, 29–51): Sl 1 pwise wyb, k5.

Row 44 (48, 52): Sl 1 pwise wyf, p5—Scallop J measures about 3½ (4, 4¼)" (9 [10, 11] cm) high; underside of foot measures about 8 (9, 9¾)" (20.5 [23, 25] cm) from CO at tip of toe.

Cont as foll for back-of-heel flap.

Row 45 (49, 53): Sl 1 pwise wyb, [k2tog] 2 times, k1—4 sts rem for Scallop J.

Even-Numbered Rows 46–68 (50–72, 54–76): Sl 1 pwise wyf, p3.

Odd-Numbered Rows 47–69 (51–73, 55–77): Sl 1 pwise wyb, k3.

Row 70 (74, 78): Sl 1 pwise wyf, p3.

Row 71 (75, 79): Sl 1 pwise wyb, k1, pm, k2—back-of-heel flap measures 2¼" (5.5 cm).

Do not turn work—4 sts rem for Scallop J, with marker in center.

Ankle and Leg

Scallop K (left side of ankle)

Row 1: (RS) With RS of Scallop J still facing, pick up and knit 42 (46, 50) sts along left side of Scallop J (end of RS rows), k1 from top of Scallop H, remove marker, k1 rem st from top of Scallop H, pick up and knit 16 (19, 22) sts along right side of Scallop I (beg of RS rows), k1 from top of Scallop I (ending 1 st before marker)—64 (71, 78) sts between markers; 2 sts each at top of Scallops H, I, and J, and 58 (65, 72) picked-up sts.

Scallop K is worked over the center 62 (69, 76) sts between markers, leaving 1 st next to marker at top of both Scallop I and J unworked.

Change to working in short-rows (do not wrap sts at turning points), and cont as foll.

Short-Row 2: (WS) Sl 1 pwise wyf, p37 (44, 51), turn work.

Short-Row 3: (RS) Sl 1 pwise wyb, k2 (5, 8), k2tog, k7 (8, 9), k2tog, k2 (5, 8), turn work—2 sts dec'd.

Short-Row 4: Sl 1 pwise wyf, purl to 1 st before turning gap, ssp (1 st each side of gap; see Glossary), p2, turn work—1 st dec'd.

Short-Row 5: Sl 1 pwise wyb, knit to 1 st before turning gap, k2tog (1 st each side of gap), k2, turn work—1 st dec'd.

Short-Row 6: Rep Short-Row 4—1 st dec'd.

Short-Row 7: Sl 1 pwise wyb, k5 (8, 11), k2tog, k6 (7, 8), k2tog, k3 (6, 9), k2tog (1 st each side of gap), k2, turn work—3 sts dec'd.

Short-Rows 8, 9, and 10: Rep Short-Rows 4, 5, and 6—3 sts dec'd.

Short-Row 11: Sl 1 pwise wyb, k1 (3, 5), k2tog, [k5 (6, 7), k2tog] 3 times, k0 (2, 4), k2tog (1 st each side of gap), k2, turn work—5 sts dec'd.

Short-Rows 12, 13, and 14: Rep Short-Rows 4, 5, and 6—3 sts dec'd.

Short-Row 15: Sl 1 pwise wyb, k4 (6, 8), k2tog, [k4 (5, 6), k2tog] 3 times, k4 (6, 8), k2tog (1 st each side of gap), k2, turn work—5 sts dec'd.

Short-Rows 16, 17, and 18: Rep Short-Rows 4, 5, and 6—3 more sts dec'd—37 (44, 51) sts total between markers after Short-Row 18; 1 unworked st next to marker at top of Scallop J at beg of RS rows; 34 (41, 48) sts worked in Row 18; 1 unworked Scallop K st and 1 unworked st next to marker at top of Scallop I at end of RS rows.

Complete Scallop K by working Rows 3–27 (31, 35) as for Scallop A over the center 35 (42, 49) sts between markers, leaving 1 st next to markers at top of Scallops I and J unworked—4 sts rem for Scallop K, with marker in center.

With RS still facing, pick up and knit 15 (19, 23) sts evenly spaced along left side of Scallop K (end of RS rows), then k1 held st from top of Scallop I (ending at marker)—20 (24, 28) sts: 4 sts from Scallop K, 15 (19, 23) picked-up sts, and 1 st from Scallop I. Place sts onto holder or spare needle. Do not break yarn.

Scallop L (right side of ankle)

Row 1: (RS) With RS of Scallop K still facing, sl m, k2 held sts from top of Scallop I, then k15 (19, 23) held sts from left side of Scallop I, k1 held st from top of Scallop G, remove marker, k1 rem st from top of Scallop G; pick up and knit 43 (46, 49) sts from right side of Scallop J (beg of RS rows), then k1 from top of Scallop J (ending 1 st before the marker)—64 (71, 78) sts between markers: 2 sts each at top of Scallops G, I, and J, and 58 (65, 72) picked-up sts.

Scallop L is worked over the center 62 (69, 76) sts between markers, leaving 1 st next to marker at top of both Scallop I and J unworked.

Change to working in short-rows and work Short-Rows 2–18 as for Scallop K—37 (44, 51) sts total between markers after Short-Row 18; 1 unworked st next to marker at top of Scallop I at beg of RS rows; 34 (41, 48) sts worked in Row 18; 1 unworked Scallop L st and 1 unworked st next to marker at top of Scallop J at end of RS rows.

Notes: Scallops K and L are in the same relative positions at the base of the leg as Scallops C and D are at the start of the foot. This means that ankle and leg Scallops M, N, O, P, Q, and R can grow out of ankle Scallops K and L the same way that foot units E, F, G, H, I, and J grew out of Scallops C and D. Temporarily rename Scallop K to be Scallop C, and rename Scallop L to Scallop D to re-use the foot instructions for next six ankle and leg scallops.

Scallop M (back of ankle)

Work as for Scallop E.

Scallop N (front of ankle)

Work as for Scallop F.

Scallop O (right side of leg)

Work as for Scallop G.

Scallop P (left side of leg)

Work as for Scallop H.

Scallop Q (front of leg)

Work as for Scallop I.

Scallop R (back of leg)

Note: Scallop R is not an exact duplicate of Scallop J because Scallop R does not include the heel flap section.

Work Row 1 as for Scallop J, then work Rows 2–27 (31, 35) as for Scallop A over the center 35 (42, 49) sts between markers, leaving 1 st next to markers at top of Scallops O and P (worked as Scallops G and H) unworked—4 sts rem for Scallop R, with marker in center.

Cuff

The two "valleys" between Scallops Q and R must be filled in before the ribbed cuff can be worked in the round. Work transitions on each side of leg to fill in the valleys as foll, using the short-row wrap and turn (w&t) technique to prevent holes from forming (see Glossary).

Left Side Cuff Set Up

Row 1: (RS) With RS of Scallop R still facing, pick up and knit 15 (19, 23) sts along left side of Scallop R (end of RS rows), k1 from top of Scallop P, remove m, k1 from top of Scallop P, pick up and knit 15 (19, 23) along right side of Scallop Q, k2 from top of Scallop Q (ending at marker)—36 (44, 52) sts between markers: 2 sts each at top of Scallops P, Q, and R, and 30 (38, 46) picked-up sts.

The left side cuff is worked over all 36 (44, 52) sts between the markers. Change to working in short-rows and cont as foll.

Short-Row 2: (WS) P21 (26, 31), wrap next st and turn work (w&t).

Short-Row 3: (RS) [K1 through back loop (tbl), p1] 3 (4, 5) times, w&t—6 (8, 10) worked sts in center with 15 (18, 21) sts at each side.

Short-Row 4: [K1, p1tbl] 3 (4, 5) times, work wrapped st tog with wrap as kw (see Stitch Guide), p1tbl, k1, p1tbl, w&t.

Short-Row 5: [K1tbl, p1] 5 (6, 7) times, work wrapped st tog with wrap as kwt (see Stitch Guide), p1, k1tbl, p1, w&t.

Short-Row 6: [K1, p1tbl] 7 (8, 9) times, kw, p1tbl, w&t.

Short-Row 7: [K1tbl, p1] 8 (9, 10) times, kwt, p1, w&t.

Short-Row 8: [K1, p1tbl] 9 (10, 11) times, kw, p2togtbl, w&t.

Short-Row 9: [K1tbl, p1] 10 (11, 12) times, kwt, p2tog, w&t.

Short-Row 10: [K1, p1tbl] 11 (12, 13) times, kw, p2togtbl, w&t.

Short-Row 11: [K1tbl, p1] 12 (13, 14) times, kwt, p2tog, w&t.

Size 6½" (16.5 cm) is complete; cont for other sizes as foll.

SIZES 7½ (8½)" (19 [21.5] CM) ONLY

Short-Row 12: [K1, p1tbl] 14 (15) times, kw, p2togtbl, w&t.

Short-Row 13: [K1tbl, p1] 15 (16) times, kwt, p2tog, w&t.

SIZE 8½" (21.5 CM) ONLY

Short-Row 14: [K1, p1tbl] 17 times, kw, p2togtbl, w&t.

Short-Row 15: [K1tbl, p1] 18 times, kwt, p2tog, w&t.

ALL SIZES

Short-Row 12 (14, 16): [K1, p1tbl] 13 (16, 19) times, kw, p2tog tbl (ending at marker), w&t (wrapping st after marker).

Short-Row 13 (15, 17): [K1tbl, p1] 14 (17, 20) times, kwt, p2tog (ending at marker)—30 (36, 42) sts between markers. Do not turn work.

Right Side Cuff Set Up

Row 1: With RS of left side cuff still facing, sl m at top of Scallop Q, k2 held sts at top of Scallop Q, then k15 (19, 23) held sts from left side of Scallop Q, k1 held st from top of Scallop O, remove marker, k1 rem st from top of Scallop O, pick up and knit 15 (19, 23) sts along right side of Scallop R (beg of RS rows), then k1 from top of Scallop R (ending 1 st before marker), w&t (this st now has 2 wraps)—36 (44, 52) sts between markers: 2 sts each at top of Scallops O, Q, and R, and 30 (38, 46) picked-up sts.

The right side cuff is worked over all 36 (44, 52) sts between the markers.

Short-Rows 2–12 (14, 16): Work as for left side cuff.

Short-Row 13 (15, 17): [K1tbl, p1] 14 (17, 20) times, kwt, sl 1 pwise wyf, insert right needle tip into double-wrapped st pwise, then down through front strands of

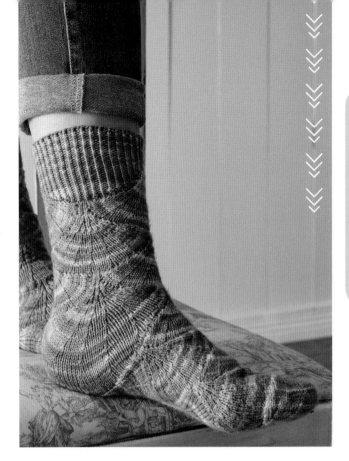

both wraps, and purl these 3 sts tog, psso—30 (36, 42) sts rem between each pair of markers; 60 (72, 84) sts total. Do not turn work.

Both Cuffs

Change to working all sts in the rnd, and cont as foll.

Rnd 1: [K1tbl, p1] 14 (17, 20) times, k1tbl, insert right needle tip into wrapped st pwise, then down through front strand of wrap, then purl these 2 sts tog, [k1tbl, p1] 15 (18, 21) times.

Rnds 2–17: *K1tbl, p1; rep from *—cuff measures about 1½" (3.8 cm) from last scallop row.

Finishing

Use Jeny's Surprisingly Stretchy Bind-Off (see Glossary) to BO all sts in patt.

Weave in loose ends.

Block as desired.

CARISSA BROWNING lives and knits in Dallas, Texas, where she has accepted the futility of stitching cozy woolen sweaters and has perhaps overcompensated with an abundance of handknitted socks. She can now last almost three months without wearing the same pair twice. More of her work can be found at CarissaKnits.com.

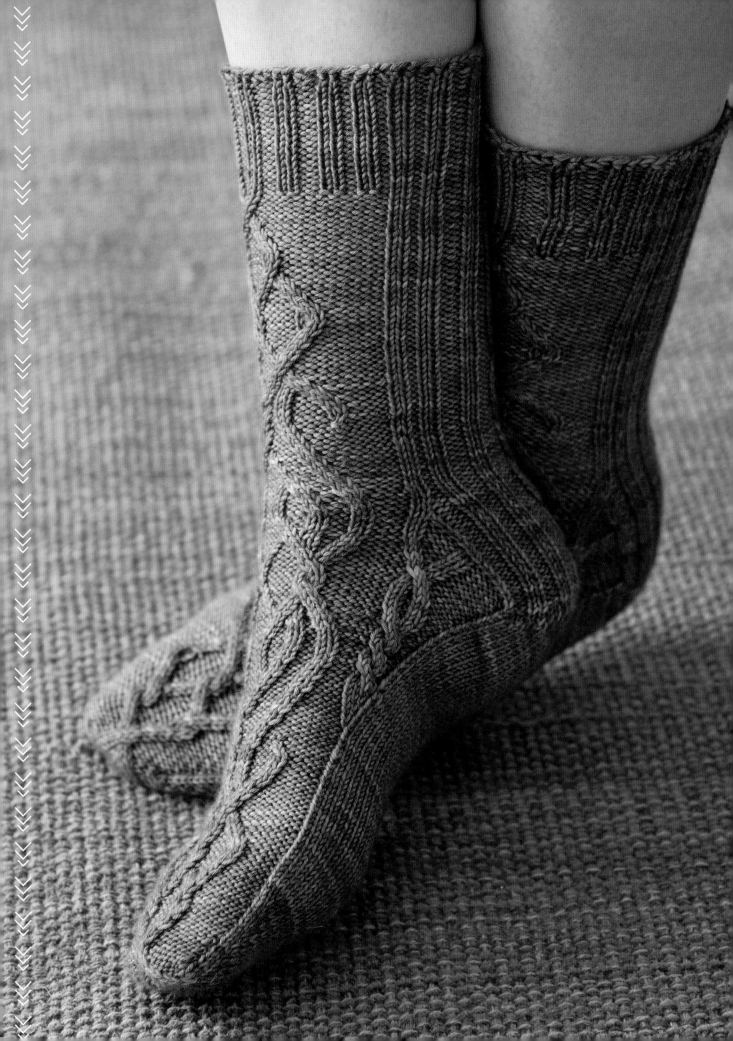

Crossfade

MARJAN HAMMINK

This design is simultaneously technical, mathematical, and geeky. Working from the toe up ensures that the sock fits your foot properly. Use a yarn that sparks joy; let the color take you through the process. Although variegated yarns may be tempting, the variegation may obscure complicated cable patterns. The pattern I used comes from a Japanese book of stitch patterns. Elegantly twining their way up, the cables will grab your attention every other round. The gusset section is, as always in my designs, made up of more than simple increases: it includes an extra cable pattern. Mirror the cables on the two socks if you'd like.

FINISHED SIZE

About 7¼ (7¾)" (18.5 [19.5] cm) foot circumference; 9 (9½)" (23 [24] cm) foot length from back of heel to tip of toe, relaxed (can stretch about ½" [1.3 cm] longer); and 9½" (24 cm) leg length from base of heel flap to top of cuff.

Socks shown measure 7¼" (18.5 cm) foot circumference.

YARN

Fingering weight (#1 Super Fine).

Shown here: Wollmeise Sockenwolle 80/20 Twin (80% merino wool, 20% nylon; 510 yd [466 m]/150 g): Mont Blanc, 1 skein for each size.

NEEDLES

Size U.S. 1½ (2.5 mm): needle for working in rounds as you prefer (see page 6).

Adjust needle size if necessary to obtain the correct gauge.

NOTIONS

Markers (1 in a unique color to indicate beg of rnd); tapestry needle.

GAUGE

14 sts and 22 rnds = 2" (5 cm) in St st worked in rnds, relaxed after blocking.

30 (32) sts of Instep and Front Leg chart measure 3 (3¼)" (7.5 [8.5] cm) wide, relaxed after blocking.

NOTES

- Slip all stitches as if to purl with the yarn held to the wrong side (carried across the inside of the sock), unless instructed otherwise.

- For the best fit, try on the socks along the way, using larger needles if extra width is needed.

- The green-shaded stitches on the charts apply to the larger size only. For the smaller size, skip over any green-shaded stitches when you come to them.

- The cables of the first sock are crossed as shown in the charts. To make the second sock a mirror image of the first, reverse the direction of the cable crossings as described in instructions for the second sock. You may also work both socks the same, or mirror some sections and not others, if desired.

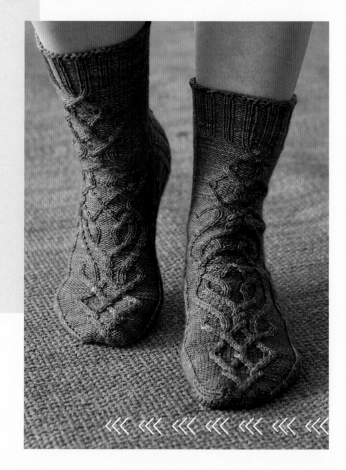

First Sock

Toe

Using Judy's Magic Cast-On (see Glossary), CO 24 sts for both sizes—12 sts each on two needles.

Place marker (pm) and join for working in rnds, being careful not to twist sts. Rnd begins at start of instep sts.

Beg as indicated for your size, work Rnd 3 (1) to Rnd 21 of Toe chart (see page 91)—60 (64) sts total; 30 (32) sts each for instep and sole; 19 (21) chart rnds completed; toe measures about 1¾ (2)" (4.5 [5] cm) from CO.

Foot

Next rnd: Work Rnd 1 of Instep and Front Leg chart (see page 90) over 30 (32) sts, then work sole sts as k1 through back loop (tbl), k28 (30), k1tbl.

Working sole sts as they appear (knit the knits and work the first and last sole tbl), cont in patt until piece measures 4¾" (12 cm) from CO for both sizes. Make a note of the last chart rnd completed so you can work the second sock to match.

Gussets

Note: As you work the gusset increases, redistribute the stitches as necessary to avoid having too many stitches on one needle. Slip all markers as you come to them.

Next rnd: M1R (counts as Rnd 1 of Left Gusset chart), pm, work 30 (32) instep sts as established, pm, M1L (counts as Rnd 1 of Right Gusset chart), work 30 (32) sole sts as established—2 sts inc'd on top of foot.

Next rnd: Pm, work Rnd 2 of Left Gusset chart (see page 91) over 1 st, sl m, work 30 (32) instep sts as established, sl m, work Rnd 2 of Right Gusset chart over 1 st, pm, work 30 (32) sole sts as established.

Keeping in patts as set, work until Rnd 32 (34) of gusset charts has been completed—92 (98) sts total; 30 (32) instep sts, 30 (32) sole sts, 16 (17) sts each gusset; piece measures 7½ (7¾)" (19 [19.5] cm) from CO.

Heel Turn

Set-up: Work Rnd 33 (35) of Left Gusset chart, sl m, work 30 (32) instep sts as established, sl m, work Rnd 33 (35) of Right Gusset chart, then stop. Make a note of the instep chart rnd just completed.

The heel turn is worked back and forth in rows on the 30 (32) sole sts; the instep and gusset sts will be worked later.

Use short-rows (see Glossary) to shape the heel cup as foll.

TWISTING CABLES WITHOUT A CABLE NEEDLE

Working cables nearly every other round will be much easier if you learn to twist the cables without a cable needle.

Step 1: Slip the designated number of stitches (1 stitch shown) off the needle and let them drop to the front of the work for a left-leaning cable, or to the back of the work for a right-leaning cable.

Step 2: Slip the designated number of stitches (1 stitch shown) temporarily onto the right-hand needle, keeping the dropped stitches in front (**Figure 1**) or back.

Step 3: Return the dropped stitches to the left-hand needle, then return the held stitches from the right-hand needle to the left-hand needle (**Figure 2**).

Step 4: Knit these stitches in their new order (**Figure 3**) to complete the cable.

☐ knit on RS rows and all rnds; purl on WS rows

• purl on RS rows and all rnds; knit on WS rows

Ω k1tbl on RS rows and all rnds; p1tbl on WS rows

/ k2tog on RS rows and all rnds; p2tog on WS rows

\ ssk on RS rows and all rnds; ssp (see Glossary) on WS rows

/ gusset dec: k2tog on RS rows and all rnds; p2tog on WS rows

\ gusset dec: ssk on RS rows and all rnds; ssp on WS rows

◣ ssk or sssk (see Glossary) on RS (see instructions; gusset dec)

◢ p2tog or p3tog on WS (see instructions; gusset dec)

R M1R

L M1L

P M1P

V sl 1 st pwise wyb on RS; sl 1 st pwise wyf on WS

• or ▨ work for larger size only; omit for smaller size (see Notes)

▨ no stitch

⟍⟋ sl 1 st onto cn and hold in back of work, k1, then k1 from cn

⟋⟍ sl 1 st onto cn and hold in front of work, k1, then k1 from cn

⟍⟋ sl 1 st onto cn and hold in back of work, k1, then p1 from cn

⟋⟍ sl 1 st onto cn and hold in front of work, p1, then k1 from cn

⟍ sl 1 st onto cn and hold in back of work, k2, then p1 from cn

⟋ sl 2 sts onto cn and hold in front of work, p1, then k2 from cn

⟍ sl 1 st onto cn and hold in back of work, k2, then k1 from cn

⟍ sl 2 sts onto cn and hold in front of work, k1, then k2 from cn

⟍⟍ sl 2 sts onto cn and hold in back of work, k2, then k2 from cn

⟋⟋ sl 2 sts onto cn and hold in front of work, k2, then k2 from cn

⟍⟍ sl 2 sts onto cn and hold in back of work, k2, then p2 from cn

⟋⟋ sl 2 sts onto cn and hold in front of work, p2, then k2 from cn

INSTEP AND FRONT LEG, RNDS 1 TO 60

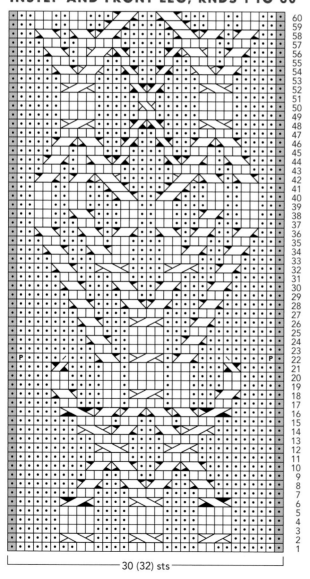

60
59
58
57
56
55
54
53
52
51
50
49
48
47
46
45
44
43
42
41
40
39
38
37
36
35
34
33
32
31
30
29
28
27
26
25
24
23
22
21
20
19
18
17
16
15
14
13
12
11
10
9
8
7
6
5
4
3
2
1

⟵ 30 (32) sts ⟶

INSTEP AND FRONT LEG, RNDS 61 TO 117

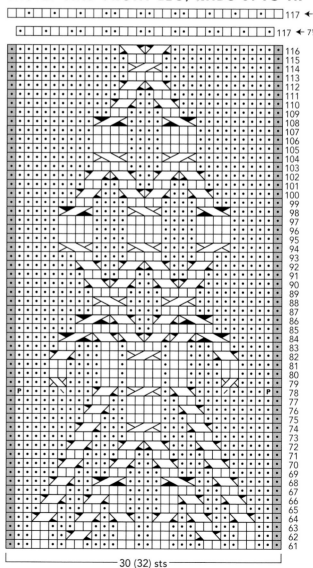

117 ⟵ 7¾"
117 ⟵ 7¼"

116
115
114
113
112
111
110
109
108
107
106
105
104
103
102
101
100
99
98
97
96
95
94
93
92
91
90
89
88
87
86
85
84
83
82
81
80
79
78
77
76
75
74
73
72
71
70
69
68
67
66
65
64
63
62
61

⟵ 30 (32) sts ⟶

HEEL AND BACK LEG

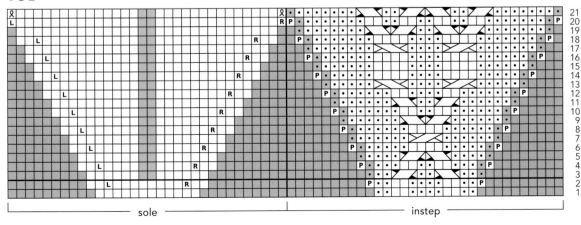

See instructions for Rows 1 to 4, and Rnds 25 to 30.

RIGHT GUSSET

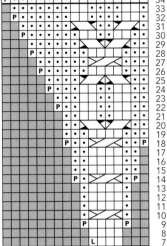

LEFT GUSSET

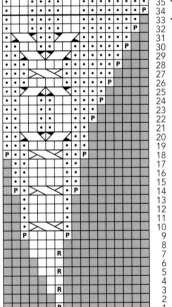

TOE

Short-Row 1: (RS): K1tbl, k27 (29), wrap next st and turn work (w&t).

Short-Row 2: (WS) P26 (28), w&t—1 unworked st at each end of row.

Short-Row 3: K25 (27), w&t.

Short-Row 4: P24 (26), w&t.

Short-Row 5: K23 (25), w&t.

Short-Row 6: P22 (24), w&t.

Short-Row 7: K21 (23), w&t.

Short-Row 8: P20 (22), w&t.

Short-Row 9: K19 (21), w&t.

Short-Row 10: P18 (20), w&t.

Short-Row 11: K17 (19), w&t.

Short-Row 12: P16 (18), w&t.

Short-Row 13: K15 (17), w&t.

Short-Row 14: P14 (16), w&t.

Short-Row 15: K13 (15), w&t.

Short-Row 16: P12 (14), w&t—1 unworked st and 8 wrapped sts at each end of row; 12 (14) sts worked in center.

Size 7¼" (18.5 cm) heel turn is complete.

SIZE 7¾" (19.5 CM) ONLY

Short-Row 17: K13, w&t.

Short-Row 18: P12, w&t—1 unworked st and 9 wrapped sts at each end of row; 12 sts worked in center.

BOTH SIZES

Next rnd: K12, work 8 (9) wrapped sts tog with their wraps, k1tbl, sl m, work 16 (17) left gusset sts as they appear, sl m, work 30 (32) instep sts as established, sl m, work 16 (17) right gusset sts as they appear, sl m, k1tbl, work 8 (9) wrapped sts tog with their wraps, ending at start of 12 center heel sts. Make a note of the instep chart rnd just completed.

Change to dpn if you're not using them already.

Place the 30 (32) instep sts on two dpn or stitch holder. With RS facing, place 16 (17) right gusset sts and first 9 (10) heel sts on one dpn, then place rem 21 (22) heel sts and 16 (17) left gusset sts on a second dpn—25 (27) sts on first dpn; 37 (39) sts on second dpn, with working yarn attached to start of second dpn; 62 (66) total heel and gusset sts.

Heel Flap

Note: The heel flap is worked back and forth in short-rows on the center-heel stitches while the gusset stitches are decreased at each side. Do not wrap any stitches when turning.

Short-Row 1: (RS) Beg at start of second dpn where working yarn is attached, work Short-Row 1 of Heel and Back Leg chart (see page 91) as k19 (20), then work pink-shaded dec symbol as sssk (see Glossary), turn work—2 left gusset sts dec'd.

Short-Row 2: (WS) Work Row 2 of chart over 29 (31) sts, then work pink-shaded dec symbol as p3tog, turn work—2 right gusset sts dec'd.

Short-Row 3: Work Row 3 of chart over 29 (31) sts, then work pink-shaded dec symbol as ssk (sssk), turn work—1 (2) left gusset sts dec'd.

Short-Row 4: Work Row 4 of chart over 29 (31) sts, then work pink-shaded dec symbol as p2tog (p3tog), turn work—1 (2) right gusset sts dec'd.

Short-Rows 5–24: Cont in chart patt, dec 1 gusset st at end of every row by working last gold-shaded chart st tog with 1 gusset st as indicated on chart—36 (38) sts rem; 30 (32) heel flap sts; 3 gusset sts at each side.

Ankle Transition

Resume working in the rnd for the ankle, pm for new beg of rnd at start of back leg sts.

Rnd 25: Work Rnd 25 of Heel and Back Leg chart to last 4 heel and gusset sts, k2tog (last heel st tog with 1 gusset st), work rem 2 gusset sts as k1, p1, work 30 (32) front leg sts as established—1 left gusset st dec'd.

Rnd 26: Work first 4 sts from Rnd 26 of Heel and Back Leg chart as p1, k1, ssk (last gusset st tog with 1 heel st), work to end of Rnd 26, work 30 (32) front leg sts as established—1 right gusset st dec'd; 2 gusset sts rem on each side of heel flap.

Rnds 27–30: Cont as established, dec 1 gusset st each rnd—60 (64) sts rem; 30 (32) heel sts; 30 (32) front leg sts; all gusset sts have been dec'd.

Leg

Cont as established until Rnd 54 of Heel and Back Leg chart has been completed.

From here until the end of the cuff, work the back leg sts as they appear in Rnd 55 of Heel and Back Leg chart for back rib patt.

Cont front leg sts in patt as set until Rnd 116 of Instep and Front Leg chart has been completed.

Cuff

Working back leg sts in established rib, work the front leg sts as they appear in rib patt from Rnd 117 of chart for your size until cuff measures 2" (5 cm), or until leg is desired length.

Use Jeny's Surprisingly Stretchy Bind-Off (see Glossary) to BO all sts.

Weave in loose ends. Block lightly under a damp cloth.

Second Sock

The second sock is worked the same as the first sock except that the center cables in some charts (see list below) are crossed in the opposite direction, in which the stitches on the cable needle are held on the opposite side of the work (in front instead of in back and vice versa). You may find it helpful to photocopy the charts and highlight the cables that should be worked differently. The gusset charts are worked the same for both socks because they are already mirror images of each other.

Toe chart: Rnd 7.

Instep and Front Leg chart: Rnds 2, 6, 18, 22, 26, 50, 74, 78, 82, 94, 98, and 114.

Heel and Back Leg chart: Rows 9 and 17; Rnds 29, 38, and 50.

Note: In the second sock shown in the photographs, the cables are mirrored in the Toe chart and the Heel and Back Leg chart; however, for the Instep and Front Leg chart, they are only mirrored up to and including Rnd 26.

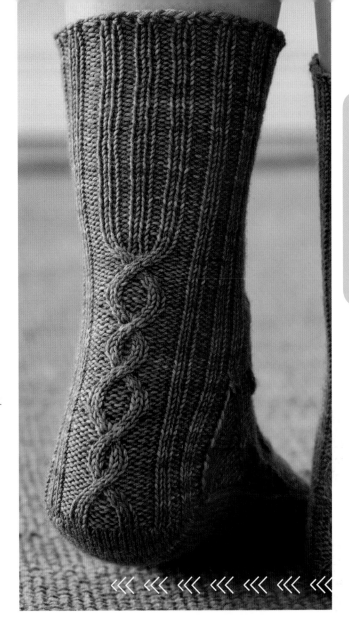

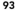

MARJAN HAMMINK started to knit at the age of four, when her grandmother observed: "You can write your name. Now I can teach you to knit." One of her first items was a small sock. Growing up in a family where creativity was always taken seriously, she's drawn to quality tools and superb fibers. Getting to know the Bavarian Wollmeise yarn took her sock knitting to a higher level. She lives the village life in the rural eastern part of the Netherlands with her husband, their three teenage sons, and two Border Terriers.

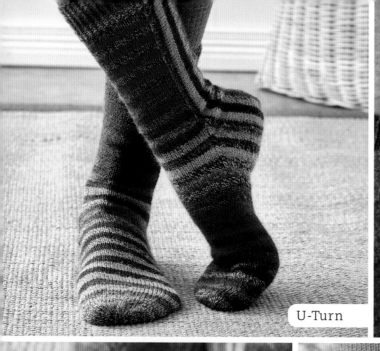
U-Turn

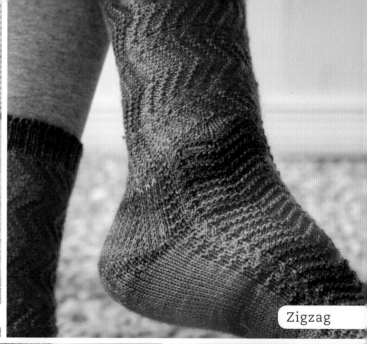
Zigzag

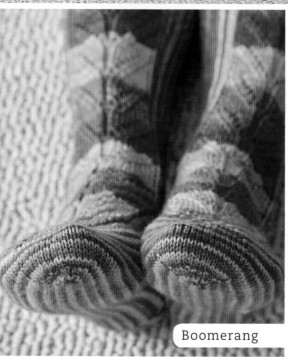
Boomerang

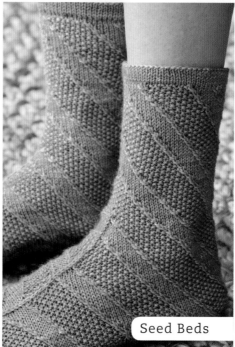
Seed Beds

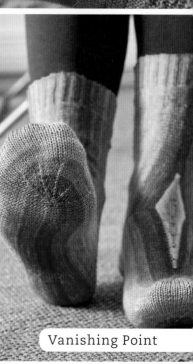
Vanishing Point

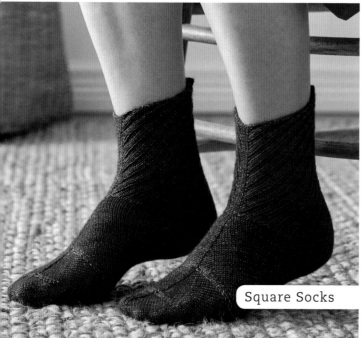
Square Socks

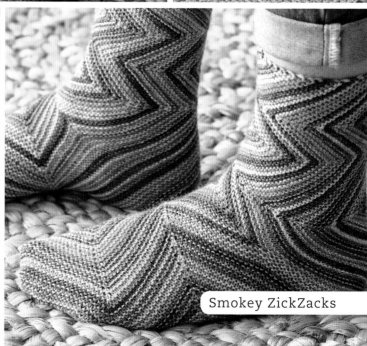
Smokey ZickZacks

CHAPTER 3
OTHER TYPES OF CONSTRUCTION

For the adventurous knitter, seven of the socks in this book are worked from side to side or are hybrids of traditional top-down and toe-up constructions. Each of these imaginative socks offers something new in the way a sock is knitted.

General Hogbuffer worked his **U-Turn** socks (page 96) outward from the center back of the leg to create a U-shape that fits around the back of the leg and cups the heel. Additional stitches are cast on for the front of the leg, which is attached to the existing stitches as they are worked. The gusset and foot stitches are worked in rounds to the tip of the toe, which is finished with the Kitchener stitch.

For **Zigzag** (page 104), Anne Campbell began by working the leg in a lace pattern that's joined into a ring. Stitches for the heel and foot are picked up along one edge of the ring; stitches for the ribbed cuff are picked up along the other edge. The heel is worked in a variation of the traditional flap-and-gusset heel pattern, in which the gusset increases are worked simultaneously with the heel flap.

Louise Robert began her **Boomerang** socks (page 112) at the back of the leg, heel, and sole and worked outward to form the sole and sides of the leg. She shaped the heel with decreases and the bottom of the toe with increases, then switched to decreases for the top of the toe. A narrow lace panel finishes the top of the foot and front of the leg. Self-striping yarn emphasizes the unusual construction.

Betty Salpekar's **Seed Beds** (page 118) begin at the sole, which is worked with an additional strand of mohair for strength and durability. The top of the foot and leg are worked in rounds outward and upward from the sole. The toe is shaped with decreases, while the heel is shaped with increases, without the need for a heel flap, gussets, picked-up stitches, or Kitchener stitch.

Using gradient yarns for **Vanishing Point** (page 126), Jeny Staiman began at the instep with a diamond shape that eliminated the need for gussets. The heel is shaped with increases and short-rows. The top of the toe is shaped with increases; the bottom of the toe is shaped with decreases. After working a short-row wedge to add calf shaping, the stitches are joined with the Kitchener stitch.

Nicola Susen's **Square Socks** (page 134) begin with a circular cast-on at the ball of the foot. She divided the stitches into quarters that radiate outward to the desired foot circumference. Then she shaped the toe with decreases and the heel with increases as she worked decreases on the top of the instep. The leg is worked in a ribbed pattern with increases along the front of the leg and decreases along the back of the leg. These socks have a somewhat awkward look when they come off the needles, but are surprisingly comfortable to wear.

Natalia Vasilieva's **Smokey ZickZacks** (page 140) are worked in garter-stitch rows with strategic placement of increases and decreases that result in a series of zigs and zags. To form the finished sock shape, she used the Kitchener stitch to join the stitches like the pieces of a puzzle. A provisional cast-on is used to shape the heel; the toe is shaped with the zigs and zags. For the best fit, Natalia made the two socks mirror images of each other.

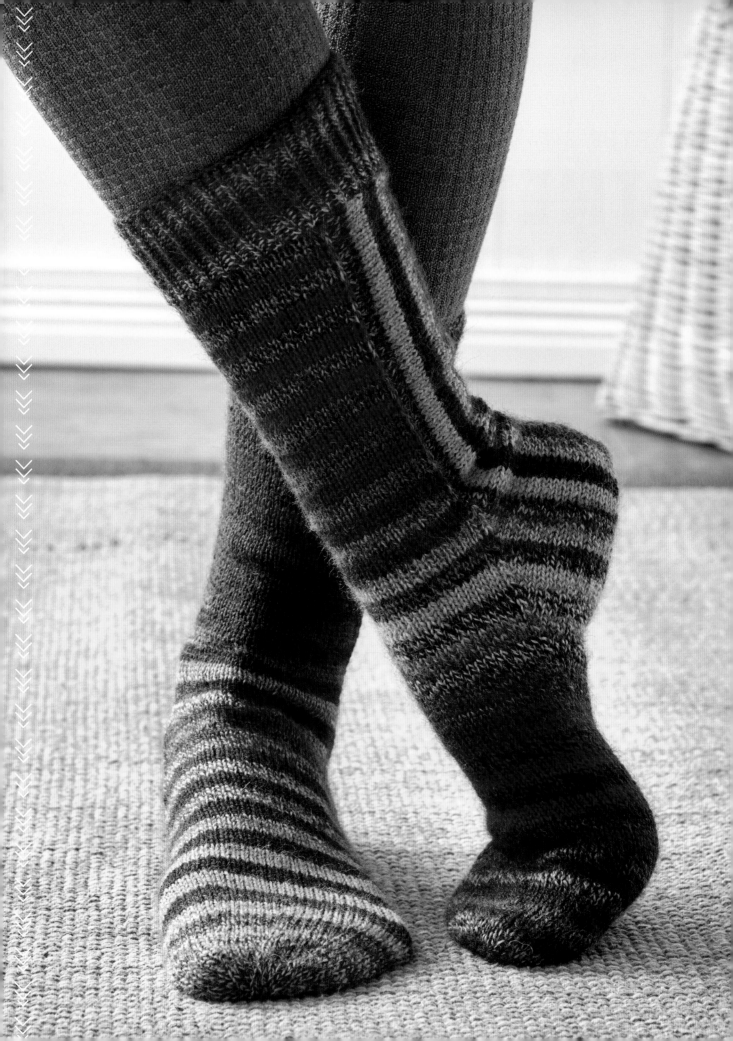

U-Turn

GENERAL HOGBUFFER

I've always been fascinated by construction and the various ways one can arrive at something that resembles a "normal" sock. This design plays with knitting in different directions in a combination of working in rows and rounds. Thankfully, there are no long seams or grafting because the parts are joined as they're worked. The stripes highlight the construction method, but you could achieve a similar effect by omitting the stripes and working the entire sock in a long gradient or self-striping yarn.

FINISHED SIZE

About 6½ (7, 7½, 8, 8½)" (16.5 [18, 19, 20.5, 21.5] cm) foot circumference, 9 (9½, 10, 10½, 11)" (23, [24, 25.5, 26.5, 28] cm) foot length from back of heel to tip of toe, and 10½" (26.5 cm) leg length from top of cuff to base of heel; all dimensions are adjustable.

Socks shown measure 7½" (19 cm) foot circumference.

YARN

Fingering weight (#1 Super Fine).

Shown here: Schoppel Wolle Zauberball Crazy (75% superwash wool, 25% nylon; 462 yd [422 m]/100 g): #1507 Herbstwind (Autumn Wind), 1 ball for all sizes.

NEEDLES

Size U.S. 1½ (2.5 mm): two 24" (60 cm) circular (cir), and set of 4 or 5 double-pointed (dpn) or third 24" (60 cm) cir.

Adjust needle size if necessary to obtain the correct gauge.

NOTIONS

Smooth cotton waste yarn in a contrasting color for provisional cast-on; markers (m); tapestry needle.

GAUGE

16 sts and 24 rows = 2" (5 cm) in St st worked in rows.

17 sts and 22 rnds = 2" (5 cm) in St st worked in rnds.

NOTES

- This project has an unusual construction that does not follow the "standard" sequences for top-down or toe-up socks.

- The socks shown were knitted using the two ends from the same ball of yarn, changing ends every 4 rows or rounds for the stripes. Not every yarn is packaged to allow easy access to both ends at the same time. If you're struggling with tangles, you may want to consider rewinding your yarn into two evenly sized balls; a digital kitchen scale is helpful for this.

- The two working strands are referred to as color A and color B in the directions, even though they are two ends from the same ball of yarn. If you're using two different colors, decide which will be A or B; you'll need about 50 grams of each color. If you use a self-striping yarn, ignore any instructions for changing colors.

- It's not necessary to cut the yarn between the stripes unless instructed. Carry the unused color loosely up the side of the work (when working in rows) or inside the tube on the back of the work (when working in rounds) until it's needed again.

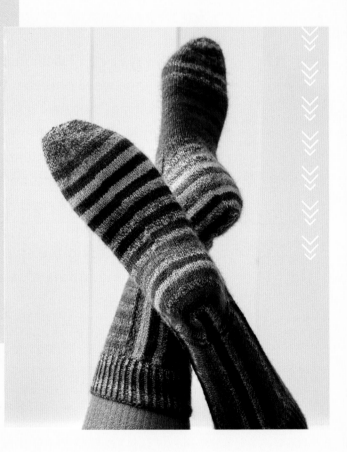

CONSTRUCTION JOURNAL

As with all alternative construction socks, at one stage or another, a certain amount of math will be involved, but fear not. Here, we only need to translate rows into stitches and vice versa. I usually work with a ratio of about 5 stitches to 7 rows or rounds. If you look at the actual gauges for the U-Turn Socks, you will see that this is a rough estimate indeed, but it works well as a basis from which to start. Please note that the 5:7 ratio is used to translate between stitches and rows; it is not a gauge.

Once the U-turn socks have been joined for working the gusset and foot in the round, the construction is the same as for other top-down socks and can be customized for a wide range of size by adjusting the gusset decreases and foot length.

The leg and heel dimensions depend on the relationship between the back and front legs, which are worked at a 90-degree angle to each other; that is, the stitches of one section correspond to the rows of the other. They can also be customized, but this is where the math comes in.

Begin by deciding how long you would like your sock leg to be, excluding the ribbed cuff, and multiply this measurement by your row gauge. I tend to work about 60 to 64 rows below the cuff for the front of a plain sock leg. For the U-Turn socks with 4-row stripes, a multiple of 8 rows is one full repeat of the stripe pattern, so I used 64 leg rows.

To calculate how many back leg stitches equal these 64 rows, translate rows into stitches. Using the rough ratio of 5 stitches to 7 rows, multiply the number of front leg rows by 5, then divide by 7.

$64 \times 5 = 320$

$320 \div 7 = 45.7$

I rounded that to 46 back leg stitches to match up with 64 front leg rows.

For a conventional top-down sock, I usually work a heel flap that's 32 rows high. I calculated how many back leg stitches would equal these 32 rows in the same manner.

$32 \times 5 = 160$

$160 \div 7 = 22.9$

I rounded that to 23 heel flap stitches to equal my preferred heel flap height.

This number should be okay for most sizes, but I could easily have gone down to 21 stitches for a shorter heel, or up to 25 stitches for a longer one.

To determine the number of stitches to cast on for the back leg and heel, add the leg stitches to the heel stitches, plus 1 extra stitch. For the U-Turn socks shown, I cast on 70 stitches for the back leg.

$46 + 23 + 1 = 70$

Next, decide how big around the leg should be. In the basic U-Turn pattern, the back contains 44 (44, 44, 52, 52) back rows. To estimate the number of front stitches, translate stitches into rows. Using the rough ratio of 7 rows to 5 stitches, divide the back rows by 7, then multiply by 5.

$44 (44, 44, 52, 52) \div 7 = 6.3 (6.3, 6.3, 7.4, 7.40)$

$6.3 (6.3, 6.3, 7.4, 7.4) \times 5 = 31.5 (31.5, 31.5, 37, 37)$

I rounded the middle size to 32 stitches, then graded the range of stitches on each side, so the basic pattern uses 28 (30, 32, 34, 36) front lg stitches. To determine cast-on number for the front leg, add 1 extra stitch.

I decided that I wanted a roomier leg for the U-Turn socks shown, so I used the largest size's 36 stitches, and cast on 37 stitches for the front leg. The extra stitches were decreased away during the gusset shaping.

Back Leg and Heel

The center back leg extends from just below the ribbed cuff to the base of the heel.

With waste yarn and using a provisional method (see Glossary), CO 70 sts. Do not join.

Change to A (see Notes).

Set-up Rows 1 and 3: (RS) Knit.

Set-up Row 2: (WS) P1, p2tog, purl to end—69 sts rem.

Set-up Row 4: Purl.

Carefully remove waste yarn from provisional CO and place 69 exposed sts onto second cir needle—one 4-row rectangle of color A between needles.

With RS facing, join B to beg of live sts from Set-up Row 4.

Row 1: (RS) With B, use Needle 1 to k46 leg sts, place marker (pm), k23 heel flap sts, pm; with RS still facing, pick up and knit 1 st from selvedge of 4-row rectangle; with Needle 2, pick up and knit 1 st from the same selvedge of 4-row rectangle, pm, k23 heel flap sts, pm, k46 leg sts—140 sts total; 70 sts each needle; 2 sts at base of U between second and third m.

Note: You now have live stitches around three sides of a narrow rectangle; the fourth side will become the top of the leg. Work back and forth in rows around three sides of the starting rectangle to create a U-shape to form the back of the leg and heel cup. Because you're working around three sides, every four U-shaped rows add two 4-row stripes, 1 stripe on each long side of the starting rectangle.

Cont as foll.

Row 2: (WS) With B, purl.

Row 3: (inc row) With B, k46, slip marker (sl m), k23, sl m, M1 (see Glossary), knit to next marker, M1, sl m, k23, sl m,

k46—2 sts inc'd at base of U between second and third m; 1 st inc'd each needle.

Row 4: With B, purl—3 stripes between long sides of U; 1 starting rectangle stripe and 1 stripe on each long side.

Cont for your size as foll.

SIZES 6½ (7, 7½)" (16.5 [18, 19] CM) ONLY

Rows 5–17: Changing colors every 4 rows, rep Rows 3 and 4 six more times, then work RS Row 3 once more—156 sts; 78 sts each needle; 18 sts at base of U between second and third m (9 sts each needle).

Rows 18 and 19: Cont to change colors as established, work even for 2 rows, ending with a RS row.

The 42 rows between the long sides of the U are a 3-row partial stripe and 4 complete stripes on each side of the starting rectangle stripe.

SIZES 8 (8½)" (20.5 [21.5] CM) ONLY

Rows 5–20: Changing colors every 4 rows, rep Rows 3 and 4 eight more times—158 sts; 79 sts each needle; 20 sts at base of U between second and third m (10 sts each needle).

Rows 21–23: Cont to change colors as established, work even for 3 rows, ending with a RS row.

The 50 rows between the long sides of the U are a 3-row partial stripe and 5 complete stripes on each side of the starting rectangle stripe.

ALL SIZES

Notes: The 46-stitch leg sections at each end of the row will be joined to the front leg panel as it is worked, forming a tube. The front leg joins one back leg stitch at the end of each row. In order for the pieces to join at the correct rate, the stitches in each back leg section are decreased to half the number of front leg rows.

Next row: (WS) Using the color needed to complete the 4-row stripe in progress, purl to first m and *at the same time* dec 14 sts evenly spaced, sl m, purl to last 43 sts, sl m, purl to end and *at the same time* dec 14 sts evenly spaced—128 (128, 128, 130, 130) sts rem; 64 (64, 64, 65, 65) sts each needle; 32 leg sts; 23 heel flap sts; 9 (9, 9, 10, 10) sts at base of U.

The 44 (44, 44, 52, 52) rows between the long sides of the U form 11 (11, 11, 13, 13) complete stripes; 5 (5, 5, 6, 6) complete stripes on each side of the starting rectangle stripe; piece measures about 3¾ (3¾, 3¾, 4¼, 4¼)" (9.5 [9.5, 9.5, 11, 11] cm) between long sides of U.

Note: For joining purposes, the needle holding the stitches at the beginning of RS rows is the left back needle; the needle holding the stitches at the end of RS rows is the right back needle.

CUSTOMIZE IT

The 70 cast-on stitches will be decreased to 69 stitches, which will be divided into 46 stitches for the leg and 23 stitches for the heel flap (see Construction Journal on page 99). Including the 2" (5 cm) ribbed cuff, this produces a leg length of 7¾" (19.5 cm) from the top of cuff to the top of heel flap, and a heel flap length of 2¾" (7 cm). To make either the leg or the heel flap longer or shorter, cast on more or fewer stitches; every 2 stitches added or removed will lengthen or shorten the section by ¼" (6 mm).

Front Leg

With dpn or third cir needle and waste yarn, use a provisional method to CO 29 (31, 33, 35, 37) sts. Do not join.

Set-up row: (WS) With B (B, B, A, A), purl across waste-yarn sts. Cut yarn.

Note: The last 4-row stripe completed on the back leg was worked with B (B, B, A, A). To ensure that the 16 planned front leg stripes also end with a stripe in B (B, B, A, A), the first front leg stripe is worked with A (A, A, B, B).

With RS of front sts facing, join A (A, A, B, B). Work front leg sts back and forth in rows, joining to back leg at end of each row as foll.

Row 1: (RS) K1, k2tog, knit to last front st, ssk (last front st tog with first st on left back needle), turn work—28 (30, 32, 34, 36) front sts rem; 1 left back st joined.

Row 2: (WS) Sl 1 purlwise with yarn in front (pwise wyf), purl to last front st, p2tog (last front st tog with first st on

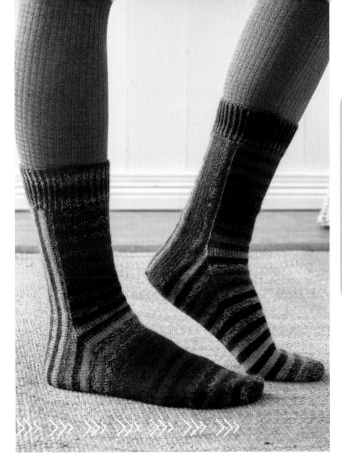

right back needle), turn work—1 right back st joined.

Row 3: Sl 1 pwise with yarn in back (wyb), knit to last front st, ssk (last front st tog with next left back st), turn work.

Row 4: Sl 1 pwise wyf, purl to last front st, p2tog (last front st tog with next right back st), turn work.

Changing colors every 4 rows and removing m at end of leg sts when you come to them, rep Rows 3 and 4 thirty more times—64 front leg rows completed; all 32 leg sts on left and right back sts have been joined; 92 (94, 96, 100, 102) sts rem; 28 (30, 32, 34, 36) front sts; 32 (32, 32, 33, 33) sts on each back needle, with 23 heel flap sts and 9 (9, 9, 10, 10) sts at base of U.

Shape Gussets

Cut both yarns. Rejoin A (A, A, B, B) with RS facing in center of heel, between the two back cir needles.

Set-up rnd: On Needle 1, k9 (9, 9, 10, 10), remove m, k22, k2tog (last back st tog with front st after it), pm, k13 (14, 15, 16, 17); on Needle 2, k13 (14, 15, 16, 17), ssk (last front st tog with back st after it), pm, k22, remove m, k9 (9, 9, 10, 10)—90 (92, 94, 98, 100) sts rem; 45 (46, 47, 49, 50) sts each needle.

Dec rnd: Knit to 2 sts before first m, k2tog, sl m, knit to second m, sl m, ssk, knit to end—2 sts dec'd; 1 st dec'd each needle.

101

CUSTOMIZE IT

The gusset shaping is for a normal instep and produces foot circumferences of about 6½ (7, 7½, 8, 8½)" (16.5 [18, 19, 20.5, 21.5] cm). For a narrower or wider foot, work more or fewer decrease rounds to achieve the desired circumference; every 2-st decrease round added or removed will decrease or increase the circumference by about ¼" (6 mm).

For a low instep and a fairly short foot, repeat the decrease round every round until you reach the desired stitch count. For a high instep and a long foot, work the decrease round every other round for the entire gusset.

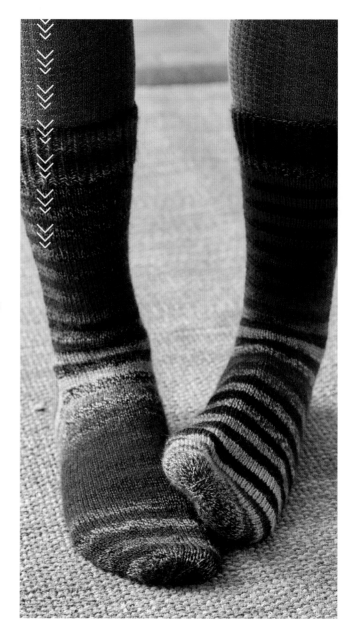

Changing colors every 4 rnds, rep the dec rnd every rnd 5 more times—78 (80, 82, 86, 88) sts rem; 39 (40, 41, 43, 44) sts each needle.

Changing colors every 4 rnds, [work 1 rnd even, then rep the dec rnd] 11 (10, 9, 9, 8) more times—56 (60, 64, 68, 72) sts rem; 28 (30, 32, 34, 36) sts each needle.

Foot

Changing colors every 4 rnds, work even until the foot measures 7 (7½, 8, 8½, 9)" (18 [19, 20.5, 21.5, 23] cm) from center back heel, or about 2" (5 cm) less than desired finished sock foot length.

Toe

Changing colors every 4 rnds, cont as foll.

Rnd 1: [K5 (13, 6, 15, 7), k2tog] 8 (4, 8, 4, 8) times—48 (56, 56, 64, 64) sts rem.

Rnds 2–6: Knit.

Rnd 7: [K4 (5, 5, 6, 6), k2tog] 8 times—40 (48, 48, 56, 56) sts rem.

Rnds 8–11: Knit.

Rnd 12: [K3 (4, 4, 5, 5), k2tog] 8 times—32 (40, 40, 48, 48) sts rem.

Rnds 13–15: Knit.

Rnd 16: [K2 (3, 3, 4, 4), k2tog] 8 times—24 (32, 32, 40, 40) sts rem.

Rnds 17 and 18: Knit.

Rnd 19: [K1 (2, 2, 3, 3), k2tog] 8 times—16 (24, 24, 32, 32) sts rem.

CUSTOMIZE IT

For a looser cuff, pick up more stitches along the upper edge of the back. You may also work a few increases as you knit across the front leg provisional cast-on. Adjust the stitch count if necessary so the cuff contains an even number of stitches.

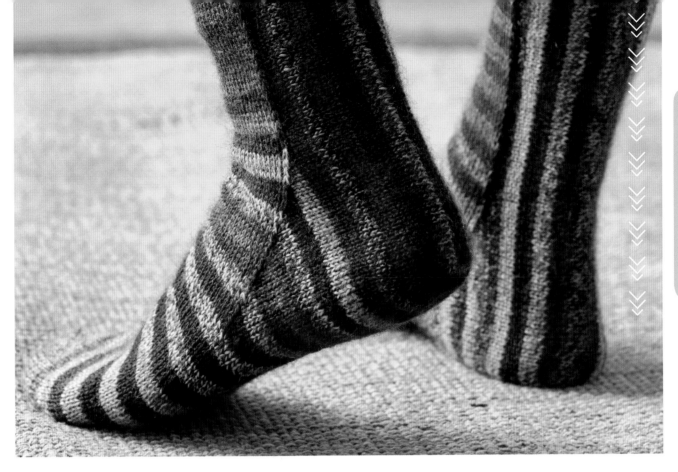

Rnd 20: Knit.

Rnd 21: [K0 (1, 1, 2, 2), k2tog] 8 times—8 (16, 16, 24, 24) sts rem.

Size 6½" (16.5 cm) is complete; skip to All Sizes.

SIZES 7 (7½, 8, 8½)" (18 [19, 20.5, 21.5] CM) ONLY

Rnd 22: [K0 (0, 1, 1), k2tog]—8 (8, 16, 16) sts rem.

Sizes 7 (7½)" (18 [19] cm) are complete; skip to All Sizes.

SIZES 8 (8½)" (20.5 [21.5] CM) ONLY

Rnd 23: *K2tog; rep from *—8 sts rem.

ALL SIZES

K2, then cut yarn, leaving a 12" (30.5 cm) tail. Arrange sts so that the first and last 2 sts of rnd are on one needle for the sole and the other 4 sts are on another needle for the top of the foot. Thread tail on a tapestry needle and use the Kitchener st (see Glossary) to graft rem sts tog.

Cuff

Carefully remove waste yarn from front leg provisional CO and place 28 (30, 32, 34, 36) exposed sts on cir or dpn. With color used for set-up row of front leg, RS facing, and beg at start of back section, pick up and knit 30 (30, 30, 36, 36) sts along back selvedge, then knit across front sts from provisional CO—58 (60, 62, 70, 72) sts total. Arrange sts on dpn or two cir needles, pm, and join for working in rnds.

Next rnd: *K1 through back loop (tbl), p1; rep from *.

Rep the last rnd for twisted rib patt until cuff measures 2" (5 cm) from pick-up rnd or desired length.

Using Jeny's Surprisingly Stretchy Bind-Off or the Sewn Bind-Off (see Glossary) to BO all sts.

Weave in loose ends.

Block as desired.

GENERAL HOGBUFFER (a.k.a. Holger Auffenberg) was taught knitting by his grandmother, but didn't take it up seriously until about six years ago when he found himself between jobs and with too much time on his hands. After studying for a MA at the Royal College of Art in London, he worked for several years in Savile Row and is currently designing men's formal wear for a British heritage brand. Born in Germany, Holger now calls London home.

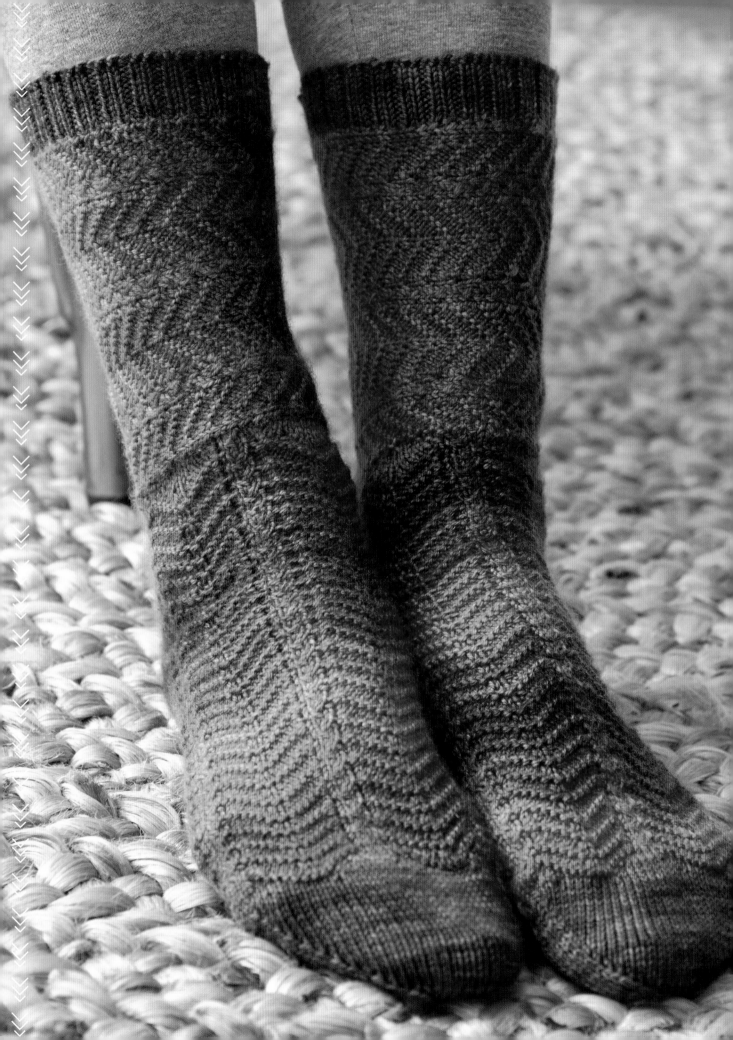

Zigzag

ANNE CAMPBELL

This sock begins with the leg, which is knitted sideways in a chevron-stitch pattern embellished with small cables, while at the same time, live stitches are created along the sides for the cuff and foot. The leg is grafted into a tube using the Kitchener stitch, then the live stitches from the sides are worked upward for the cuff on one side and down the foot to the toe on the other—no need to pick up stitches when changing the direction of knitting.

The heel flap is worked in a standard slipstitch pattern, and the instep is worked in the same chevron-stitch as the leg. The heel flap widens toward the base of the foot to form the gussets. The heel is turned on a larger-than-usual number of stitches, continuing the slip-stitch pattern for durability. After the heel is created, the rest of the foot and toe are worked conventionally in the round.

FINISHED SIZE

About 7 (8, 9)" (18 [20.5, 23] cm) foot circumference, 9 (10¼, 11½)" (23 [26, 29] cm) foot length from back of heel to tip of toe (length is adjustable), and 7¼ (7¾, 8½)" (18.5 [19.5, 21.5] cm) leg length from top of leg to base of heel (adjustable by changing cuff length).

Socks shown measure 8" (20.5 cm) foot circumference.

YARN

Fingering weight (#1 Super Fine).

Shown here: Twisted Fiber Art Tasty (80% superwash merino, 10% cashmere, 10% nylon; one 380 yd [347 m]/100 g self-striping skein and one 95 yd [87 m]/25 g coordinating miniskein in each set): Dowager, 1 set for each size, plus 1 extra 100 g skein for size Large only. Self-striping yarn is MC, coordinating solid is CC.

NEEDLES

Size U.S. 1 (2.25 mm): two 16" or 24" (40 or 60 cm) circular (cir).

Adjust needle size if necessary to obtain the correct gauge.

NOTIONS

Markers (m); waste yarn for provisional cast-on and stitch holders; tapestry needle.

GAUGE

18 sts and 24 rows/rnds = 2" (5 cm) in St st.

19 sts and 26 rows/rnds = 2" (5 cm) in chevron patt for leg.

NOTES

- The leg is worked back and forth in rows around three sides of a rectangle. The center section is worked even for the sideway-knitted leg. Increases in the first section create stitches to be worked later for the cuff; increases in the third section create stitches to be worked later for the foot and heel flap.

- When working the leg rectangle on a single circular needle, the stitches may become uncomfortably tight at some point. When this happens, transfer the first and/or last group of stitches onto waste-yarn holders, leaving the section marker and one stitch outside the marker on the needle to provide a place from which to continue the section. When the stitches become tight again, transfer more stitches to the waste-yarn holders, again leaving the marker and one stitch outside the marker on the needle.

- To work a wrap together with its wrapped stitch, use the right needle tip to lift the wrap and place it behind the wrapped stitch on the left needle. Then work the stitch and the wrap after it together.

STITCH GUIDE

LT: Skip the first st on the left needle tip, knit the second st through the back loop, then knit the first stitch and slip both sts off the left needle

RT: K2tog but don't remove original sts from left needle, knit the first of these two sts again, then slip both sts off the left needle.

w&t: Bring yarn to front between needle tips, sl 1 pwise, bring yarn to back between needle tips, return slipped st to left needle, then turn the work. See Notes at left for working wraps together with wrapped sts.

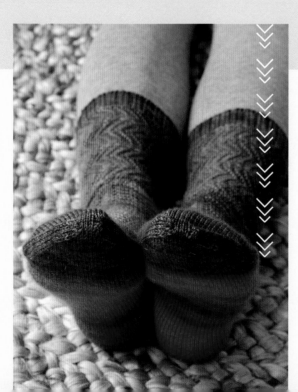

Leg

With waste yarn and using a provisional method (see Glossary), CO 44 (50, 56) sts. Change to MC.

Work along three sides of rectangle as foll (see Notes).

Set-up row: (WS) P1, place marker (pm), p42 (48, 54), pm, p1—42 (48, 54) leg sts; 1 cuff and 1 foot st at each side, outside markers.

Row 1: (RS) K1f&b (see Glossary), slip marker (sl m), [M1 (see Glossary), k3 (4, 5), ssk, LT (see Stitch Guide), k1, k2tog, k3 (4, 5), M1, k1] 3 times, sl m, k1f&b, turn work—2 sts inc'd; 1 st inc'd outside each marker.

Row 2: (WS) P2, sl m, [k6 (7, 8), p3, k5 (6, 7)] 3 times, sl m, p1 leaving last st unworked, turn work.

Row 3: K1f&b, sl m, [M1, k3 (4, 5), ssk, k1, RT (see Stitch Guide), k2tog, k3 (4, 5), M1, k1] 3 times, sl m, k1f&b leaving last st unworked, turn work—48 (54, 60) sts total; 42 (48, 54) center leg sts; 3 cuff or foot sts outside each marker.

Row 4: P2, sl m, purl to next marker, sl m, p1 leaving rem sts unworked, turn work.

Row 5: K1f&b, sl m, [M1, k3 (4, 5), ssk, LT, k1, k2tog, k3 (4, 5), M1, k1] 3 times, sl m, k1f&b leaving rem sts unworked, turn work—2 sts inc'd; 1 st inc'd outside each marker.

Row 6: P2, sl m, [k6 (7, 8), p3, k5 (6, 7)] 3 times, sl m, p1 leaving rem sts unworked, turn work.

Row 7: K1f&b, sl m, [M1, k3 (4, 5), ssk, k1, RT, k2tog, k3 (4, 5), M1, k1] 3 times, sl m, k1f&b leaving rem sts unworked, turn work—2 sts inc'd; 1 st inc'd outside each marker.

Rep Rows 4–7 (do not rep set-up or Rows 1–3) 19 (23, 27) more times, ending with a RS row—84 (100, 116) rows total including set-up row; piece measures about 6½ (7¾, 9)" (16.5 [19.5, 23] cm) from CO—128 (150, 172) sts total; 42 (48, 54) leg sts; 43 (51, 59) sts outside each marker.

Notes: To adjust leg circumference, work more or fewer repeats of Rows 4–7 until the length of the center leg section measures the desired circumference. Every 4-row repeat added or removed will widen or narrow the leg by about ¼" (6 mm).

Join the Leg

Place 42 (50, 58) sts outside each marker onto separate lengths of waste yarn or stitch holders—44 (50, 56) sts rem on needle; 1 st outside each marker and 42 (48, 54) center leg sts.

Carefully remove waste yarn from provisional CO and place 44 (50, 56) exposed sts onto a second cir needle. Cut yarn, leaving a tail 4 to 6 times the width of the sts to be joined.

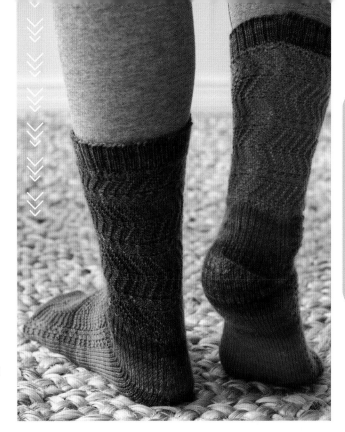

Thread tail on a tapestry needle.

Hold the two needles parallel with WS of fabric facing tog and RS facing out, then use the Kitchener st (see Glossary) to graft the two sets of 44 (50, 56) sts tog, removing markers when you come to them.

Cuff

Notes: While working the leg, one cuff stitch was created for every 2 rows of knitting. Stitches are increased before working the cuff to obtain a ratio of about 3 stitches for every 4 rows of knitting. If you changed the number of leg rows, adjust the increases to achieve a ratio of 3 stitches to 4 rows, rounding up to a multiple of 6 stitches (multiple of 3 stitches on each needle).

Place 42 (50, 58) sts from one holder onto two cir needles, 21 (25, 29) sts on each needle.

Join CC with RS facing at Kitchener join.

Set-up rnd: On Needle 1, pick up and knit 1 st from join, M1L, [k2, M1L] 10 (12, 14) times, k1; on Needle 2, k1, M1L, k1, [M1L, k2] 9 (11, 13) times, k1, M1L, pick up and knit 1 st from join—66 (78, 90) sts total; 33 (39, 45) sts each needle. Pm and join for working in rnds.

Next rnd: *K2, p1; rep from *.

Rep the last rnd until cuff measures 1" (2.5 cm) from set-up rnd or desired length.

Use Jeny's Surprisingly Stretchy Bind-Off (see Glossary) to BO all sts in rib patt.

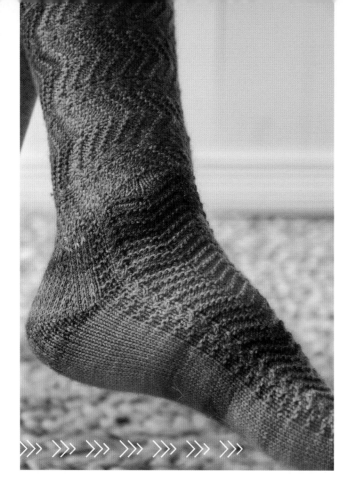

Instep and Heel Flap/ Gussets

Place rem 42 (50, 58) held sts onto two cir needles, 21 (25, 29) sts on each needle. The sts on Needle 1 form the instep; the sts on Needle 2 form the heel. Pm and join for working in rnds. Join MC to beg of sts on Needle 1 with RS facing.

Note: If you're using a self-striping yarn, you can use this opportunity to join the yarn at a point in the stripe sequence that looks good against the end of the leg.

Inc for your size as foll to achieve a ratio of about 3 sts for every 4 leg rows.

SIZE 7" (18 CM) ONLY

Inc rnd: On Needle 1, [M1L, k1] 3 times, [M1L, k2] 7 times, [M1L, k1] 3 times, M1L, k1; on Needle 2, M1L, k1, [M1L, k2] 9 times, [M1L, k1] 2 times—35 instep sts, 33 heel sts.

SIZE 8" (20.5 CM) ONLY

Inc rnd: On Needle 1, M1L, k1, [M1L, k2] 11 times, [M1L, k1] 2 times; on Needle 2, k1, [M1L, k2] 5 times, M1L, k3, [M1L, k2] 5 times, M1L, k1—39 instep sts, 37 heel sts.

SIZE 9" (23 CM) ONLY

Inc rnd: On Needle 1, k1, [M1L, k2] 6 times, M1L, k3, [M1L, k2] 6 times, M1L, k1; on Needle 2, k1, [M1L, k2] 3 times,

[M1L, k3] 5 times, [M1L, k2] 3 times, M1L, k1—43 instep sts, 41 heel sts.

ALL SIZES

Notes: On the next 32 rounds, the instep and heel stitches are worked simultaneously but in different patterns. In other words, work Rnd 1 of the instep pattern on Needle 1 followed by Rnd 1 of the heel pattern on Needle 2 to complete an entire round. Read all the way through the following sections before proceeding.

Work instep patt on 35 (39, 43) sts of Needle 1 as foll.

Rnd 1: On Needle 1, k2, *k1, RT, k2tog, k6 (9, 12), w&t (see Stitch Guide), p5 (7, 9), w&t, k3 (5, 7), w&t, p1 (3, 5), w&t, M1, k1, M1, k3 (4, 5) while working wraps tog with wrapped sts when you come to them (see Notes), ssk; rep from * once more, k1, RT, k2—1 rnd created at each side, and 5 short-rows in each of 2 triangular "peaks" to accommodate the zigzags of the chevron patt.

Rnd 2: Knit.

Rnd 3: K2, [LT, k1, k2tog, k3 (4, 5), M1, k1, M1, k3 (4, 5), ssk] 2 times, LT, k3.

Rnd 4: P2, [k3, p11 (13, 15)] 2 times, k3, p2.

Rnd 5: K2, [k1, RT, k2tog, k3 (4, 5), M1, k1, M1, k3 (4, 5), ssk] 2 times, k1, RT, k2.

Rnds 6–32: Rep Rnds 2–5 (do not rep Rnd 1) 6 more times, then work Rnds 2–4 once.

At the same time work 33 (37, 41) heel sts on Needle 2 as foll, slipping sts purlwise with yarn in back of work (pwise wyb).

Rnd 1: Knit.

Rnd 2: [K1, sl 1] 3 times, M1, [k1, sl 1] 5 (6, 7) times, M1, [k1, sl 1] 5 (6, 7) times, k1, M1 [sl 1, k1] 3 times—36 (40, 44) heel sts.

Odd-numbered Rnds 3–31: Knit.

Rnd 4: [K1, sl 1] 3 times, k1, [k1, sl 1] 5 (6, 7) times, k1, [k1, sl 1] 5 (6, 7) times, k2, [sl 1, k1] 3 times.

Rnd 6: [K1, sl 1] 3 times, M1, [sl 1, k1] 6 (7, 8) times, M1, [k1, sl 1] 6 (7, 8) times, M1, [sl 1, k1] 3 times—39 (43, 47) heel sts.

Rnd 8: K1, *sl 1, k1; rep from *.

Rnd 10: [K1, sl 1] 3 times, M1, [k1, sl 1] 6 (7, 8) times, k1, M1, [sl 1, k1] 7 (8, 9) times, M1, [sl 1, k1] 3 times—42 (46, 50) heel sts.

Rnd 12: [K1, sl 1] 3 times, k1, [k1, sl 1] 6 (7, 8) times, k2, [sl 1, k1] 7 (8, 9) times, k1, [sl 1, k1] 3 times.

Rnd 14: [K1, sl 1] 3 times, M1, [sl 1, k1] 7 (8, 9) times, sl 1, M1, [sl 1, k1] 7 (8, 9) times, sl 1, M1, [sl 1, k1] 3 times—45 (49, 53) heel sts.

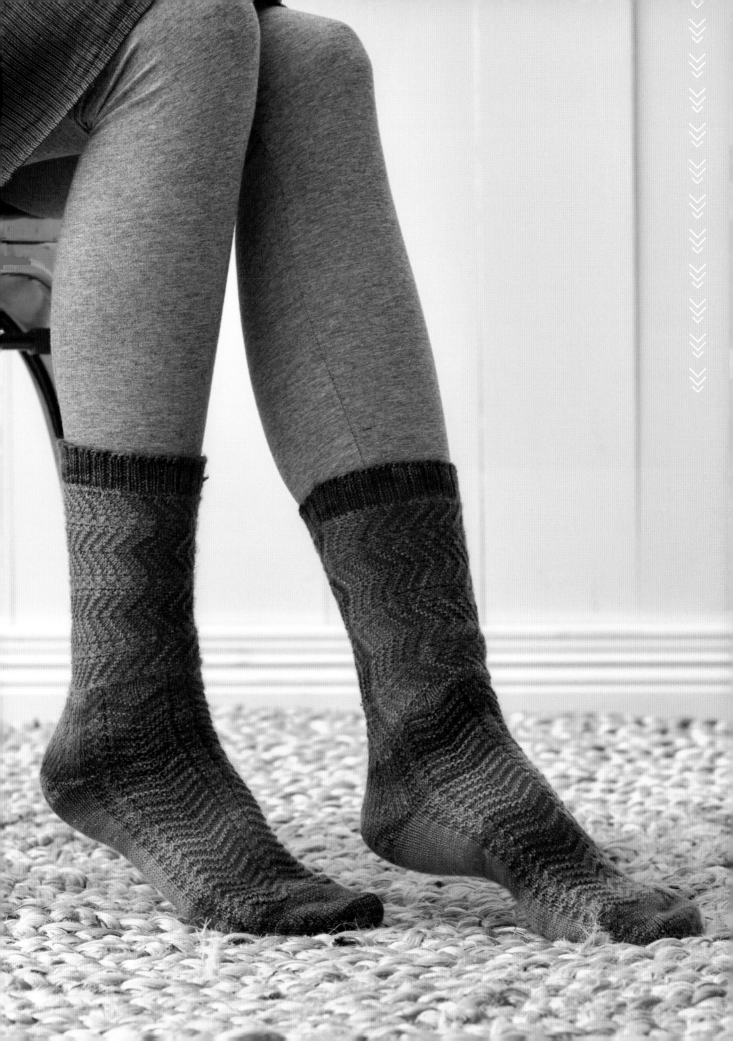

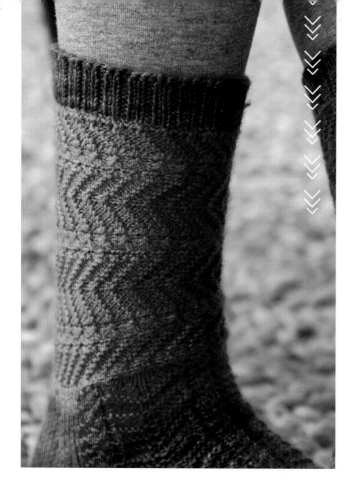

Rnd 16: K1, *sl 1, k1, rep from *.

Rnd 18: [K1, sl 1] 3 times, M1, [k1, sl 1] 8 (9, 10) times, M1, [k1, sl 1] 8 (9, 10) times, k1, M1, [sl 1, k1] 3 times—48 (52, 56) heel sts.

Rnd 20: [K1, sl 1] 3 times, k1, [k1, sl 1] 8 (9, 10) times, k1, [k1, sl 1] 8 (9, 10) times, k2, [sl 1, k1] 3 times.

Rnd 22: [K1, sl 1] 3 times, M1, [sl 1, k1] 9 (10, 11) times, M1, [k1, sl 1] 9 (10, 11) times, M1, [sl 1, k1] 3 times—51 (55, 59) heel sts

Rnd 24: K1, *sl 1, k1; rep from *.

Rnd 26: [K1, sl 1] 3 times, M1, [k1, sl 1] 9 (10, 11) times, k1, M1, [sl 1, k1] 10 (11, 12) times, M1, [sl 1, k1] 3 times—54 (58, 62) heel sts.

Rnd 28: [K1, sl 1] 3 times, k1, [k1, sl 1] 9 (10, 11) times, k2, [sl 1, k1] 10 (11, 12) times, k1, [sl 1, k1] 3 times.

Rnd 30: [K1, sl 1] 3 times, M1, [sl 1, k1] 10 (11, 12) times, sl 1, M1, [sl 1, k1] 10 (11, 12) times, sl 1, M1, [sl 1, k1] 3 times—57 (61, 65) heel sts.

Rnd 32: *K1, sl 1; rep from * to last st, k1.

After completing 32 rnds, there will be 92 (100, 108) sts total: 35 (39, 43) instep sts on Needle 1, and 57 (61, 65) heel sts on Needle 2; heel flap measures about 1¾" (4.5 cm).

Heel Turn

Note: The heel turn is worked in the slip-stitch heel pattern for durability and padded comfort.

With WS facing, join CC to start of heel sts on Needle 2. Do not cut MC.

Work 57 (61, 65) heel sts back and forth in rows as foll; rem 35 (39, 43) sts on Needle 1 will be worked later for instep.

Sl sts pwise with yarn in front (wyf) on WS rows; sl sts pwise with yarn in back (wyb) on RS rows.

Row 1: (WS) Sl 1, p29 (32, 35), p2tog, p1, turn work—1 heel st dec'd; 24 (25, 26) unworked sts at end of row.

Row 2: (RS) Sl 1, [k1, sl 1] 1 (2, 3) times, k2, ssk (1 st each side of gap), k1, turn work—1 heel st dec'd; 24 (25, 26) unworked sts each end of needle.

Row 3: Sl 1, purl to 1 st before gap, p2tog (1 st each side of gap), p1, turn work—1 heel st dec'd.

Row 4: Sl 1, k2, *sl 1, k1; rep from * to 1 st before gap, ssk, k1, turn work—1 heel st dec'd.

Row 5: Rep Row 3—1 heel st dec'd.

Row 6: Sl 1, *k1, sl 1; rep from * to 3 sts before gap, k2, ssk, k1, turn work—1 heel st dec'd; 51 (55, 59) heel sts rem; 11 (13, 15) worked sts in center; 20 (21, 22) unworked sts each end of needle.

Rep Rows 3–6 four (four, five) more times, then work Rows 3 and 4 one (one, zero) time, ending with a RS row—33 (37, 39) sts rem; 29 (31, 35) worked sts in center, and 2 (3, 2) unworked sts each end of needle.

Cont for your size as foll.

SIZE 7" (18 CM) ONLY

Work Rows 5 and 6 once more, but do not turn work at end of RS Row 6—31 heel sts rem; all sts have been worked.

SIZE 8" (20.5 CM) ONLY

Next row: (WS) Sl 1, purl to 1 st before gap, p2tog, p2, turn work—36 sts, no unworked sts at end of needle.

Next row: (RS) Sl 1, k2, *sl 1, k1; rep from * to 2 sts before gap, k1, ssk, k2, do not turn work—35 heel sts rem; all sts have been worked.

SIZE 9" (23 CM) ONLY

Work Rows 3 and 4 once more, but do not turn work at end of RS Row 4—37 heel sts rem; all sts have been worked.

Foot

Cut CC. Resume working in rnds using MC still attached at end of Needle 2.

Next rnd: On Needle 1, work 35 (39, 43) instep sts in Rnd 5 of established instep patt; on Needle 2, k1 (k1, k1f&b), knit to last st, k1 (k1, k1f&b)—66 (74, 82) sts total; 35 (39, 43) instep sts; 31 (35, 39) sole sts.

Cont established instep patt on Needle 1 and work sole sts on Needle 2 in St st until foot measures 7 (8¼, 9¼)" (18 [21, 23.5] cm) from center back heel or 2 (2, 2¼)" (5 [5, 5.5] cm) less than desired total length, ending with Rnd 4 of instep patt (the garter ridge rnd) on Needle 1, then knit to end of Needle 2.

Work short-rows triangles to fill in the "valleys" of the chevron patt and even out the end of the foot as foll.

Next rnd: Working wraps tog with wrapped sts when you come to them, k5, w&t, p4, w&t, k6, w&t, p6, w&t, k18 (20, 22), w&t, p5, w&t, k7, w&t, p9, w&t, k21 (23, 25), w&t, p5, w&t, k6, w&t, p8, w&t, k8, sl last st of Needle 1 onto beg of Needle 2, knit slipped st, knit to end of Needle 2, sl first st of Needle 1 onto end of Needle 2, knit slipped st—still 66 (74, 82) sts; 33 (37, 41) sts on each needle.

Cut MC.

Toe

Join CC.

Rnd 1: Knit.

Rnd 2: On Needle 1, *k1, ssk, knit to last 3 sts, k2tog, k1; on Needle 2, rep from *—4 sts dec'd.

Rep these 2 rnds 7 (8, 9) more times—34 (38, 42) sts rem; 17 (19, 21) sts each needle.

Rep Rnd 2 every rnd 5 (6, 7) more times—14 sts rem; 7 sts each needle.

Carefully lift the second-from-the-end stitch over the end stitch and off the needle on both ends of both needles—10 sts rem; 5 sts each needle.

Cut yarn, leaving a 20" (51 cm) tail.

Finishing

Thread tail on a tapestry needle and use the Kitchener st to join the two groups of sts tog.

Weave in loose ends.

Block as desired.

ANNE CAMPBELL has been knitting and designing for more than fifty years. A dozen or so years ago, she knitted her first pair of socks and has never looked back. Her daughter Meg founded Twisted Fiber Art in 2004, and Anne has been knitting with the company's lovely self-striping and gradient yarns ever since.

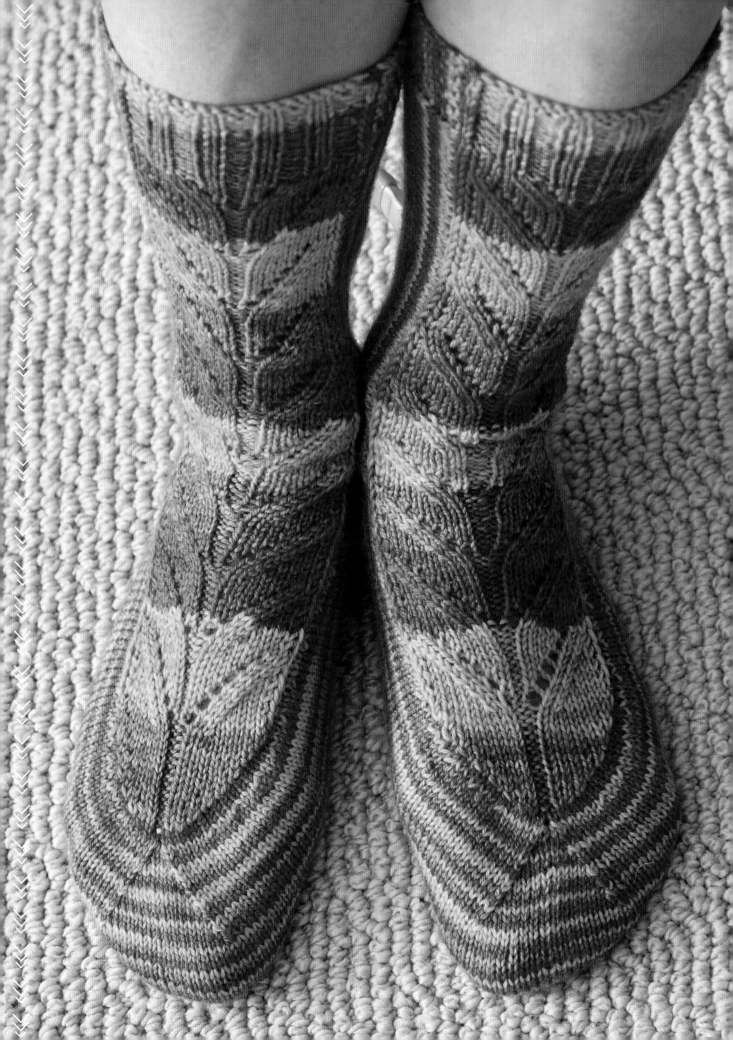

Boomerang

LOUISE ROBERT

The back leg, heel, and sole of these socks are worked in one piece that's shaped like a boomerang, then the top of the foot and front of the leg are worked in a lace pattern while the sides of the boomerang are joined into a tube. A traditional boomerang is a historic hunting weapon that spins on its axis as it flies along a curved path, eventually returning to the thrower. The type of boomerang that I'm proposing here is the perfect tool to master a new way to knit a sock.

FINISHED SIZE

About 9½" (24 cm) foot circumference for all sizes, 8 (9, 9¾)" (20.5 [23, 25] cm) foot length from tip of toe to center of heel section, and 9¼" (23.5 cm) leg length from top of cuff to center of heel section for all sizes.

Socks shown measures 9" (23 cm) foot length.

YARN

Fingering weight (#1 Super Fine).

Shown here: Biscotte & Cie Felix Self-Striping (80% superwash merino, 20% nylon; 365 yd [334 m]/100 g): Boomerang (green/rose/lavender mix), 1 (1, 2) skeins.

NEEDLES

Size U.S. 1.5 (2.5 mm): 40" (100 cm) circular (cir).

Adjust needle size if necessary to obtain the correct gauge.

NOTIONS

Markers (m); tapestry needle.

GAUGE:

15 sts and 22 rows = 2" (5 cm) in St st, relaxed after blocking.

20 sts from patt rep section of Boomerang chart measure 2¾" (7 cm) wide, relaxed after blocking.

NOTES

- The construction of these socks does not lend itself to adjusting the foot circumference easily. If you need a smaller circumference, consider working a shorter foot and blocking the sock feet longer and narrower.

- To adjust foot length, cast on more or fewer sole stitches, taking care to make the same change to both sole sections. Every 4 stitches total (2 sts in each sole section) added to or removed from the starting cast-on number will lengthen or shorten the foot by about ¼" (6 mm).

STITCH GUIDE

Seed Stitch for Cuff (even number of sts)

All Rows: (RS and WS) [K1, p1] 5 times, work according to instructions to last 10 sts, [p1, k1] 5 times.

Rep this row for patt.

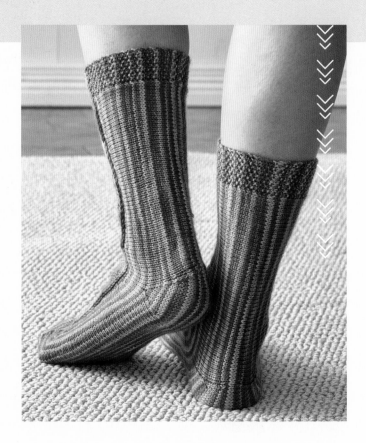

Back Leg, Heel, and Sole

Notes: Each V-shaped row of this piece begins at the top of the cuff and is worked down the leg, around the heel, down the sole to the toe, across the end of the toe, up the sole to the heel, around the heel again, up the leg, and up to the top of the cuff. As the piece grows outward from the center cast-on, each row completed adds 2 rows of knitting, 1 row on each side of the cast-on centerline.

Using Judy's Magic Cast-On (see Glossary), CO 246 (258, 270) sts. Do not join. Work back and forth in rows as foll.

Row 1: (RS) Work 10 seed sts for cuff (see Stitch Guide), k48 for leg, place marker (pm), k24 for heel, pm, k40 (46, 52) for sole, pm, [k1f&b (see Glossary)] 2 times for toe, pm, k40 (46, 52) for sole, pm, k24 for heel, pm, k48 for leg, work 10 seed sts for cuff—248 (260, 272) sts total; 58 leg sts at each end of row; 24 sts each marked heel section; 40 (46, 52) sole sts at each side between heel and toe; 4 center sts in marked toe section.

Slip markers (sl m) as you come to them.

Even-numbered Rows 2–10: (WS) Work 10 sts in seed st, purl to last 10 sts, work 10 sts in seed st.

Row 3: Work 10 seed sts, knit to m, sl m, ssk, knit to 2 sts before next m, k2tog, sl m, knit to next m, sl m, [k1f&b] 4 times, sl m, knit to next m, sl m, ssk, knit to 2 sts before next m, k2tog, sl m, knit to last 10 sts, work 10 seed sts— no change to total st count; 22 sts between each pair of heel markers; 8 sts in center between toe markers.

Row 5: Work 10 seed sts, knit to m, sl m, ssk, knit to 2 sts before next m, k2tog, sl m, knit to next m, sl m, k1f&b, k6, k1f&b, sl m, knit to next m, sl m, ssk, knit to 2 sts before next m, k2tog, sl m, knit to last 10 sts, work 10 seed sts—246 (258, 270) sts rem; no change to leg and sole sts; 20 sts each heel section; 10 toe sts.

Row 7: Work 10 seed sts, knit to m, sl m, ssk, knit to 2 sts before next m, k2tog, sl m, knit to next m, sl m, [k1f&b, k2] 3 times, k1f&b, sl m, knit to next m, sl m, ssk, knit to 2 sts before next m, k2tog, sl m, knit to last 10 sts, work 10 seed sts—no change to total st count; 18 sts each heel section; 14 toe sts.

Row 9: Work 10 seed sts, knit to m, sl m, ssk, knit to 2 sts before next m, k2tog, sl m, knit to next m, sl m, k1f&b, k12, k1f&b, sl m, knit to next m, sl m, ssk, knit to 2 sts before next m, k2tog, sl m, knit to last 10 sts, work 10 seed sts—244 (256, 268) sts rem; no change to leg and sole sts; 16 sts each heel section; 16 toe sts.

Row 11: Work 10 seed sts, knit to m, sl m, ssk, knit to 2 sts before next m, k2tog, sl m, knit to next m, sl m,

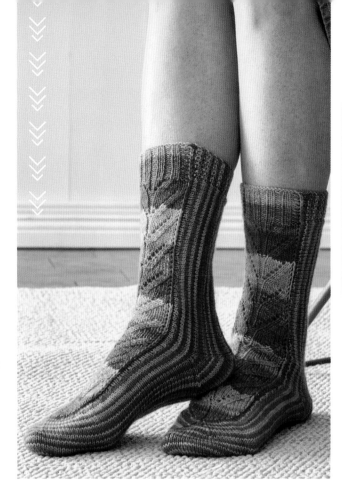

k1f&b, k14, k1f&b, sl m, knit to next m, sl m, ssk, knit to 2 sts before next m, k2tog, sl m, knit to last 10 sts, work 10 seed sts—242 (254, 266) sts rem; no change to leg and sole sts; 14 sts each heel section; 18 toe sts.

Row 12: (WS) Work 10 seed sts, purl to last 10 sts, work 10 seed sts.

Sides of Leg and Foot and Top of Toe

The toe has now reached its maximum number of sts. Cont working heel decs while working toe sts even as foll.

Odd-numbered Rows 13–19: (RS) Work 10 seed sts, knit to m, sl m, ssk, knit to 2 sts before next m, k2tog, sl m, knit to next m, sl m, k18 toe sts, sl m, knit to next m, sl m, ssk, knit to 2 sts before next m, k2tog, sl m, knit to last 10 sts, work 10 seed sts—226 (238, 250) sts rem after Row 19; no change to leg and sole sts; 6 sts each heel section; 18 toe sts.

Even-numbered Rows 14–20: (WS) Work 10 seed sts, purl to last 10 sts, work 10 seed sts.

Beg dec for top of toe while cont heel decs as foll.

Row 21: (RS) Work 10 seed sts, knit to m, sl m, ssk, knit to 2 sts before next m, k2tog, sl m, knit to next m, sl m, ssk, knit to last 2 toe sts, k2tog, sl m, knit to next m, sl m, ssk,

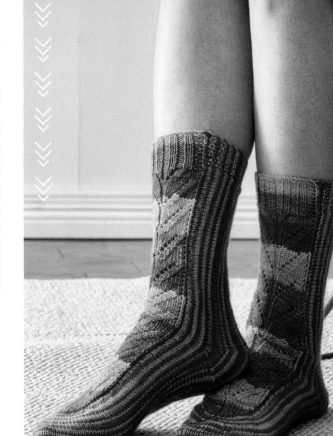

knit to 2 sts before next m, k2tog, sl m, knit to last 10 sts, work 10 seed sts—6 sts dec'd; 2 sts dec'd from each heel section, and 2 sts dec'd from toe.

Row 22: (WS) Work 10 seed sts, purl to last 10 sts, work 10 seed sts.

Row 23: Rep Row 21—214 (226, 238) sts; no change to leg and sole sts; 2 sts each heel section; 14 toe sts.

Row 24: Rep Row 22.

Heel shaping is now complete. Cont to dec for toe as foll.

Odd-numbered Rows 25–33: Work 10 seed sts, knit to next m, sl m, k2 heel sts, sl m, knit to next m, sl m, ssk, knit to last 2 toe sts, k2tog, sl m, knit to next m, sl m, k2 heel sts, sl m, knit to last 10 sts, work 10 seed sts—2 sts dec'd for toe in each row; 204 (216, 228) sts rem after Row 33; no change to leg, sole, and heel sts; 4 toe sts.

Even-numbered Rows 26–32: (WS) Work 10 seed sts, purl to last 10 sts, work 10 seed sts.

Row 34: Work 10 seed sts, p48, *remove heel m, p2, remove heel m,* p40 (46, 52), sl toe m, p4, sl toe m, p40 (46, 52), rep from * to *, p48, work 10 seed sts—100 (106, 112) sts on each side of 4 marked toe sts.

Dec sts in preparation for working the lace panel as foll.

Row 35: (RS) Work 10 seed sts, [k2, k2tog] 21 (23, 24) times, k6 (4, 6), sl toe m, ssk, k2tog, sl toe m, k6 (4, 6), [k2tog, k2] 21 (23, 24) times, work 10 seed sts—160 (168, 178) sts rem; 79 (83, 88) sts on each side of 2 marked toe sts.

Row 36: (WS) Work 10 seed sts, purl to last 10 sts, work 10 seed sts—74 rows between needle halves; 36 rows and 1 CO row on each side of centerline; piece measures 6¾" (17 cm) between needle halves.

Top of Foot and Front Leg

The lace panel that forms the top of the foot and front leg is worked back and forth in rows, dec 1 st in each row. Rearrange sts as necessary to make this part as easy to work as possible.

Work Boomerang chart as foll.

Row 1: (RS) K77 (81, 86) to 2 sts before m, work 7 sts from Row 1 of chart as k2, remove m, p2, remove m, k1, ssk, k1, turn work—1 st dec'd.

Row 2: (WS) Work 8 sts from Row 2 of chart as sl 1 st purlwise with yarn in front (pwise wyf) p2, k2, p1, p2tog, p1—1 st dec'd.

Cont in this manner, work Rows 3–14 of chart over progressively more center sts while dec 1 st in each row—146 (154, 164) sts rem; 63 (67, 72) sts on each side of 20 worked center sts.

Cont chart patt on 20 center sts, work Rows 15–26 a total of 8 (9, 10) times, then work 10 (6, 4) rows from Row 15 to Row 24 (20, 18) once more—40 sts rem; 10 cuff sts on each side of 20 worked center sts.

Change to working center sts in rib patt while cont to dec as foll.

Row 1: (RS) Sl 1 st pwise wyb, [p2, k2] 4 times, p2, k2tog through back loops (tbl), turn work—1 st dec'd.

Row 2: (WS) Sl 1 st pwise wyf, [k2, p2] 4 times, k2, p2tog, turn work—1 st dec'd.

Rep the last 2 rows 8 times, then work RS Row 1 once more—21 sts rem; 1 cuff st and 20 worked sts. With WS facing, BO all sts loosely in rib patt, working last 2 sts as p2tog as you BO to dec rem cuff st.

Finishing

Weave in loose ends. Block lightly.

BOOMERANG

knit on RS; purl on WS

. purl on RS; knit on WS

/ k2tog on RS; p2tog on WS

\ ssk

k2tog through back loops

V sl 1 st pwise wyib on RS; sl 1 st pwise wyif on WS

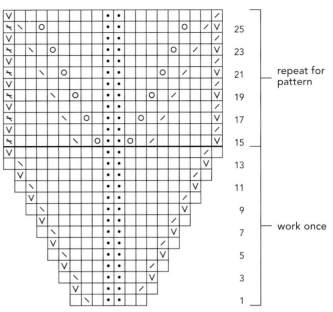

repeat for pattern

work once

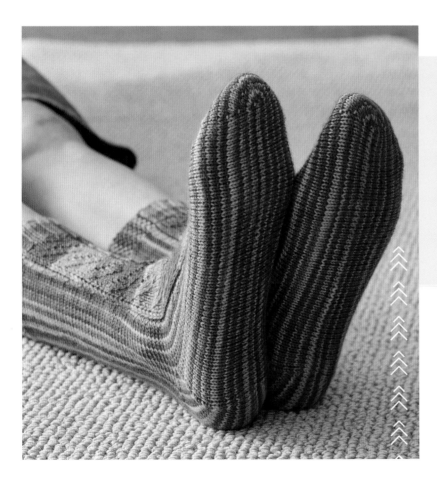

LOUISE ROBERT lives in metropolitan Montreal, Quebec, Canada, where she earned a BA in art history. She lives with her husband, three kids, and two Peterbald cats. She's the owner of Biscotte & Cie, a yarn shop where she hand-dyes yarn in all kinds of self-striping, semisolid, and variegated colorways. Her patterns are available on her website BiscotteYarns.com; patterns for her Carousel and Stitch Surfer socks are available at Knitty.com

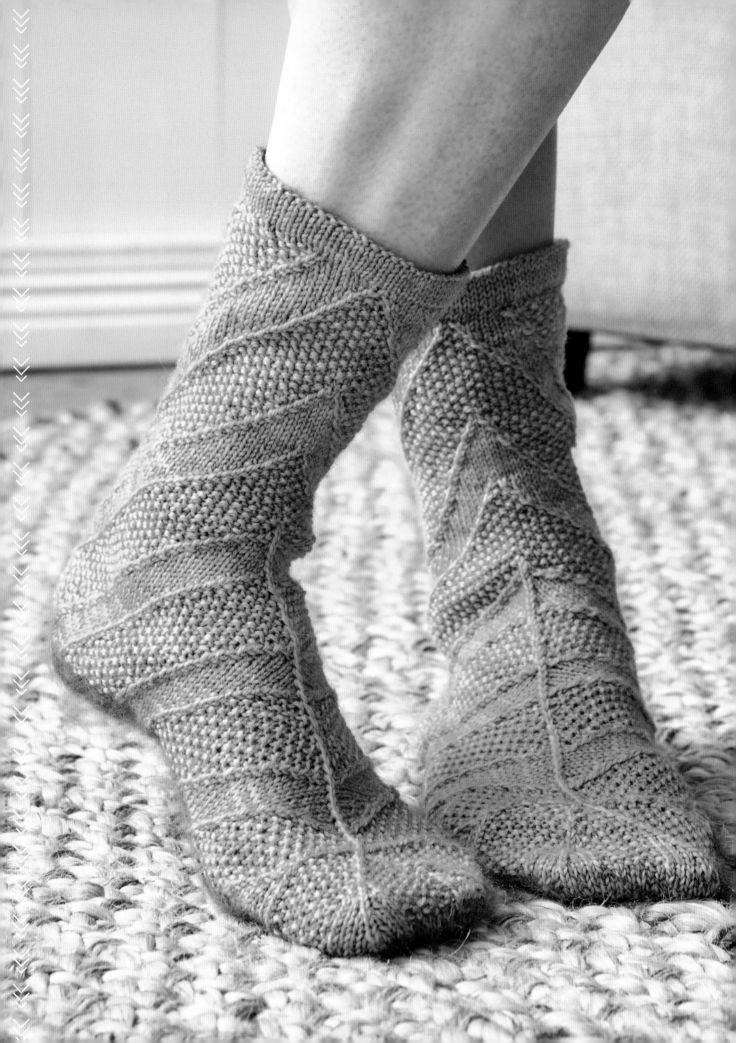

Seed Beds

BETTY SALPEKAR

These socks are knitted from the ground up—literally. Stitches are cast on along the centerline of the sole and worked outward in rounds for the bottom of the foot, then the rest of the foot and leg are worked upward from the sole. There are no stitches to pick up, no gussets, no heel flap, and no grafting or Kitchener stitch. This construction allows the sole to be isolated for the addition of a reinforcement yarn, and makes it easy to maintain the continuity of the stitch patterns through the top of the toe, the heel, and the leg. The angled beds of seed stitches, neatly outlined with twisted stitches, meet at the center front and back. Maybe I'll lay out my next garden this way!

FINISHED SIZE

About 7 (7½, 8½)" (18 [19, 21.5] cm) foot circumference, 9¼ (10¼, 11)" (23.5 [26, 28] cm) foot length from back of heel to tip of toe, and 7½ (8½, 9½)" (19 [21.5, 24] cm) leg length from base of heel to top of hemmed cuff.

Socks shown measure 7½" (19 cm) foot circumference.

YARN

Fingering weight (#1 Super Fine) and Laceweight (#0 Lace).

Shown here: SweetGeorgia Yarns Tough Love Sock (80% superwash merino wool, 20% nylon; 425 yd [388 m]/4oz [115 g]): Glacier (MC, turquoise), 1 (1, 2) skein(s).

Schulana Kid-Seta (70% kid mohair, 30% silk; 230 yd [210 m]/25 g): #16 Dark Teal (CC), 1 skein for all sizes.

NEEDLES

Size U.S. 1½ (2.5 mm): 2 circular (cir); two sets of 4 or 5 double-pointed (dpn), or 1 long cir (see page 6).

Adjust needle size if necessary to obtain the correct gauge.

NOTIONS

Markers (m) in 3 different colors, with 2 of the same color; cable needle (cn); 1 dpn in size U.S. 1 (2.5 mm) or smaller; tapestry needle.

GAUGE

15 sts and 20 rnds = 2" (5 cm) in St st worked in rnds with MC and CC held tog for sole, relaxed after blocking.

15½ sts and 24 rnds = 2" (5 cm) average gauge in patt from Charts A and B worked in rnds with MC only, relaxed after blocking.

NOTES

- When working the sole, use different-colored markers to distinguish Markers 1, 2, and 3.
- If you prefer to work the sole using double-pointed needles, cast on using a single long circular needle (or one point of each needle if using two circulars), work the first two rounds, then knit the stitches onto the double-pointed needles. At the outer edges of the sole, you may need more than a single set of double-pointed needles to hold all the stitches—for example, three needles to hold the stitches for each side and a seventh needle for working.

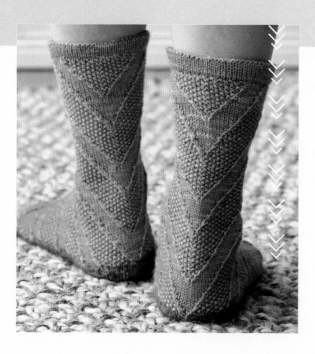

STITCH GUIDE

CDD (centered double decrease): Sl 2 sts as if to k2tog, k1, pass 2 slipped sts over—2 sts dec'd.

M1B (make 1 using the backward-loop method): Make loop around finger from back to front, twist it to the left, and place the loop on the right needle—1 st inc'd.

M1F (make 1 by using the forward-loop method): Make loop around finger from front to back, twist it to the right, and place the loop on the right needle—1 st inc'd.

M1L (make 1, left-leaning): Insert left needle under strand between stitches from front to back, then knit into back leg of lifted strand—1 st inc'd.

LC: Sl 1 st onto cn and hold in front of work, k1tbl, then k1tlb from cn.

RC: Sl 1 st onto cn and hold in back of work, k1tbl, then k1tlb from cn.

LPC: Sl 1 st onto cn and hold in front of work, p1, then k1tbl from cn.

RPC: Sl 1 st onto cn and hold in back of work, k1tbl, then p1 from cn.

Sole

Cut a separate strand of MC about 18" (45.5 cm) long for joining the top of the instep later and set aside.

With MC and CC held tog, use Judy's Magic Cast-On (see Glossary) to CO 100 (108, 116) sts—50 (54, 58) sts each on two needles; CO counts as 1 row on each side of sole centerline.

Set-up rnd: On Needle 1, work Rnd 1 of Sole Heel chart (see page 123) as k1, M1F (see Stitch Guide), k1, place marker (pm) in Color 1 for end of heel, k45 (49, 53), pm in Color 2 for beg of toe, work first 3 sts from Rnd 1 of Sole Toe chart as k3.

On Needle 2, cont Rnd 1 of Sole Toe chart as k1, M1L (see Glossary), k1, pm in Color 2 for end of toe, k45 (49, 53), pm in Color 3 for end-of-rnd, leaving last 3 sts unworked at end of Needle 2—102 (110, 118) sts total; 51 (55, 59) sts each needle; 6 toe sts between Color 2 markers; 6 heel sts between markers in Colors 1 and 3.

Note: Rounds begin and end at Color 3 marker, at start of sole heel stitches.

Next rnd: On Needle 2, work Rnd 2 of Sole Heel chart over last 3 sts on needle, increasing them to 4 sts as shown.

On Needle 1, cont Rnd 2 of Sole Heel chart over 3 sts, increasing them to 4 sts; slip marker (sl m) in Color 1, k45 (49, 53), sl m in Color 2; work Rnd 2 of Sole Toe chart over 3 sts, increasing them to 4 sts.

On Needle 2, cont Rnd 2 of Sole Toe chart over 3 sts, increasing them to 4 sts, sl m in Color 2, k45 (49, 53) to end at m in Color 3—106 (114, 122) sts total; 53 (57, 61) sts each needle; 8 toe sts between Color 2 markers; 8 heel sts between Color 1 and 3 markers.

Working 45 (49, 53) sts between toe and heel at each side in St st, cont as established until Rnd 9 of charts has been completed—138 (146, 154) sts total; 69 (73, 77) sts each needle; 24 toe sts between Color 2 markers; 24 heel sts between Color 1 and 3 markers.

Rnd 10: On Needle 2, work Rnd 10 of Sole Heel chart over last 12 sts, increasing them to 15 sts.

On Needle 1, cont Rnd 10 of Sole Heel chart over 12 sts, inc'd them to 15 sts; sl m in Color 1, k45 (49, 53), sl m in Color 2.

Work 3 short-rows as foll.

Short-Row 10a: (RS) On Needle 1, work Short-Row 10a of chart over 12 sts, increasing them to 15 sts. On Needle 2, cont Short-Row 10a of chart over 12 sts, increasing them to 15 sts, sl m in Color 2, k8, wrap next st, turn work.

Short-Row 10b: (WS) On Needle 2, p8 to m in Color 2, sl m, p15. On Needle 1, p15 to m in Color 2, sl m, p8, wrap next st, turn work.

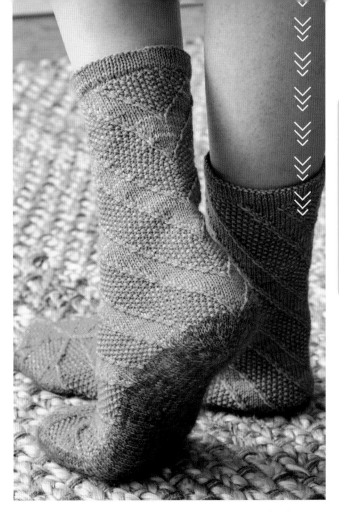

Short-Row 10c: (RS) On Needle 1, k8 to m in Color 2, sl m, work Short-Row 10c of chart over 15 sts, inc them to 17 sts. On Needle 2, cont Short-Row 10c of chart over 15 sts, inc them to 17 sts, sl m in Color 2, k45 (49, 53) working wrap tog with wrapped st to end at m in Color 3—154 (162, 170) sts total; 77 (81, 85) sts each needle; 34 toe sts between Color 2 markers; 30 heel sts between Color 1 and 3 markers.

Working the rem wrap tog with wrapped st when you come to it, cont as established until Rnd 13 (15, 16) of charts has been completed—164 (180, 198) sts total; 82 (90, 99) sts each needle; 40 (44, 50) toe sts between Color 2 markers; 34 (38, 42) heel sts between Color 1 and 3 markers.

Knit 1 (1, 2) rnd(s), removing Color 1 and 2 markers in last rnd, leaving Color 3 marker in place. Remove Color 3 marker, k17 (19, 21) to center of heel, replace Color 3 marker for new start of rnd at center back.

Dec rnd: K9 (8, 10), k2tog, [k14 (16, 14), k2tog] 9 (9, 11) times, k9 (8, 10)—154 (170, 186) sts rem—16 (18, 20) rows on each side of center line at the heel, counting the CO; sole measures about 3¼ (3½, 4)" (8.5 [9, 10] cm) wide at the heel and 9¼ (10¼, 11)" (23.5 [26, 28] cm) long from back of heel to tip of toe.

Cut CC.

	knit on RS rows and all rnds; purl on WS rows
·	purl
ℓ	k1tbl
/	k2tog
\	ssk
∧	CDD (see Stitch Guide)
↴	M1B (see Stitch Guide)
↳	M1F (see Stitch Guide)
L	M1L (see Stitch Guide)
▨	no stitch
☐	pattern repeat
✕	LC (see Stitch Guide)
✕	RC (see Stitch Guide)
✕	LPC (see Stitch Guide)
✕	RPC (see Stitch Guide)

CHART A

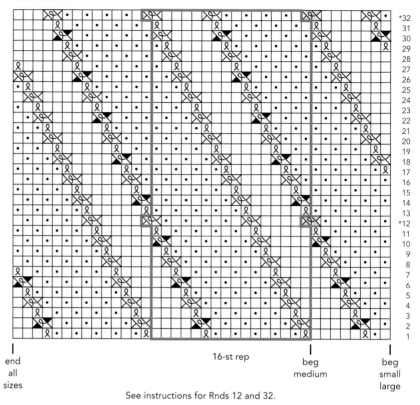

See instructions for Rnds 12 and 32.

CHART B

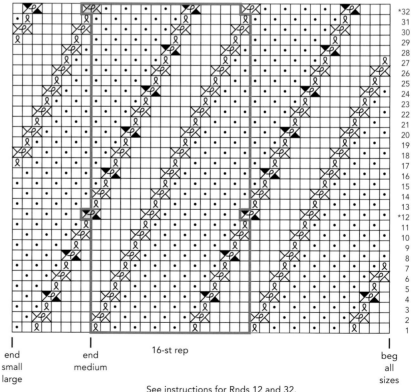

See instructions for Rnds 12 and 32.

SOLE HEEL

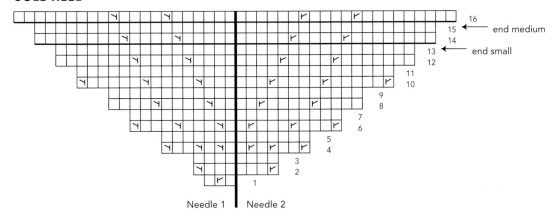

Needle 1 | Needle 2

16
15 ← end medium
14
13 ← end small
12
11
10
9
8
7
6
5
4
3
2
1

SOLE TOE

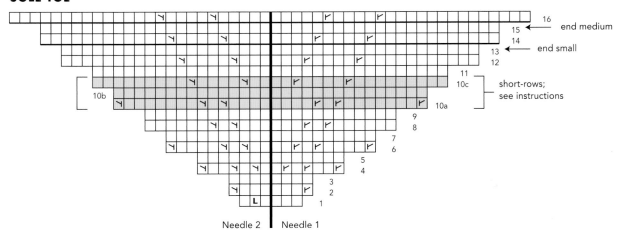

16
15 ← end medium
14
13 ← end small
12
11
10c
10b
10a
9
8
7
6
5
4
3
2
1

short-rows;
see instructions

Needle 2 | Needle 1

TOE

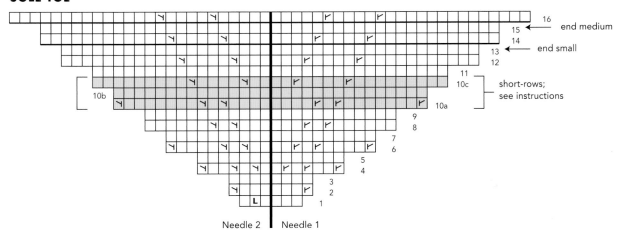

18
17
16
15
14
13
12
11
10
9
8
7
6
5
4
3
2
1

46 sts decreased to 10 sts

123

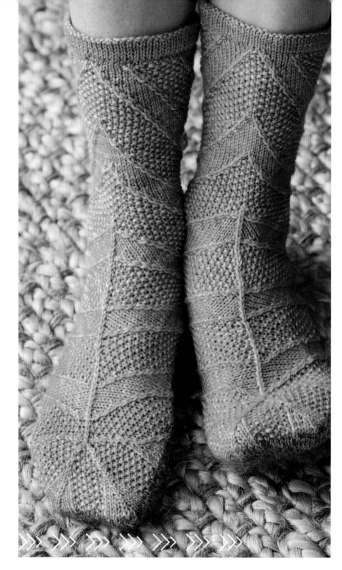

Sides of Foot and Top of Toe

Cont with MC only as foll.

Rnd 1: Beg where indicated for your size, work Rnd 1 of Chart A over 54 (62, 70) sts, working the red outlined patt rep 2 (3, 3) times; pm for start of toe, work Rnd 1 of Toe chart over 46 sts, pm for end of toe; work Rnd 1 of Chart B over 54 (62, 70) sts, working the red outlined patt rep 2 (3, 3) times, and ending where indicated for your size.

Notes: For sizes 7" (18 cm; small) and 8½" (21.5 cm; large), the beginning and ending points of the charts do not cut through the middle of a 2-stitch cable; for these sizes, work each chart as shown, working the gold-shaded cable symbols normally.

For size 7½" (19 cm; medium), in Chart A begin the pattern in Rnds 12 and 32 by working k1tbl in the place of the gold-shaded cable, then work as shown to the end; in Chart B work Rnds 12 and 32 as shown to the last stitch, then end the pattern by substituting k1tbl for the gold-shaded cable.

Cont as established, work Rnds 2–18 of charts—118 (134, 150) sts rem; no change to Chart A and B stitch counts; 10 toe sts rem.

Cont for your size as foll.

SIZES 7½ (8½)" (19 [21.5] CM) ONLY

Rnd 19: Work Rnd 19 of Chart A to m, sl m, [k2, p1] 3 times, k1, sl m, work Rnd 19 of Chart B to end.

SIZE 8½" (21.5 CM) ONLY

Rnd 20: Work Rnd 20 of Chart A to m, sl m, k1, [p1, k2] 3 times, sl m, work Rnd 20 of Chart B to end.

ALL SIZES

Rnd 19 (20, 21): Work Rnd 19 (20, 21) of Chart A to m, sl m, ssk, [CDD (see Stitch Guide)] 2 times, k2tog, sl m, work Rnd 19 (20, 21) of Chart B to end—112 (128, 144) sts rem; 54 (62, 70) sts at each side and 4 toe sts.

Join Top of Instep

Work Rnd 20 (21, 22) of Chart A over 41 (47, 53) sts, then drop working yarn. Sl the last 13 (15, 17) sts of Chart A purlwise (pwise) onto right needle, remove toe m, and sl 1 toe st onto right needle—41 (47, 53) worked sts and 14 (16, 18) slipped sts on right needle. Removing the second toe m, place the rem 3 toe sts and first 13 (15, 17) of Chart B onto the single smaller dpn, which will temporarily be used as a left needle—16 (18, 20) sts on single dpn; 41 (47, 53) Chart B sts rem on main needle.

Join separate 18" (45.5 cm) strand with RS facing to start of sts on dpn left needle. Leaving a 4" (10 cm) tail, use right needle tip to work k2tog over first 2 toe sts on dpn left needle to join the center 2 of the 4 toe sts, then return the k2tog st to dpn left needle—15 (17, 19) sts on dpn left needle: 1 center toe st, 1 regular toe st, and 13 (15, 17) sts from Chart B.

Make a "zip-line" join up the center of the foot using the separate strand of yarn as foll.

*Sl 1 st pwise from right needle to dpn left needle, CDD (slipped st, center toe st, and next st), return CDD st to dpn left needle—1 st joined on each side of center "zip-line" st. Rep from * 12 (14, 16) more times—2 sts rem on dpn left needle; 1 zip-line st and 1 st from Chart B; 1 slipped st from Chart A rem on right needle. Sl 1 st pwise from right needle to dpn left needle, CDD, and leave CDD st on right needle—no sts rem on dpn.

Resume using the working strand of MC attached to the end of the Chart A sts and the left tip of the main needle, and work Rnd 20 (21, 22) of Chart B as established to end of rnd—83 (95, 107) sts rem; 41 (47, 53) sts for each chart;

1 zip-line st in center of instep; sides of foot measure about 1¾ (1¾, 2)" (4.5 [4.5, 5] cm) from last sole rnd to instep join.

Instep Shaping and Ankle

Rearrange sts on two cir needles, if necessary, so the 41 (47, 53) sts of Chart A are on Needle 1, and the zip-line st and 41 (47, 53) sts of Chart B are on Needle 2.

Note: During the following shaping, if there are not enough stitches to work a complete 2-stitch cable next to the zip-line stitch, work the remaining stitch of the partial cable as k1 through back loop (tbl).

Rnd 21 (22, 23) to Rnd 25 (27, 29): Work in patt as established to 1 st before zip-line st, CDD, work in patt to end—2 sts dec'd in each rnd; 73 (83, 93) sts rem after Rnd 25 (27, 29), 36 (41, 46) sts each side of zip-line st.

Rnd 26 (28, 30): Work even in patts as established, working zip-line st as k1.

Rnd 27 (29, 31): Work in patt as established to 1 st before zip-line st, CDD, work in patt to end—2 sts dec'd.

Rep the last 2 rnds 7 (8, 9) more times—57 (65, 73) sts rem; 28 (32, 36) sts each side of zip-line st.

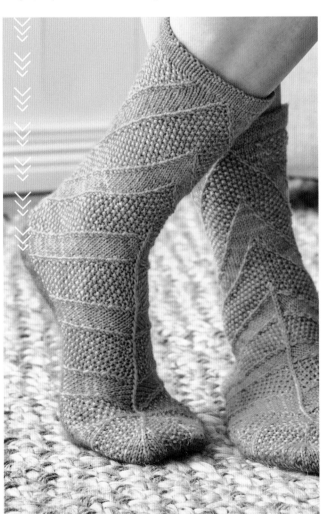

Next rnd: Work in patt to zip-line st, work k2tog or p2tog (zip-line st tog with st after it) as necessary to maintain patt, work in patt to end—56 (64, 72) sts rem; 28 (32, 36) sts each needle.

Leg

Notes: The two charts now meet at center front. If there are not enough stitches to work a complete 2-stitch cable on each side of the meeting point, work the remaining stitch of each partial cable as k1tbl; do not cross any stitches at center front.

Work even in patts as established until piece measures 6 (6½, 7)" (15 [16.5, 18] cm) from last sole rnd.

Note: For a wider calf, change to needles one size larger at this point.

Cont in patt for 1 (1½, 2)" (2.5 [3.8, 5] cm) more, or ½" (1.3 cm) less than desired leg length—piece measures 7 (8, 9)" (18 [20.5, 23] cm) from last sole rnd.

Cuff

Knit 7 rnds, then purl 1 rnd for hem fold line—piece measures 7½ (8½, 9½)" (19 [21.5, 24] cm) from last sole rnd.

Dec rnd: K3, [k2tog, k6] 6 (7, 8) times, k2tog, k3—49 (56, 63) sts rem.

Knit 5 rnds for hem facing.

Using a flexible method (see Glossary), BO all sts.

Cut yarn, leaving a 24" (61 cm) tail. Thread tail on a tapestry needle, fold facing to WS along fold line, and sew invisibly in place.

Finishing

Weave in loose ends, using the tails from the separate length of yarn to close up any holes at the start and end of the instep join.

Block lightly.

BETTY SALPEKAR lives in Atlanta, Georgia, where she likes to explore new ways to knit things that can be worn in a hot climate (which results mostly in lightweight vests and lace shawls). Her explorations of solefull sock architecture have resulted in the book *Solefull Socks*, the website Solefullsocks.com, and patterns in *Knitty.com* and *Interweave Knits* magazine.

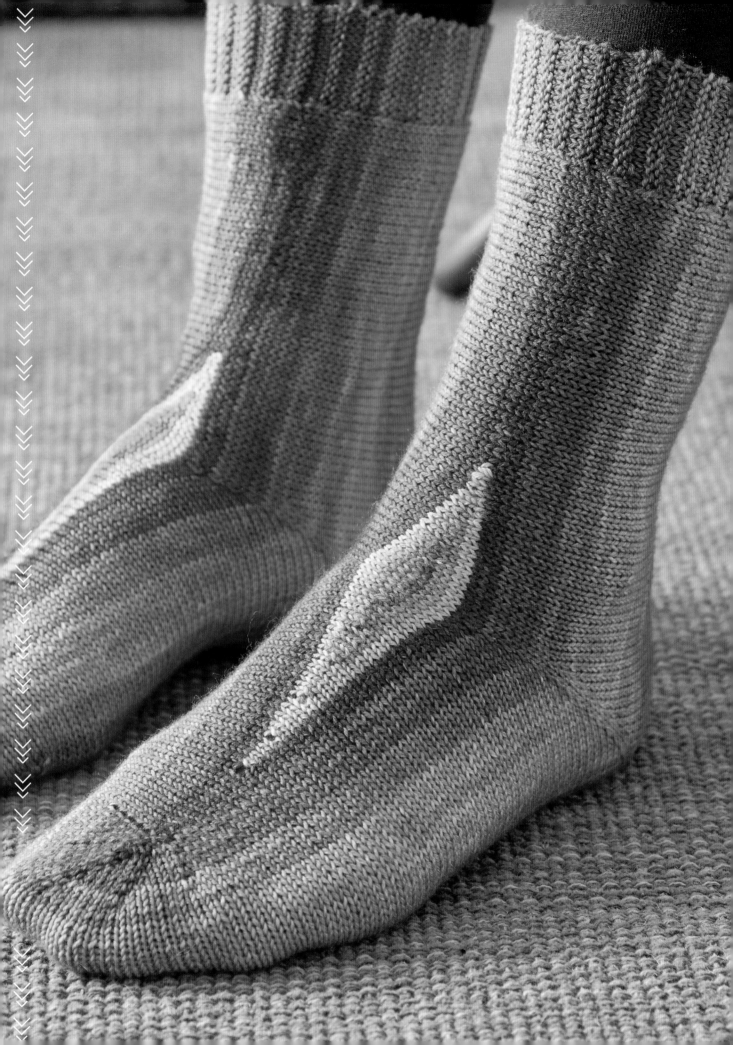

Vanishing Point

JENY STAIMAN

I've always wanted to design a sock that started on the instep, but it has taken me years to come up with one that I liked. Here it is! Vanishing Point borrows a technique I used in my very first pattern, Duck (published on Knitty.com in 2011) to work a flat diamond shape. Once you have the diamond, a separate length of yarn is used to cast on along the entire length of the foot. The unique thing about the cast-on for this sock is that it starts out as a standard Judy's Magic Cast-On using two strands of yarn, then the strands separate from each other in order to work across each side of the diamond. They then rejoin to continue casting on up to the cuff. The sides of the sock are worked back and forth simultaneously, so when a gradient yarn is used, the pattern is mirrored across both sides. Instructions are given for a five-shade gradient kit, which gives you control over where the color changes take place.

FINISHED SIZE

Sizes Small (Medium, Large, Extra Large).

About 7¾ (8, 8, 8½)" (19.5 [20.5, 20.5, 21.5] cm) foot circumference, 7¾ (8¼, 8½, 9)" (19.5 [21, 21.5, 23] cm) foot length from back of heel to tip of toe (unstretched) that will stretch up to 9¼ (10, 10¼, 10¾)" (23.5 [25.5, 26, 27.5] cm) foot length (see Notes), and 8 (8¼, 8¼, 8¼)" (20.5 [21, 21, 21] cm) leg length from top of cuff to base of heel.

Socks shown in size Medium.

YARN

Fingering weight (#1 Super Fine).

Shown here: Black Trillium Fibres Gradient Yarn Lilt Sock (85% superwash merino, 15% mulberry silk; 380 yd [347 m]/100 g): one Pebble Gradient Kit in color Scotch contains 5 shades (C1 to C5) and has (635 yd [580 m] /165 g) total.

NEEDLES

Size U.S. 1 (2.5 mm): sizes 24" and 40" (60 and 100 cm) circular (cir).

Adjust needle size if necessary to obtain the correct gauge.

NOTIONS

Markers (m) in 3 different colors or styles; tapestry needle.

GAUGE

17½ sts and 23 rows/rnds = 2" (5 cm) in St st.

NOTES

- When choosing a size, plan for about 20% negative ease in foot length because socks with sideway construction have more stretch in the lengthwise direction than do traditional socks worked in the round.

- The socks are worked "sideway," beginning with a diamond on the instep. Stitches for the front of the leg and top of the foot are worked outward from the four sides of the initial diamond. New cast-on stitches extend the work from the top point of the diamond to the top of the cuff for the leg and from the bottom point of the diamond to the tip of the toe for the foot.

- Count your stitches often to ensure there will be the right number on each needle when it comes time to graft the edges together. If you discover you're off by a stitch or two, don't rip back. Just work an extra increase or decrease to correct the stitch count, then continue.

STITCH GUIDE

Cuff Pattern (worked on 12 sts)

Row 1: (RS) Purl.

Row 2: (WS) Knit.

Row 3: Knit.

Row 4: Purl.

Rep Rows 1–4 for patt.

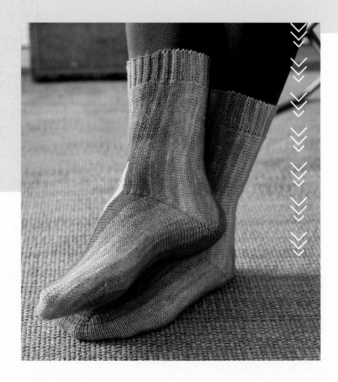

Instep Diamond

With C3, 24" (60 cm) cir needle, and wrapping the needles according to Judy's Magic Cast-On (see Glossary), use the tail and working yarn to make wraps for 4 CO sts on each needle tip, place Marker 1 on the top needle (Needle 1) and Marker 2 on the bottom needle (Needle 2), then make wraps for 4 more CO sts on each needle—16 wraps total; 8 each needle with marker in center.

Notes: As you work the following instructions, rotate the needles like the hands of a clock to bring the required needle into the top position; the markers will help identify the needles (Marker 1 on Needle 1; Marker 2 on Needle 2). The RS of the work faces you throughout.

Add new sts while working previous CO wraps in St st as foll.

Rnd 1: With Needle 1 still on top and wrapping the needles using the working yarn according to the Turkish (also called Eastern) Cast-On (see Glossary), make wraps for 4 sts on each needle—12 sts each needle. Rotate needles to place Needle 2 on top, and k12 to end. Use the Turkish Cast-On method to make wraps for 3 more sts on each needle—15 sts each needle. Rotate the needles to place Needle 1 on top, and k15 to end—30 sts total; 15 sts each needle.

Rnd 2: With Needle 1 still on top, use the Turkish Cast-On to make wraps for 4 sts on each needle; this is the toe end of the diamond—19 sts each needle. With Needle 2 on top, k12 to Marker 2. Change to C2, and k7 to end. Use the Turkish Cast-On to make wraps for 3 sts on each needle; this is the leg end of the diamond—22 sts each needle. With Needle 1 on top, k22 to end—44 sts total.

Rnd 3: With Needle 1 on top, use the Turkish Cast-On to make wraps for 4 sts on each needle—26 sts each needle. With Needle 2 on top, k26 to end. Use the Turkish Cast-On to make wraps for 3 sts on each needle—29 sts each needle. With Needle 1 on top, k13 to Marker 1. Change to C1, and k16 to end—58 sts total.

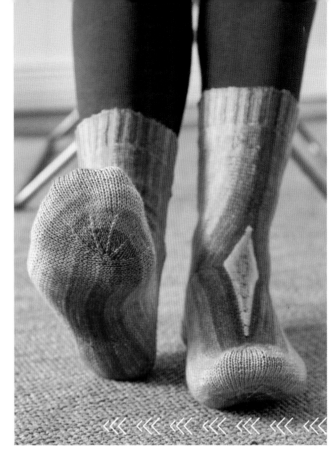

Rnd 4: With Needle 1 on top, use the Turkish Cast-On to make wraps for 4 sts on each needle—33 sts each needle. With Needle 2 on top, k33 to end. Use the Turkish Cast-On to make wraps for 3 sts on each needle—36 sts each needle. With Needle 1 on top, k36 to end—72 sts total.

Rnd 5: With Needle 1 on top, use the Turkish Cast-On to make wraps for 4 sts on each needle—40 sts each needle. With Needle 2, k40 to end. Use the Turkish Cast-On to make wraps for 3 sts on each needle—43 sts each needle. With Needle 1, k43 to end—86 sts total.

Rnd 6: With Needle 1 on top, use the Turkish Cast-On to make wraps for 4 sts on each needle—47 sts each needle. With Needle 2 on top, k41 to last 6 sts, then sl 41 sts just worked back onto left needle tip without working them—94 sts total. Cut yarn, leaving a 6" (15 cm) tail.

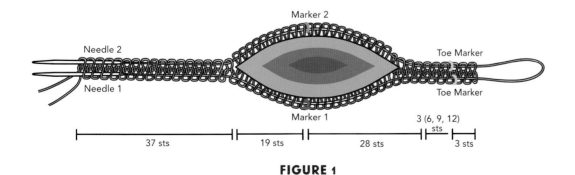

FIGURE 1

129

With Needle 2 still on top, RS facing, both needle tips pointing to the right, and reading from right to left, each needle will have 28 instep sts before the marker, 19 front leg sts after the marker, and the cut end of C1 will be hanging from the 41st st on Needle 2.

Cast-on for Top of Foot and Front of Leg

With C5, pull out a tail about 5 feet (1.5 m) long, then use Judy's Magic Cast-On to make wraps for 3 sts on each tip of the 40" (100 cm) cir needle, place a toe marker in the 3rd color or style on each needle, then make wraps for 3 (6, 9, 12) more CO sts on each needle—12 (18, 24, 30) wraps total; 6 (9, 12, 15) on each needle.

With RS facing, use C5 and the top 40" (100 cm) cir needle to k47 sts from Needle 2, leaving Marker 2 in place.

Turn work so WS is facing, and use the other tip of 40" (100 cm) cir needle and the other strand of C5 to p47 sts from Needle 1—53 (56, 59, 62) sts on each half of 40" (100 cm) cir needle. Turn work so RS is facing. Holding both needle tips tog, twist the two strands of C5 around each other, then use Judy's Magic Cast-On to make wraps for 37 sts on each needle—90 (93, 96, 99) sts on each needle (**Figure 1**).

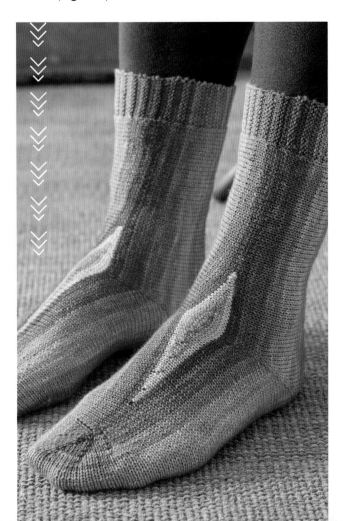

Hold needles so the needle with Marker 1 is on top (new Needle 1), the needle with Marker 2 is on the bottom (new Needle 2), and both needle tips are pointing to the right. In this position and reading from right to left, both yarn ends will be at the needle tips. Before the first marker on each needle, there will be 37 CO wraps for leg and 19 leg sts from instep diamond; after the first marker on each needle, there will be 28 instep sts from diamond, 3 (6, 9, 12) CO wraps for end of foot, the toe marker, and 3 CO wraps for toe.

Shape Top of Foot and Toe

Note: In this section, stitches are increased on the foot side of Markers 1 and 2, and also in each toe section.

With Needle 1 still on top and RS facing, cont with strand of C5 attached to the ball of yarn as foll.

Row 1: (RS) On Needle 1, work Row 1 of cuff patt (see Stitch Guide) over 12 sts, knit to toe marker, slip marker (sl m), k1, [M1L (see Glossary), k1] 2 times—2 toe sts inc'd; on Needle 2, [M1L, k1] 3 times, sl m, knit to last 12 sts, work Row 1 of cuff patt over 12 sts—5 toe sts inc'd; 92 (95, 98, 101) sts on Needle 1, 93 (96, 99, 102) sts on Needle 2; 11 toe sts total: 5 on Needle 1, 6 on Needle 2.

Row 2: (WS) On Needle 1, work 12 sts in cuff patt, purl to end; on Needle 1, purl to last 12 sts, work in cuff patt to end.

As you work the shaping of the next 30 (32, 32, 34) rows from Row 3 to Row 32 (34, 34, 36), change colors for your size as foll.

SIZE SMALL ONLY

6 rows C4, 6 rows C3, 5 rows C2, 5 rows C1, 5 rows C2, and 3 rows C3.

SIZES MEDIUM AND LARGE ONLY

6 rows C4, 6 rows C3, 6 rows C2, 5 rows C1, 6 rows C2, and 3 rows C3.

SIZE EXTRA LARGE ONLY

1 row C5, 6 rows C4, 6 rows C3, 6 rows C2, 5 rows C1, 6 rows C2, and 4 rows C3.

ALL SIZES

Row 3: On Needle 1, work 12 sts in cuff patt, knit to Marker 1, sl m, k1, M1L, knit to toe marker, sl m, k1, [M1L, k2] 2 times—1 foot st and 2 toe sts inc'd; on Needle 2, [M1L, k2] 3 times, sl m, knit to 1 st before Marker 2, M1R (see Glossary), k1, sl m, knit to last 12 sts,

work in cuff patt to end—1 foot st and 3 toe sts inc'd; 95 (98, 101, 104) sts on Needle 1, 97 (100, 103, 106) sts on Needle 2; 16 toe sts total: 7 on Needle 1, 9 on Needle 2.

Even-numbered Rows 4–10: Rep Row 2.

Row 5: On Needle 1, work 12 sts in cuff patt, knit to Marker 1, sl m, k1, M1L, knit to toe marker, sl m, k1, [M1L, k3] 2 times—1 foot st and 2 toe sts inc'd; on Needle 2, [M1L, k3] 3 times, sl m, knit to 1 st before Marker 2, M1R, k1, sl m, knit to last 12 sts, work in cuff patt to end—1 foot st and 3 toe sts inc'd; 98 (101, 104, 107) sts on Needle 1, 101 (104, 107, 110) sts on Needle 2; 21 toe sts total: 9 on Needle 1, 12 on Needle 2.

Row 7: On Needle 1, work 12 sts in cuff patt, knit to Marker 1, sl m, k1, M1L, knit to toe marker, sl m, k1, [M1L, k4] 2 times—1 foot st and 2 toe sts inc'd; on Needle 2, [M1L, k4] 3 times, sl m, knit to 1 st before Marker 2, M1R, k1, sl m, knit to last 12 sts, work in cuff patt to end—1 foot st and 3 toe sts inc'd; 101 (104, 107, 110) sts on Needle 1, 105 (108, 111, 114) sts on Needle 2; 26 toe sts total: 11 on Needle 1, 15 on Needle 2.

Row 9: On Needle 1, work 12 sts in cuff patt, knit to Marker 1, sl m, k1, M1L, knit to toe marker, sl m, k1, [M1L, k5] 2 times—1 foot st and 2 toe sts inc'd; on Needle 2, [M1L, k5] 3 times, sl m, knit to 1 st before Marker 2, M1R, k1, sl m, knit to last 12 sts, work in cuff patt to end—1 foot st and 3 sts inc'd; 104 (107, 110, 113) sts on Needle 1, 109 (112, 115, 118) sts on Needle 2; 31 toe sts total; 13 on Needle 1, 18 on Needle 2.

Row 11: On Needle 1, work 12 sts in cuff patt, knit to Marker 1, sl m, k1, M1L, knit to toe marker, sl m, k1, [M1L, k6] 2 times—1 foot and 2 toe sts inc'd; on Needle 2, [M1L, k6] 3 times, sl m, knit to 1 st before Marker 2, M1R, k1, sl m, knit to last 12 sts, work in cuff patt to end—1 foot and 3 toe sts inc'd; 107 (110, 113, 116) sts on Needle 1, 113 (116, 119, 122) sts on Needle 2; 36 toe sts total: 15 on Needle 1, 21 on Needle 2.

Row 12: Rep Row 2—13 rows completed in ball-of-foot section between diamond point and toe, including CO row; 26 rows across top of foot between needles; foot measures about 2¼" (5.5 cm) between needles.

Shape Sides of Foot and Leg

Note: In this section, stitches are increased on both the sides of Markers 1 and 2; and the toe stitches are worked even.

Row 13: (RS) On Needle 1, work 12 sts in cuff patt, knit to 1 st before Marker 1, M1R, k1, sl m, k1, M1L, knit to end—1

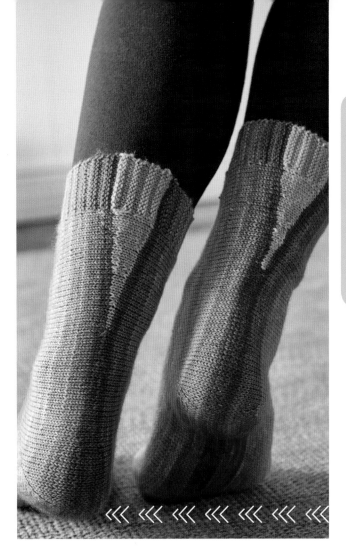

foot and 1 leg st inc'd; on Needle 2, knit to 1 st before Marker 2, M1R, k1, sl m, k1, M1L, knit to last 12 sts, work in cuff patt to end—1 foot and 1 leg st inc'd; 109 (112, 115, 118) sts on Needle 1, 115 (118, 121, 124) sts on Needle 2.

Row 14: (WS): On Needle 2, work 12 sts in cuff patt, purl to end; on Needle 1, purl to last 12 sts, work in cuff patt to end.

Rows 15 and 16: Rep Rows 13 and 14—111 (114, 117, 120) sts on Needle 1, 117 (120, 123, 126) sts on Needle 2.

Rows 17 and 18: Rep Rows 13 and 14—113 (116, 119, 122) sts on Needle 1, 119 (122, 125, 128) sts on Needle 2.

Rows 19 and 20: Rep Rows 13 and 14—115 (118, 121, 124) sts on Needle 1, 121 (124, 127, 130) sts on Needle 2.

Rows 21 and 22: Rep Rows 13 and 14—117 (120, 123, 126) sts on Needle 1, 123 (126, 129, 132) sts on Needle 2.

Rows 23 and 24: Rep Rows 13 and 14—119 (122, 125, 128) sts on Needle 1, 125 (128, 131, 134) sts on Needle 2.

Rows 25 and 26: Rep Rows 13 and 14—121 (124, 127, 130) sts on Needle 1, 127 (130, 133, 136) sts on Needle 2.

Rows 27 and 28: Rep Rows 13 and 14—123 (126, 129, 132) sts on Needle 1, 129 (132, 135, 138) sts on Needle 2.

Rows 29 and 30: Rep Rows 13 and 14—125 (128, 131, 134) sts on Needle 1, 131 (134, 137, 140) sts on Needle 2.

Rows 31 and 32: Rep Rows 13 and 14—127 (130, 133, 136) sts on Needle 1, 133 (136, 139, 142) sts on Needle 2—66 ball-of-foot rows between needles; foot measures about 5¾" (14.5 cm) between needles.

Size Small is complete; skip to next section.

SIZES (MEDIUM, LARGE, EXTRA LARGE) ONLY

Rows 33 and 34: Rep Rows 13 and 14—(132, 135, 138) sts on Needle 1, (138, 141, 144) sts on Needle 2—70 ball-of-foot rows between needles; foot measures about 6" (15 cm) between needles.

Sizes Medium and Large are complete; skip to next section.

SIZE EXTRA LARGE ONLY

Rows 35 and 36: Rep Rows 13 and 14—140 sts on Needle 1, 146 sts on Needle 2—74 ball-of-foot rows between needles; foot measures about 6½" (16.5 cm) between needles.

Shape Bottom of Foot, Toe, and Heel

Note: In this section, stitches continue to increase on both sides of Markers 1 and 2 while the toe stitches are decreased.

As you work the next 10 rows, change colors for your size as foll.

SIZES SMALL, MEDIUM, AND LARGE ONLY

Work 3 rows C3, 6 rows C4, and 1 row C5.

SIZE EXTRA LARGE ONLY

Work 2 rows C3, 6 rows C4, and 2 rows C5.

ALL SIZES

Cont as foll.

Row 1: (RS) On Needle 1, work 12 sts in cuff patt, knit to 1 st before Marker 1, M1R, k1, sl m, k1, M1L, knit to toe m, sl m, k1, [k5, k2tog] 2 times—1 foot and 1 leg st inc'd, 2 toe sts dec'd; on Needle 2, [k5, k2tog] 3 times, knit to 1 st before Marker 2, M1R, k1, sl m, k1, M1L, knit to last 12 sts, work 12 sts in cuff patt—1 foot and 1 leg st inc'd, 3 toe sts dec'd; 127 (132, 135, 140) sts on Needle 1, 132 (137, 140, 145) sts on Needle 2; 31 toe sts total: 13 on Needle 1, 18 on Needle 2.

Even-numbered Rows 2–8: (WS) On Needle 2, work 12 sts in cuff patt, purl to end; on Needle 1, purl to last 12 sts, work in cuff patt to end.

Row 3: On Needle 1, work 12 sts in cuff patt, knit to 1 st before Marker 1, M1R, k1, sl m, k1, M1L, knit to toe m, sl m, k1, [k4, k2tog] 2 times—1 foot and 1 leg st inc'd, 2 toe sts dec'd; on Needle 2, [k4, k2tog] 3 times, knit to 1 st before Marker 2, M1R, k1, sl m, k1, M1L, knit to last 12 sts, work 12 sts in cuff patt—1 foot and 1 leg st inc'd, 3 toe sts dec'd; no change to Needle 1 sts, 131 (136, 139, 144) sts on Needle 2; 26 toe sts total: 11 on Needle 1, 15 on Needle 2.

Row 5: On Needle 1, work 12 sts in cuff patt, knit to 1 st before Marker 1, M1R, k1, sl m, k1, M1L, knit to toe m, sl m, k1, [k3, k2tog] 2 times—1 foot and 1 leg st inc'd, 2 toe sts dec'd; on Needle 2, [k3, k2tog] 3 times, knit to 1 st before Marker 2, M1R, k1, sl m, k1, M1L, knit to last 12 sts, work 12 sts in cuff patt—1 foot and 1 leg st inc'd, 3 toe sts dec'd; no change to Needle 1 sts, 130 (135, 138, 143) sts on Needle 2; 21 toe sts total: 9 on Needle 1, 12 on Needle 2.

Row 7: On Needle 1, work 12 sts in cuff patt, knit to 1 st before Marker 1, M1R, k1, sl m, k1, M1L, knit to toe m, sl m, k1, [k2, k2tog] 2 times—1 foot and 1 leg st inc'd, 2 toe sts dec'd; on Needle 2, [k2, k2tog] 3 times, knit to 1 st before Marker 1, M1R, k1, sl m, k1, M1L, knit to last 12 sts, work 12 sts in cuff patt—1 leg and 1 foot st inc'd, 3 toe sts dec'd; no change to Needle 1 sts, 129 (134, 137, 142) sts on Needle 2; 16 toe sts total: 7 on Needle 1, 9 on Needle 2.

Row 9: On Needle 1, work 12 sts in cuff patt, knit to 1 st before Marker 1, M1R, k1, sl m, k1, M1L, knit to toe m, sl m, k1, [k1, k2tog] 2 times—1 foot and 1 leg st inc'd, 2 toe sts dec'd; on Needle 2, [k1, k2tog] 3 times, knit to 1 st before Marker 2, M1R, k1, sl m, k1, M1L, knit to last 12 sts, work 12 sts in cuff patt—1 foot and 1 leg st inc'd, 3 toe sts dec'd; no change to Needle 1 sts, 128 (133, 136, 141) sts on Needle 2; 11 toe sts total: 5 on Needle 1, 6 on Needle 2.

Row 10: Rep Row 2—86 (90, 90, 94) ball-of-foot rows between needles; foot measures about 7½ (7¾, 7¾, 8¼)" (19 [19.5, 19.5, 21] cm) between needles.

With C5, work short-rows (see Glossary) to complete heel shaping while cont toe decs as foll.

Short-Row 1: (RS) On Needle 1, work 12 sts in cuff patt, knit to Marker 1, sl m, k15 for underside of heel, wrap next st and turn work (w&t).

Short-Row 2: (WS) Sl 1 st pwise wyf, p14, sl m, p15 for back of heel, w&t.

Short-Row 3: Sl 1 pwise wyb, knit to toe marker, working wrap tog with wrapped st when you come to it, sl m, k1, [k2tog] 2 times—2 toe sts dec'd; on Needle 2, [k2tog] 3

times, sl m, knit to Marker 2, sl m, k15 for back of heel w&t—3 toe sts dec'd; 125 (130, 133, 138) sts on each needle; 6 toe sts total: 3 on each needle.

Short-Row 4: Sl 1 pwise wyf, p14, sl m, p15 for underside of heel, w&t.

Short-Row 5: Sl 1 pwise wyb, knit to last 12 sts, working wrap tog with wrapped st when you come to it, work 12 sts in cuff patt.

Short-Row 6: (WS) On Needle 2, work 12 sts in cuff patt, purl to end, working wrap tog with wrapped st when you come to it—3 more ball-of-foot rows added (1 on Needle 1; 2 on Needle 2); 89 (93, 93, 97) ball-of-foot rows between needles; foot measures about 7¾ (8, 8, 8½)" (19.5 [20.5, 20.5, 21.5] cm) between needles.

Cut yarn, leaving a 60" (152.5 cm) tail of C5 between the needles at the toe to use for grafting later.

Calf Shaping

With RS of Needle 2 facing, sl 101 (106, 109, 114) sts onto the right needle tip without working them—24 leg sts rem on left needle tip of Needle 2. Join C1 with RS facing. Work short-rows to shape the calf on Needle 2 only as foll, working wraps tog with wrapped sts when you come to them on subsequent rows.

Short-Row 1: (RS) Knit to last 12 sts, work 12 cuff patt sts.

Short-Row 2: (WS) Work 12 cuff patt sts, w&t.

Short-Row 3: Work 12 cuff patt sts.

Short-Row 4: Work 12 cuff patt sts, p6, w&t.

Short-Row 5: Sl 1 pwise wyb, k5, work 12 cuff patt sts.

Short-Row 6: Work 12 cuff patt sts, p12, w&t.

Short-Row 7: Sl 1 pwise wyb, k11, work 12 cuff patt sts.

Short-Row 8: Work 12 cuff patt sts, p18, w&t.

Short-Row 9: Sl 1 pwise wyb, k17, work 12 cuff patt sts.

Short-Row 10: Work 12 cuff patt sts, p12, w&t.

Short-Row 11: Sl 1 pwise wyb, k11, work 12 cuff patt sts.

Short-Row 12: Work 12 cuff patt sts, p6, w&t.

Short-Row 13: Sl 1 pwise wyb, k5, work 12 cuff patt sts.

Short-Row 14: Work 12 cuff patt sts, w&t.

Short-Row 15: Work 12 cuff patt sts.

Short-Row 16: Work 12 cuff patt sts, p19, working wraps tog with wrapped sts.

Cut yarn. Return the 31 sts just worked onto the left needle tip of Needle 2.

Finishing

Arrange the sts on the needles so the toe sts are at the needle tips. Hold the needles tog with WS facing tog and RS facing out.

Thread the long tail of C5 on a tapestry needle and use the Kitchener st (see Glossary) to graft the two sets of sts tog, beginning at the toe and ending at the cuff. Depending on the number of cuff patt rows worked for your size, you may want to graft the cuff in rev St st.

Weave in loose ends.

Block as desired.

JENY STAIMAN'S techniques and patterns are born from equal parts of love for handmade objects, compulsion to take things apart and understand how they work, stubborn determination to conquer or exploit any constraint, and an eccentric habit of knitting in her head all day long. Visit her blog at *www.curiousknitter.com*.

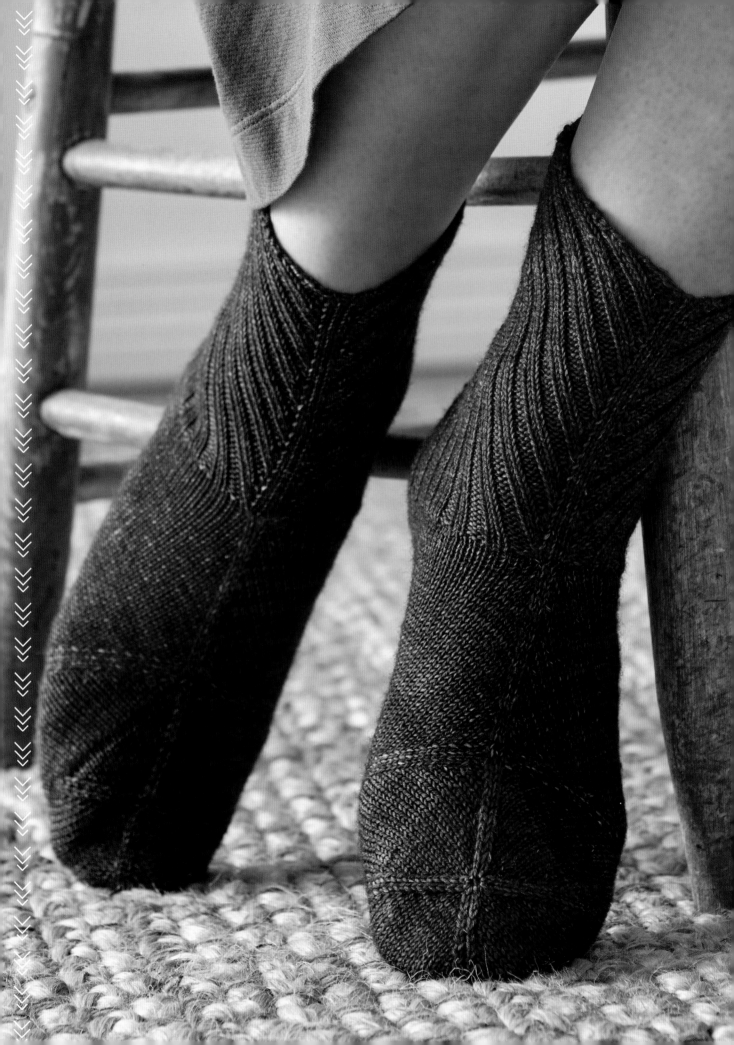

Square Socks

NICOLA SUSEN

We're all familiar with classic top-down or toe-up socks and have probably knitted from both directions over and over again. With this pattern, you'll make completely new footprints. No matter what your gauge is, this construction is the clever formula for squaring the circle: two squares and two tubes, with each section worked seamlessly from the one before. The amazing fit of this unusual sock will surprise you. Although specific instructions are provided for the socks shown, there are tips aimed at providing nothing less than maximum knitting freedom using your yarn, your gauge, and your size for a truly customized pair.

FINISHED SIZE

Finished dimensions are adjustable depending on your yarn, gauge, and foot measurements.

About 7 (8½)" (18 [21.5] cm) foot circumference, 9¼ (10¾)" (23.5 [27.5] cm) foot length from back of heel to tip of toe, and 7¾ (9¼)" (19.5 [23.5] cm) leg length from top of center back leg to base of heel (leg is shorter at center front).

Socks shown measure 7" (18 cm) foot circumference.

YARN

Fingering weight (#1 Super Fine).

Shown here: WOLLkenSchaf 4-Ply Merino (100% merino wool; 437 yd [400 m]/100 g): Malve (red-purple) and Violett Dunkel (dark blue-violet), 1 skein each (see Notes).

NEEDLES

Size U.S. 1 (2.5 mm): set of 5 double-pointed (dpn) or one 40" (100 cm) circular (cir) to use in magic-loop technique (see page 6).

Adjust needle size if necessary to obtain the correct gauge.

NOTIONS

Size B/1 (2.5 mm) crochet hook; smooth, contrasting waste yarn; markers (m); tapestry needle.

GAUGE

Shown here: 18 sts and 22 rnds = 2" (5 cm) in St st, worked in rnds.

NOTES

- These socks can be worked in any yarn, but fingering weight is suggested because it makes lightweight socks that fit in regular shoes. If you decide to customize the pattern, choose an appropriate needle size for your yarn and desired gauge.

- Each sock begins with a circular cast-on of a small number of stitches centered under the ball of the foot. The cast-on stitches are divided into four groups that are worked outward in rounds as increases are worked on both sides of each group to form the foot square, which determines the fit.

- When the diagonal of the foot square is the same as the foot circumference, the live stitches from two adjacent sides of the square are worked in a diamond shape to form the top of the toe. The stitches from the remaining two sides of the foot square are worked even in bias stockinette until the foot reaches the desired length, then the stitches are worked upward in a bias rib pattern for the leg.

- Designate one color as A and the other as B for the first sock, then reverse the colors in the second sock. The socks shown used about 35 (50) grams of each color.

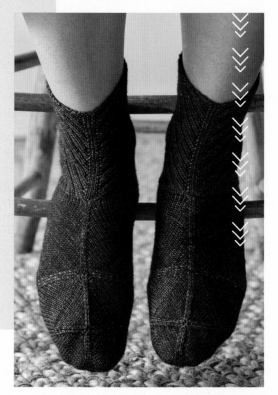

First Sock

Foot Square

With A (see Notes on page 136), use Emily Ocker's Cast-On (see Glossary) to CO 8 sts.

Arrange sts on four dpn or cir needle so that there are four quarters, each with 2 sts. These four foot quarters are identified as F1, F2, F3, and F4, with F1 at the start of the rnd.

Rnds 1 and 3: Knit.

Rnd 2: *K1, M1 (see Glossary), k1; rep from *—12 sts; 3 sts each quarter.

Rnd 4: *K1, LLI (see Glossary), k1, LRI (see Glossary), k1; rep from *—20 sts; 5 sts each quarter.

Rnd 5: Knit.

Rnd 6: *K2, LLI, knit to last 2 sts of quarter, LRI, k2; rep from *—8 sts inc'd; 2 sts inc'd each quarter.

Rep Rnds 5 and 6 only 16 (20) more times—156 (188) sts; 39 (47) sts each quarter; 38 (46) rnds completed; piece measures 3½ (4¼)" (9 [11] cm) from center CO, measured straight up along the 2 sts at the side of a quarter and 7 (8½)" (18 [21.5] cm) across the entire diagonal of the square from corner to corner.

CUSTOMIZE IT

To change the foot circumference or to adjust for a different yarn and gauge, repeat Rounds 5 and 6 until the entire diagonal of the square fits comfortably around the ball of your foot, making sure that the number of stitches in each quarter is a multiple of 4 stitches minus 1—for example, 23, 27, 31, 35, 39, 43, 47, 51, or 55 sts.

Place the stitches temporarily onto waste-yarn holders to check the fit. Center the cast-on under the ball of your foot, rotate the square so that one corner points toward the end of your toes and the opposite corner points toward the back of your heel, then bring the remaining two corners around the sides of your foot to meet on top of your instep. If necessary, add or remove rounds to make the foot larger or smaller.

Toe Square

Place sts from F3 and F4 (the last two quarters of the rnd) onto waste-yarn holder—78 (94) sts on holder; two quarters with 39 (47) sts each rem on the needles.

Join B to beg of F1 sts with RS facing, but do not cut A (it will be used later). Use the backward-loop method (see Glossary) to CO 2 sts with B at beg of left needle.

CUSTOMIZE IT

Begin the toe-square set-up round by casting on 2 stitches. The starting number of stitches in the toe square (F1, F2, and the new cast-on stitches) should be a multiple of 16, with a multiple of 4 in each quarter.

Knit the first cast-on stitch. Starting with the second cast-on stitch, knit 1 round, dividing the stitches into four equal quarters, and end by knitting the first cast-on stitch again at the end of the fourth quarter.

Repeat Rounds 1 and 2 until half the starting number of stitches remain. Repeat Round 1 to decrease every round until 8 stitches remain, then fasten off the stitches.

Set-up rnd: With B, knit the first new CO st; it will become the last st of the rnd later. Knit the second new CO st, then knit the first 19 (23) sts of F1; these 20 (24) sts are now the first toe quarter. Knit the rem 20 (24) sts of F1; these sts are now the second toe quarter. Knit the first 20 (24) sts of F2; these sts are now the third toe quarter. Knit the rem 19 (23) sts of F2, then knit the first CO st again; these 20 (24) sts are now the fourth toe quarter—80 (96) sts total; 20 (24) sts each quarter. The rnd begins between the 2 CO sts.

Rnd 1: *Ssk, knit to last 2 sts of quarter, k2tog; rep from *—8 sts dec'd; 2 sts dec'd each quarter.

Rnd 2: Knit.

Rep the last 2 rnds 4 (5) more times—40 (48) sts rem; 10 (12) sts each quarter.

Rep Rnd 1 (i.e., dec every rnd) 4 (5) times—8 sts rem for both sizes; 2 sts each quarter.

Cut yarn, leaving a 10" (25.5 cm) tail. Thread tail on a tapestry needle, draw through rem sts, pull tight to close hole, and fasten off on WS.

CUSTOMIZE IT

The starting number of stitches for the instep and underside of heel (F3, F4, and the new picked-up stitches) should be a multiple of 8, with a multiple of 4 stitches in each half. Knit the first picked-up stitch. Starting with the second picked-up stitch, knit 1 round, dividing the stitches into two equal halves, and end by knitting the first picked-up stitch again at the end of the second half.

The foot length along the center of the sole is equal to the entire diagonal of the foot square, plus the length of this section, as measured along the center 2-stitch column on the underside of the heel. Work according to the directions until the foot is about the desired length. Try the sock on, and—if necessary—work more or fewer rounds even, until the sole of the sock reaches the back of your heel.

Instep and Underside of Heel

Return 39 (47) held sts each for F3 and F4 to working needle—78 (94) sts. With RS facing, use A (attached at end of F4 sts) to pick up and knit 1 st from each of the 2 CO sts at the start of the toe square—80 (96) sts.

Set-up rnd: Knit the 2 picked-up sts, knit to end, then knit the first picked-up st again; the rnd begins between the 2 picked-up sts—40 (48) sts each for F3 and F4.

Notes: The foot is worked even in rounds of bias stockinette. Rounds begin on top of the instep, at the start of the F3 stitches. In every other round, each half (F3 or F4) has an increase at one side and a compensating decrease at the other side, so the stitch count remains constant.

Rnd 1: On F3 sts, ssk, knit to last 2 sts, LRI, k2; on F4 sts, k2, LLI, knit to last 2 sts, k2tog.

Rnd 2: Knit.

Rep the last 2 rnds 10 more times, then work Rnd 1 once more—24 foot rnds completed for both sizes, including set-up rnd; piece measures 2¼" (5.5 cm) from sts picked up from toe square measured straight up along the 2-st column on top of the instep, and 9¼ (10¾)" (23.5 [27.5] cm) from tip of toe measured along the 2-st column centered on the underside of the foot.

Cut A.

Leg

Notes: The leg is worked even in rounds of bias k2, p2 rib, with rounds beginning at the center front leg. As for the instep and underside of the heel, in every other round each half contains an increase at one side and a decrease at the other, so the stitch count remains constant.

Set-up Rnd 1: With B, pick up and knit 1 st in the back of the ssk at the beg of the previous rnd, knit the 40 (48) sts of F3; these 41 (49) sts are now the first half of the leg (L1). Knit the 40 (48) sts of F4, then pick up and knit 1 st in the back of the k2tog at the end of the previous rnd; these 41 (49) sts are now the second half of the leg (L2)—82 (98) sts total.

Set-up Rnd 2: On L1, [k2, p2] 10 (12) times, k1; on L2, k1, [p2, k2] 10 (12) times.

Work bias k2, p2 rib as foll.

Rnds 1 and 3: On L1, k2, LLI, work sts as they appear (knit the knits and purl the purls) to last 6 sts, k2tog, k1, p2, k1; on L2, k1, p2, k1, ssk, work sts as they appear to last 2 sts, LRI, k2.

Rnds 2 and 4: Work all sts as they appear.

Rnds 5 and 7: On L1, k2, LLI, work sts as they appear to last 6 sts, k2tog, k1, p2, k1; on L2, k1, p2, k1, ssk, work sts as they appear to last 2 sts, LRI, k2.

Rnds 6 and 8: K2, p1 (inc st of previous rnd), work sts as they appear to last 3 sts, p1 (inc st of previous rnd), k2.

Rep the last 8 rnds 5 (6) more times, or until piece measures desired length at front of leg, ending with Rnd 8—50 (58) leg rnds, including 2 set-up rnds; ribbing measures 4½ (5¼)" (11.5 [13.5] cm), measured straight up along the 2-st column at center front leg. Leg measures about 3¼ (4)" (8.5 [10] cm) longer at center back.

Change to working back and forth in rows as foll.

Row 1: (RS) On L1, k1, work 1 st in patt, pass the first st on right needle over the second and off the needle to dec 1 st, work sts as they appear to last 6 sts, k2tog, k1, p2, k1; on L2, k1, p2, k1, ssk, work sts as they appear to last st, k1—3 sts dec'd; 2 sts in L1 and 1 st in L2.

Row 2: (WS) P1, work 1 st in patt, pass the first st over the second and off the needle to dec 1 st, work in patt to last st, p1—1 st dec'd in L2.

Rep the last 2 rows 16 (20) more times—14 sts rem for both sizes; 7 sts each half.

Next row: (RS) On L1, k1, k2tog, k1, p2, k1; on L2, k1, p2, k1, ssk, k1—12 sts rem: 6 sts each half.

Next row: Ssp (see Glossary), work in patt to last 2 sts, p2tog—10 sts rem; 5 sts each half; piece measures 3¼ (4)" (8.5 [10] cm) from last leg rnd, measured straight up along 2-st column at center back leg; ribbing measures 7¾ (9¼)" (19.5 [23.5] cm) at center back.

With RS facing, BO rem sts in patt.

CUSTOMIZE IT

The starting number of stitches for the ribbed leg (F3, F4, and the new picked-up stitches) should be a multiple of 8 plus 2, with a multiple of 4 stitches plus 1 in each half (L1 or L2). In Set-up Rnd 2 and Rnds 1–8 of the rib pattern, work more or fewer repeats of [k2, p2] in L1 and [p2, k2] in L2 as necessary for your number of stitches.

For a longer or shorter leg, work more or fewer repeats of Rnds 1–8 before changing to working the top of the leg back and forth in rows.

Second Sock

Work as for first sock, reversing colors A and B.

Finishing

Weave in ends.

Block lightly if desired, taking care not to stretch the ribbing.

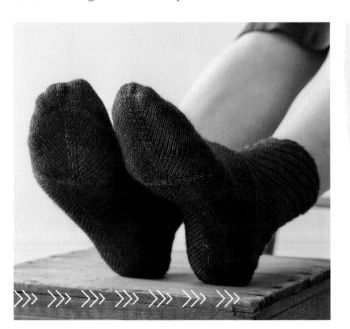

NICOLA SUSEN lives in Hamburg, Germany. She likes to devise patterns that provide maximum knitting freedom—your yarn, your gauge, your size. Her style features casual designs in elaborate constructions with detailed step-by-step instructions for knitting your new favorite clothes. You can see more of Nicola's work at Nicolor.de.

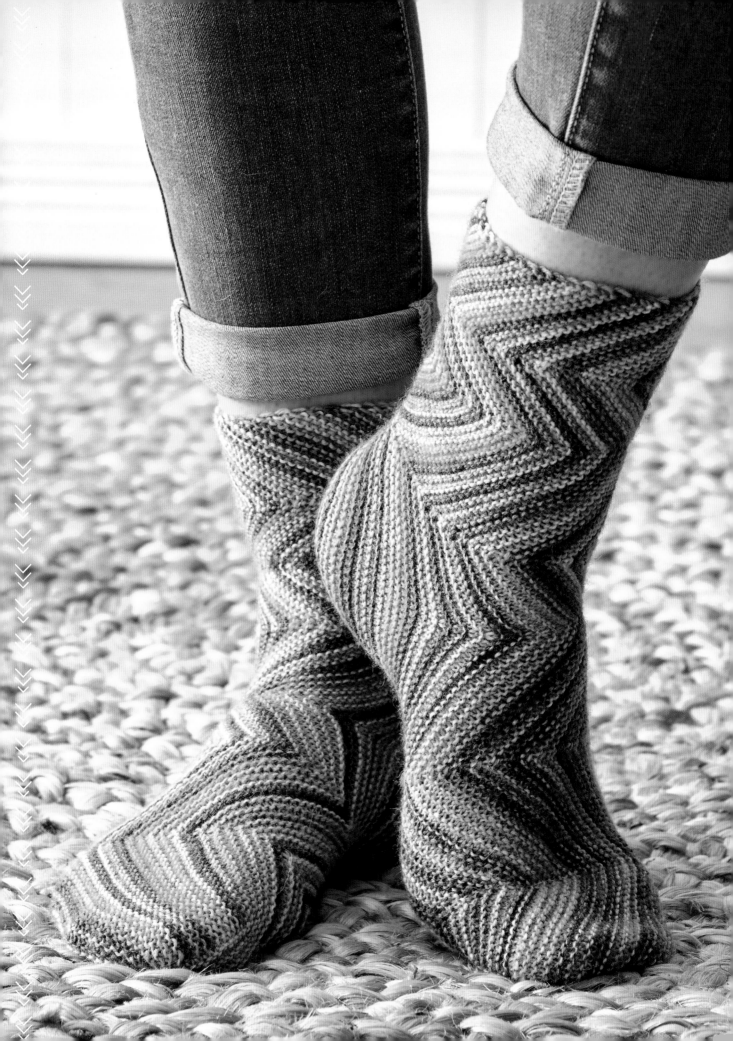

Smokey Zickzacks

NATALIA VASILIEVA

Do you love to buy self-striping yarns but are tired of using them for plain vanilla socks? Continuing to explore the theme I started with my Exotic Whirlpool socks (pattern is free at Ravelry.com), Smokey Zickzacks are anything but plain. Worked side to side in garter stitch, increases and decreases form chevrons that are strategically placed to produce the traditional knitted-in-the-round sock shape. Ending with a row of grafting that mimics the chevron pattern, this sock construction requires a leap of faith. The rows contain a relatively large number of stitches that create different stripe sequences than would otherwise appear with hand-dyed yarns.

FINISHED SIZE

Sized based on 5 (6, 7, 8)-stitch units.

About 5¼ (6¼, 7¾, 8¾)" (13.5 [16, 19.5, 22] cm) foot circumference, will stretch to fit up to 6½ (7⅞, 9¼, 10½)" (16.5 [20, 23.5, 26.5] cm) foot circumference; 5¾ (6¾, 7⅞, 8⅞)" (14.5 [17, 20, 22.5] cm) foot length from back of heel to tip of toe, will stretch to fit up to 7½ (9, 10½, 11¾)" (19 [23, 26.5, 30] cm) foot length; and 6⅛ (7¼, 8¼, 9½)" (15.5 [18.5, 21, 24] cm) leg length from top of cuff to base of heel.

Socks shown measure 7¾" (19.5 cm) foot circumference.

YARN

Fingering weight (#1 Super Fine).

Shown here: Zwerger Garn Opal Smokey Eyes & Coloured Lips (75% wool, 25% polyamide (nylon); 465 yd [425 m]/100 g): #6642 Gray/turquoise/lavender mix, 1 (1, 1, 2) ball(s).

NEEDLES

Size U.S. 1 (2.25 mm): 40" (100 cm) or longer circular (cir).

Note: It is very important that the needle has a flexible cable.

Adjust needle size if necessary to obtain the correct gauge.

NOTIONS

Waste yarn for provisional cast-on; spare cir needle in same size as main needle; size B/1 (2.25 mm) crochet hook for provisional CO; locking stitch markers in 2 different colors; tapestry needle.

GAUGE

16 sts and 31 rows = 2" (5 cm) in garter st, relaxed after blocking (see sidebar at right).

Note: For the best results, the stitch-to-row ratio should be as close as possible to 1:2; in other words, one stitch for every two garter rows (one garter ridge).

NOTES

- The four sizes are based on units of 5 (6, 7, 8) stitches. Use your swatch (see sidebar on page 143) to determine the best base unit for your size.

- Bias garter stitch is very elastic, so plan on working the socks with significant negative ease. The socks will stretch more lengthwise than they will around the foot, so choose a size with more negative ease in foot length, and less negative ease in foot circumference.

- Use different-colored removable markers to identify where to increase and decrease. Start by placing these markers directly in the indicated stitches; not on the needle between stitches. As you work, move the markers up to purl bumps closer to the needle to make it easier to identify each marked stitch column.

- In the set-up row for each sock, the number of stitches between the marked increase and decrease stitches is a multiple of the base number 5, 6, 7, or 8. For example, in the set-up row of the right sock, the sections between the marked stitches contain either 10 (12, 14, 16) stitches (two times the base number) or 15 (18, 21, 24) stitches (three times the base number).

- Each sock leg and foot consists of six tiers. Each tier contains the same number of garter ridges as the number of stitches in the base unit, so each tier has 5 (6, 7, 8) garter ridges.

- The instructions for the right and left socks are written so the U-shaped bend at the side of the heel shows on the outer edge of the foot for a more decorative presentation, but the socks can be worn on either foot.

STITCH GUIDE

Backward yarnover: Bring the yarn to the front over the top of the right needle, then to the back again between the needles. Doing so creates a yo with a reversed stitch mount.

Double yarnover increase: On the RS, work yo, k1, backward yo (see above)—3 sts made from 1 st. When you come to these 3 sts on the next WS row, knit the first yo you come to (the backward yo) through its front loop to twist it, k1, then knit the second yo you come to (regular yo) through its back loop to twist it.

Sk2p (double decrease): Slip 1 knitwise with yarn in back (kwise wyb), k2tog, pass slipped st over (psso)—2 sts dec'd.

CHOOSING A SIZE USING A BIAS GARTER-STITCH SWATCH

The unconventional construction of this sock requires working a strip of bias garter stitch to determine the size. For a sock based on units of 5 (6, 7, 8) stitches, cast on 12 (14, 16, 18) stitches (twice the base number, plus 2).

Row 1: (RS) Yo, knit to last 3 sts, k2tog, k1.

Row 2: (WS) Knit.

Work Rows 1 and 2 a total of 30 (36, 42, 48) times—60 (72, 84, 96) rows total; 30 (36, 42, 48) garter ridges on the RS (6 times the base number).

Each sock consists of 6 tiers encircling the leg and foot, and each tier contains the same number of garter ridges as the base number. If you hold the short ends of the swatch together to form a circle, it will have the same circumference as 6 tiers of the sock leg or foot. Check that the swatch fits the way you want around your calf, the base of your leg at the ankle, and around the ball of the foot. Insert your foot through the swatch circle to ensure that you will be able pull the finished sock on over your heel.

If the swatch doesn't fit, add or remove rows until you have the number of garter ridges specified for the next size up or down and compare the swatch to your leg and foot again. If the swatch needs to be adjusted by fewer than 6 ridges, you may want to try a different needle size. The main point is to discover whether a sock based on units of 5, 6, 7, or 8 stitches will produce the desired circumference.

Right Sock

With waste yarn and crochet hook, use the Crochet-On Provisional Cast-On method (see Glossary) to provisionally CO 93 (110, 127, 144) sts around working needle. Slide sts to the opposite needle tip so the first stitch of the chain cast-on is at the beg of the row.

Join working yarn and cont as foll.

Set-up row: (WS) K1 (toe selvedge), k1 and place 2 decrease-color markers (see Notes) in this st, k10 (12, 14, 16), k1 and place an increase-color marker in this st, k15 (18, 21, 24), k1 and place a dec marker in this st, k10 (12, 14, 16), k1 and place 2 inc markers in this st, k15 (18, 21, 24), k1 and place a dec marker in this st, k10 (12, 14, 16), k1 and place an inc marker in this st, k10 (12, 14, 16), k1 and place a dec marker in this st, k15 (18, 21, 24) to end at top of leg.

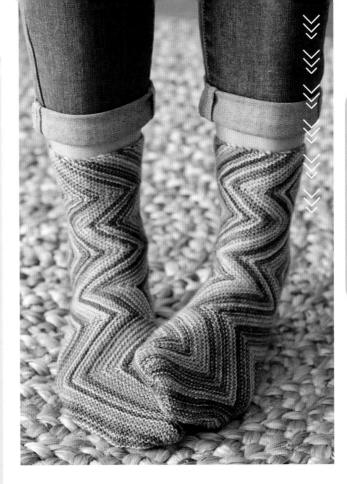

Tiers A and B

Notes: In each RS row, the first six sections have an increase at one side and a decrease at the other, and their stitch counts remain constant. In the first section at the top of the leg, the yarnover at the beginning of the row corresponds to the first half of the first double decrease; take care not to pull this starting yarnover too tightly. In the last section at the toe, the second half of the final double yarnover increase does not have a corresponding decrease, and the toe section increases by one stitch in each RS row.

Move the 2 decrease markers in the same stitch at the toe (end of RS rows) to the WS; they will not be needed until Tier C.

Row 1: (RS) Yo, *knit to 1 st before st with dec marker, sk2p (marked st tog with sts on each side of it; see Stitch Guide), knit to st with inc marker, work double yarnover inc (see Stitch Guide) in marked st; rep from * 2 more times, knit to end, ignoring the paired dec markers at end of row—1 st inc'd in toe section.

Row 2: (WS) Knit, twisting the loops of each double yarnover inc (see Stitch Guide) to prevent holes.

Rep these 2 rows 8 (10, 12, 14) more times, then work RS Row 1 once again—103 (122, 141, 160) sts; 22 (26, 30, 34) sts in toe section (end of RS rows; including st with 2 dec markers and selvedge st); 19 (23, 27, 31) rows completed

(not including set-up row); 9 (11, 13, 15) garter ridges on RS; 5 (6, 7, 8) garter ridges for Tier A, and 4 (5, 6, 9) garter ridges for Tier B.

Figure 1 shows the arrangement of the stitches with RS facing after completing Tier B.

Tier C

With waste yarn, crochet hook, and spare needle, use the Crochet-On Provisional Cast-On method to provisionally CO 15 (18, 21, 24) sts for heel insert. Set aside.

Notes: In the heel set-up row that follows, you'll work stitches outward in both directions from the heel's provisional cast-on. Doing so requires making a hairpin turn in the knitting, which is easier if your main circular needle has a very flexible cable. After working the stitches along one side of the cast-on, pull out a loop of circular needle cable as for the magic-loop method, then work the stitches from the other side of the cast-on. After working enough rows to smooth out the U-bend, you'll be able to

flatten the piece, pull the ends of the needle to remove the magic loop, and continue as before.

Set-up row: (WS) Twisting yarnovers as necessary, k1 selvedge st, k1 st with 2 dec markers, k20 (24, 28, 32), k1 inc st, k15 (18, 21, 24), k1 dec st, k10 (12, 14, 16), ending at st with 2 inc markers. Remove both inc markers. With WS still facing and using working yarn, knit the previously marked inc st, knit the first 14 (17, 20, 23) sts from provisional CO on heel insert needle. Pull out a magic loop in the main needle, knit the last CO st, and place 2 inc markers in this st. Insert the spare needle through the 15 (18, 21, 24) purl bumps of main yarn along the provisional CO and k15 (18, 21, 24) from spare needle. Twisting yarnovers as necessary, knit to end of main needle—133 (158, 183, 208) sts; 20 (24, 28, 32) rows completed; 10 (12, 14, 16) garter ridges on RS.

Figure 2 shows the arrangement of the stitches with RS facing after completing this set-up row; the stitch with 2 increase markers in the center of the heel should be the stitch before the magic loop.

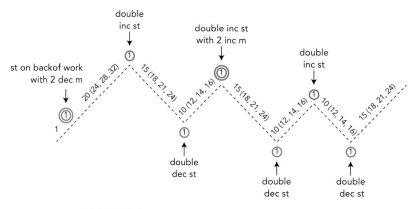

FIGURE 1: Right sock after completing Tier B.

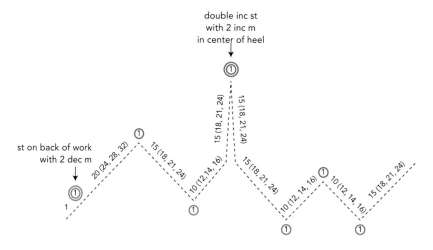

FIGURE 2: Right sock after Tier C Set-up row.

Note: For the rest of Tier C, each section contains one increase and one decrease, and the stitch counts remain constant.

Move the 2 decrease markers in the same stitch at the toe to the RS.

Row 1: (RS) Yo, knit to 1 st before dec st, sk2p; knit to inc st, work double yarnover inc in marked st; knit to 1 st before dec st, sk2p. Knit to heel st with 2 inc markers, work double yarnover inc in marked st, placing the second yo of the dec after the magic loop in the cir needle so that 1 st is added on each side of magic loop. Knit to 1 st before dec st, sk2p; knit to inc st, work double yarnover inc in marked st. Knit to 1 st before toe st with 2 dec markers, k2tog (next st tog with marked toe st), k1 selvedge st—no change to st count.

Row 2: (WS) Knit, twisting the loops of each double yarnover inc.

Rep these 2 rows 4 (5, 6, 7) more times—still 133 (158, 183, 208) sts; 30 (36, 42, 48) rows completed; 15 (18, 21, 24) garter ridges on RS.

Carefully remove waste yarn from the provisional CO heel sts.

Tiers D and E

Notes: In these tiers, the heel section is worked without any increases in the center while the decreases continue at each side; this decreases 2 stitches in the heel section every RS row. In the toe section, the stitch with 2 decrease markers is worked together with the stitch after it to create a toe "seam"; the second half of the final double yarnover increase corresponds to this "seam" decrease, and the stitch count of the toe section remains constant. At some point during Tier D or Tier E, you should be able to pull out the magic loop and flatten the work.

Move the 2 inc markers in the same st at the center of the heel to the WS; they won't be needed again until it's time

to match the marked st to the inc line in the cast-on edge during finishing.

With RS facing, move the 2 dec markers in the same st at the toe to the 12 (14, 16, 18)th st from the end of the row. Reading backward from the end of the row, the 22 (26, 30, 34) sts in the toe section should be 1 selvedge st, 10 (12, 14, 16) sts, 1 st with 2 dec markers, and 10 (12, 14, 16) sts.

Row 1: (RS) Yo, knit to 1 st before dec st, sk2p; knit to inc st, work double yarnover inc in marked st; knit to 1 st before dec st, sk2p. Knit across heel section (omit heel incs) to 1 st before next dec st, sk2p. Knit to inc st, work double yarnover inc in marked st. Knit to toe st with 2 dec markers, ssk (marked toe st tog with st after it), turn work, leaving rem sts unworked at end of row—2 sts dec'd in heel section; 1 st inc'd at start of toe section (second half of final double yarnover inc); 1 toe st dec'd between marked toe st and selvedge st.

Row 2: (WS) Knit, twisting the loops of each double yarnover inc.

Rep these 2 rows 9 (11, 13, 15) more times—113 (134, 155, 176) sts rem; 36 (43, 50, 57) heel sts between marked dec sts; with RS facing, 22 (26, 30, 34) toe sts after last marked inc st; no sts rem between toe st with 2 dec markers and selvedge st; 50 (60, 70, 80) rows completed; 25 (30, 35, 40) garter ridges on RS.

Figure 3 shows the arrangement of the stitches with RS facing after completing Tier E.

Tier F

Note: In this tier, the heel section continues to decrease by 2 stitches in each RS row as established; there's no change to the stitch counts of the other sections.

Row 1: (RS) Yo, knit to 1 st before dec st, sk2p; knit to inc st, work double yarnover inc in marked st; knit to 1 st before dec st, sk2p. Knit across heel section (omit heel incs) to 1 st before next dec st, sk2p. Knit to inc st, work

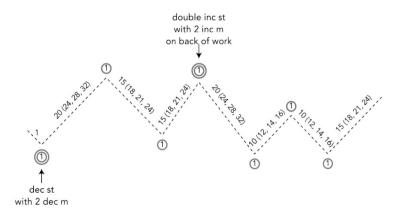

FIGURE 3: Right sock after completing Tier E.

double yarnover inc in marked st, knit to 1 st before toe st with 2 dec markers, k2tog (next st tog with marked toe st), k1 selvedge st—2 sts dec'd in heel section.

Row 2: (WS) Knit, twisting the loops of each double yarnover inc.

Rep these 2 rows 3 (4, 5, 6) more times—105 (124, 143, 162) sts rem; 28 (33, 38, 43) heel sts between marked dec sts; 58 (70, 82, 94) rows completed; 29 (35, 41, 47) garter ridges on RS; yarn tail is at top-of-leg end of needle.

Move the 2 inc markers in the same st at the center of the heel to the corresponding st in the last row as an aid for grafting in patt.

Skip to Finishing.

Left Sock

Notes: The left sock is worked similarly to the right sock, but it begins with a RS row and has different marker placement. If your yarn has a directional color sequence, start the left sock from the other end of the skein if you want the color order to be the same in both socks.

With waste yarn and crochet hook, use the Crochet-On Provisional Cast-On method to provisionally CO 87 (104, 121, 138) sts around working needle. Slide sts to the opposite needle tip so the first st of the chain cast-on is at the beg of the row.

Join working yarn and cont as foll.

Set-up Row 1: (RS) K1 (toe selvedge), k1 and place 2 dec markers in this st, k5 (6, 7, 8), backward yo, k1 and place inc marker in this st, yo, k14 (17, 20, 23), k1 and place dec marker in this st, k14 (17, 20, 23), backward yo, k1 and place 2 inc markers in this st, yo, k9 (11, 13, 15), k1 and place dec marker in this st, k14 (17, 20, 23), backward yo, k1 and place inc marker in this st, yo, k9 (11, 13, 15), k1 and place dec marker in this st, k14 (17, 20, 23) to end at top of leg—93 (110, 127, 144) sts.

Note: Although Set-up Row 1 contains double yarnover increases, it does not contain any sk2p decreases because they will be implemented when grafting in pattern.

Set-up Row 2: (WS) Yo, knit to end, working double yarnover incs as necessary to twist the sts—94 (111, 128, 145) sts; 1 garter ridge on RS.

Figure 4 shows the arrangement of the stitches with RS facing after completing Set-up Row 2.

Tiers A and B

Notes: In the first section at the toe, the first half of the first double yarnover increase does not have a

corresponding decrease, so the toe section increases by one stitch in each RS row. The middle five sections have an increase at one side and a decrease at the other; their stitch counts remain constant. In the last section for the top of the leg, the decrease in each RS row (second half of the final decrease) corresponds to the yarnover at the beginning of the following WS row and the stitch count in the top-of-leg section will be restored to its original number after each WS row; take care not to pull this starting yarnover too tightly.

Move the 2 decrease markers in the same stitch at the toe (beg of RS rows) to the WS; they will not be needed until Tier C.

Row 1: (RS) Ignoring the paired dec markers on WS at beg of row, *knit to st with inc marker, work double yarnover inc in marked st, knit to 1 st before st with dec marker, sk2p; rep from * 2 more times, knit to end—1 st inc'd in toe section; 1 st dec'd in leg section.

Row 2: (WS) Yo, knit to end, twisting the yarnovers of each double yarnover inc—1 st inc'd in leg section.

Rep these 2 rows 7 (9, 11, 13) more times, then work RS Row 1 once again—102 (121, 140, 159) sts; 17 (20, 23, 26) sts in toe section (beg of RS rows; including st with 2 dec markers and selvedge st); top-of-leg section temporarily contains 14 (17, 20, 23) sts; 19 (23, 27, 31) rows completed (including set-up rows); 9 (11, 13, 15) garter ridges on RS; 5 (6, 7, 8) garter ridges for Tier A, and 4 (5, 6, 7) garter ridges for Tier B.

Tier C

With waste yarn, crochet hook, and spare needle, use the Crochet-On Provisional Cast-On method to provisionally CO 15 (18, 21, 24) sts for heel insert. Set aside.

Note: As for the right sock, you'll work stitches outward in both directions from the heel's provisional cast-on by pulling out a magic loop of the circular needle cable.

Set-up row: (WS) Yo, knit to the st with 2 inc markers, twisting the yarnovers of each double yarnover inc. Remove both inc markers. With WS still facing and using working yarn, knit the previously marked inc st, knit the first 14 (17, 20, 23) sts from provisional CO on heel insert needle. Pull out a magic loop in the main needle, knit the last CO st, and place 2 inc markers in this st. Insert the spare needle through the 15 (18, 21, 24) purl bumps of main yarn along the provisional CO and k15 (18, 21, 24) from spare needle. Twisting yarnovers as before, knit to end of main needle—133 (158, 183, 208) sts; top-of-leg section has been restored to 15 (18, 21, 24) sts; 20 (24, 28, 32) rows completed; 10 (12, 14, 16) garter ridges on RS; 5 (6, 7, 8) garter ridges each for Tiers A and B.

Figure 5 shows the arrangement of the sts with RS facing after completing this set-up row; the st with 2 inc markers in the center of the heel should be the st before the magic loop.

Note: For the rest of Tier C, after completing each WS row, all sections will contain one increase and one decrease, and the stitch count remains constant.

Move the 2 dec markers in the same st at the toe to the RS.

Row 1: (RS) K1 selvedge st, k2tog (marked toe st tog with st after it), knit to inc st and work double yarnover inc in marked st, knit to 1 st before dec st, sk2p. Knit to heel st with 2 inc markers, work double yarnover inc in marked st, placing the second yo of the dec after the magic loop in the cir needle so that 1 st is added on each side of the magic loop. Knit to 1 st before dec st, sk2p; knit to inc st and work double yarnover inc in marked st, knit to 1 st before dec st, sk2p, knit to end—1 st dec'd in leg section.

Row 2: (WS) Yo, knit to end, twisting the loops of each double yarnover inc—1 st inc'd in leg section.

Rep these 2 rows 4 (5, 6, 7) more times—still 133 (158, 183, 208) sts; 17 (20, 23, 26) sts in toe section (including marked st and selvedge st); 30 (36, 42, 48) rows completed; 15 (18, 21, 24) garter ridges on RS.

Carefully remove waste yarn from the provisional CO heel sts.

Tiers D and E

Notes: As for the right sock, the heel section in these tiers is worked without any increases in the center while the decreases continue at each side; this decreases 2 stitches in the heel section every RS row. The number of stitches in the toe section remains constant while creating a "seam" of joined stitches; every stitch decreased between the marked toe stitch and the selvedge stitch corresponds to the first half of the first double yarnover increase. At some point during Tier D or Tier E, you should be able to pull out the magic loop and flatten the work.

Move the 2 inc markers in the same st at the center of the heel to the WS; they won't be needed again until it's time to match the marked st to the inc line in the cast-on edge during finishing.

With RS facing, remove the 2 dec markers in the same st at the toe and place them on the needle after the 12 (14, 16, 18)th st from the beg of the row; these markers will

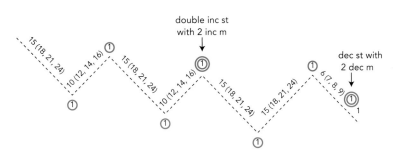

FIGURE 4: Left sock after completing Set-up Row 2.

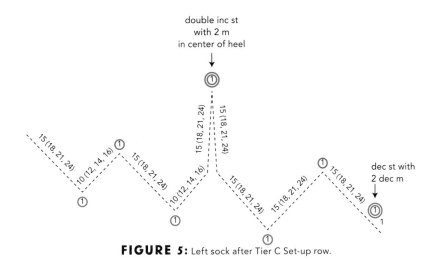

FIGURE 5: Left sock after Tier C Set-up row.

remain on the needle until the last row of Tier E. Reading from the start of the RS row, the 17 (20, 23, 26) sts in the toe section should be 1 selvedge st, 11 (13, 15, 17) sts, 2 dec markers on the needle, and 5 (6, 7, 8) sts.

Row 1: (RS) Knit to 2 sts before the 2 toe dec markers, k2tog, slip markers, knit to inc st and work double yarnover inc in marked st, knit to 1 st before dec st and sk2p. Knit across heel section (omit heel incs) to 1 st before next dec st and sk2p. Knit to inc st and work double yarnover inc in marked st, knit to 1 st before dec st and sk2p, then knit to end—2 sts dec'd in heel section; 1 st dec'd in leg section; 1 st inc'd in toe section; 1 toe st dec'd between markers on needle and selvedge st.

Row 2: (WS) Yo, then twisting the loops of each double yarnover inc, knit to toe dec markers, slip markers, k1, p1, turn work—1 st inc'd in leg section.

Row 3: Pass the second st on the left needle over the first st, sl that first stitch kwise wyb, slip toe markers, knit to inc st, work double yarnover inc in marked st, knit to 1 st before dec st, sk2p. Knit across heel section (omit heel incs) to 1 st before next dec st, sk2p. Knit to inc st, work double yarnover inc in marked st, knit to 1 st before dec st, sk2p, then knit to end—2 sts dec'd in heel section; 1 st dec'd in leg section; 1 st inc'd in toe section; 1 toe st dec'd between markers on needle and selvedge st.

Rep Rows 2 and 3 only 8 (10, 12, 14) more times, ending with a RS row—112 (133, 154, 175) sts; top-of-leg section temporarily contains 14 (17, 20, 23) sts 36 (43, 50, 57) heel sts between marked dec sts.

Next row: (WS) Yo, then twisting the loops of each double yarnover inc, knit to toe dec markers, remove markers, k1 and place both markers in this toe st as before, k1 (selvedge st)—113 (134, 155, 176) sts; 36 (43, 50, 57) heel sts between marked dec sts; top-of-leg section has been restored to 15 (18, 21, 24) sts; with RS facing, 17 (20, 23, 26) toe sts before first marked inc st; no sts rem between toe st with 2 dec markers and selvedge st; 50 (60, 70, 80) rows completed; 25 (30, 35, 40) garter ridges on RS.

Figure 6 shows the arrangement of the stitches with RS facing after completing Tier E.

TIER F

Note: In this tier, the heel section continues to decrease by 2 stitches in each RS row as established; there is no change to the stitch counts of the other sections after the top-of-leg stitch count has been restored in each WS row.

Row 1: (RS) K1 selvedge st, k2tog (marked toe st tog with st after it), knit to inc st, work double yarnover inc in marked st, knit to 1 st before dec st, sk2p. Knit across heel section (omit heel incs) to 1 st before next dec st, sk2p. Knit to inc st, work double yarnover inc in marked st, knit to 1 st before dec st, sk2p, then knit to end—2 sts dec'd in heel section; 1 st dec'd in leg section.

Row 2: (WS) Yo, knit to end, twisting the loops of each double yarnover inc—1 st inc'd in leg section.

Rep these 2 rows 3 (4, 5, 6) more times, then work RS Row 1 once more—102 (121, 140, 159) sts rem; 26 (31, 36, 41) heel sts between marked dec sts; top-of-leg section contains 14 (17, 20, 23) sts, add the missing yo at the start of this section during grafting 59 (71, 83, 95) rows completed; 29 (35, 41, 47) garter ridges on RS; yarn tail is at top-of-leg end of needle.

Move the 2 inc markers in the same st at the center of the heel to the corresponding st in the last row as an aid for grafting in patt.

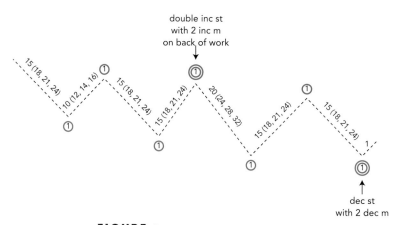

FIGURE 6: Left sock after completing Tier E.

Finishing (both socks)

To estimate the length of yarn tail needed for grafting, k10 (12, 14, 16) sts and mark where the working yarn meets the last st with a slipknot or pin. Undo these 10 (12, 14, 16) sts and return them to the left needle tip. Measure the length of yarn from the needle tip to the knot or pin—this is the length needed to graft 10 (12, 14, 16) sts. Multiply this length by 10 to find the length needed to graft the sts on the needle and cut the yarn.

Note: You may find it helpful to leave the provisional cast-on in place as you work the grafting row in order to use the path of cast-on yarn as a guide. If desired, you may "unzip" and remove the provisional cast-on as you finish grafting each section.

Using the tail threaded on a tapestry needle, with RS facing for right sock or WS facing for left sock, graft the last row of live sts to the CO loops, implementing a yarnover at the beginning of grafting row, and joining with double increases and decreases at the established points (see grafting illustrations below).

Sew the last 10 (12, 14, 16) live sts to the selvedge of the toe, matching 1 st to 1 garter ridge to maintain the 1:2 ratio, then sew the remaining two straight edges at the very tip of the toe tog.

Weave in loose ends.

Block as desired.

GRAFTING IN PATTERN

Note: The grafting yarn is shown in green.

Grafting a yarnover at the beginning of the row.

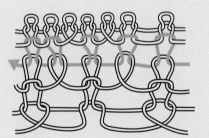

Grafting double yarnover on wrong side.

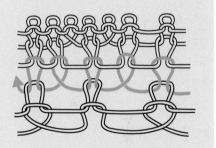

Grafting double yarnover on right side.

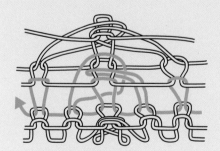

Grafting sk2p on wrong side.

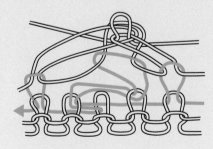

Grafting sk2p on right side.

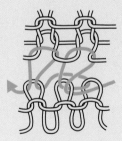

Grafting k2tog on right side.

NATALIA VASILIEVA of Moscow, Russia, was always amazed by sock construction. She constantly seeks new ways to make familiar shapes. You may find more of her work at ravelry.com/people/skeincharmer.

GLOSSARY OF TERMS AND TECHNIQUES

Abbreviations

beg(s)	begin(s); beginning	**m**	marker	**Rev St st**	reverse stockinette stitch
BO	bind off	**mm**	millimeter(s)	**rnd(s)**	round(s)
CC	contrast color	**M1**	make one (increase)	**RS**	right side
cir	circular	**M1L**	make one left slant (increase)	**sl**	slip
cm	centimeter(s)			**st(s)**	stitch(es)
cn	cable needle	**M1P**	make one purlwise (increase)	**St st**	stockinette stitch
CO	cast on			**tbl**	through back loop
cont	continue(s); continuing	**M1R**	make on right slant (increase)	**tog**	together
dec(s)('d)	decrease(s); decreasing; decreased			**w&t**	wrap and turn
		oz	ounce	**WS**	wrong side
dpn	double-pointed needles	**p**	purl	**wyb**	with yarn in back
foll	follow(s); following	**p1f&b**	purl into the front and back of the same stitch (increase)	**wyf**	with yarn in front
g	gram(s)			**yd**	yard(s)
inc(s)('d)	increase(s); increasing; increase(d)	**p2tog**	purl two stitches together (decrease)	**yo**	yarnover
				*****	repeat starting point
k	knit	**patt(s)**	pattern(s)	*** ***	repeat all instructions between asterisks
k1f&b	knit into the front and back of the same stitch (increase)	**pm**	place marker		
		psso	pass slipped stitch over	**()**	alternate measurements and/or instructions
		pwise	purlwise, as if to purl		
k2tog	knit two stitches together (decrease)	**rem**	remain(s); remaining	**[]**	work instructions as a group a specified number of times
kwise	knitwise, as if to knit	**rep**	repeat(s); repeating		

Bind-Offs

Decrease Bind-Off

This flexible bind-off technique works well at the cuff of a sock.

Slip the first stitch, knit the second stitch, then *knit these two stitches together by inserting the left-hand needle into the front of both from left to right and knitting them together through their back loops with the right needle (**Figure 1**).

Knit the next stitch (**Figure 2**).

Repeat from * for the desired number of stitches.

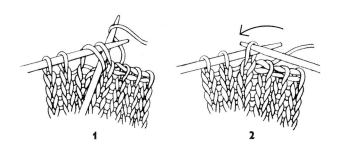

Gathered Tip

This bind-off is an easy way to finish the toe of top-down sock.

Cut the yarn, leaving a 10" (25.5 cm) tail. Thread the tail on a tapestry needle, then draw the needle through all of the remaining stitches (**Figure 1**) once (or twice for a sturdier join) and pull the yarn tight to close the hole (**Figure 2**). Insert the tapestry needle through the center of the hole and weave in the loose end on the wrong side.

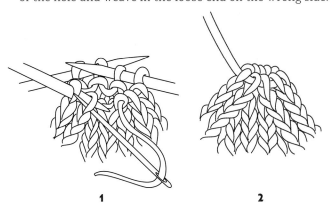

Jeny's Surprisingly Stretchy Bind-Off

This flexible bind-off technique works well at the cuff of a sock.

To Collar a Knit Stitch: Bring working yarn from back to front over needle in the opposite direction of a normal yarnover (**Figure 1**), knit the next stitch, then lift the yarnover over the top of the knitted stitch and off the needle (**Figure 2**).

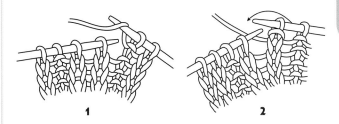

To Collar a Purl Stitch: Bring working yarn from front to back over needle as for a normal yarnover (**Figure 3**), purl the next stitch, then lift the yarnover over the top of the purled stitch and off the needle (**Figure 4**).

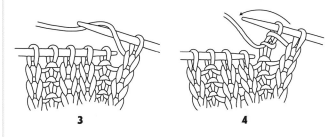

To begin, collar each of the first two stitches to match their knit or purl nature. Then pass the first collared stitch over the second and off the right needle—one stitch is bound off.

*Collar the next stitch according to its nature (**Figure 5**), then pass the previous stitch over the collared stitch and off the needle (**Figure 6**).

Repeat from * until one stitch remains on the right needle. Cut the yarn, leaving a 6" (15 cm) tail, then pull on the loop of the last stitch until the tail comes free.

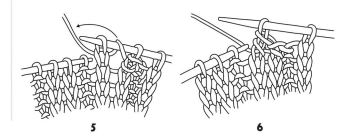

Kitchener Stitch

This grafting method adds a row of knitting by joining two sets of live stitches.

Step 1. Bring tapestry needle through the first stitch on the front needle (a knit stitch) as if to purl and leave the stitch on the needle (**Figure 1**).

Step 2. Bring tapestry needle through the first stitch on the back needle (a purl stitch) as if to knit and leave that stitch on the needle (**Figure 2**).

Step 3. Bring tapestry needle through the first front stitch as if to knit and slip this stitch off the needle, then bring the tapestry needle through the next front (knit) stitch as if to purl, and leave this stitch on the needle (**Figure 3**).

Step 4. Bring tapestry needle through the first back stitch as if to purl and slip this stitch off the needle, then bring the tapestry needle through the next back (purl) stitch as if to knit, and leave this stitch on the needle (**Figure 4**).

Repeat Steps 3 and 4 until one stitch remains on each needle, adjusting the tension to match the rest of the knitting as you go. To finish, bring the tapestry needle through the front stitch as if to knit, and slip this stitch off the needle, then bring the tapestry needle through the back stitch as if to purl and slip this stitch off the needle.

Insert the tapestry needle into the center of the last stitch worked, pull the yarn to the wrong side, and weave the tail into the purl bumps on the wrong side of the toe.

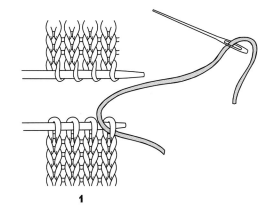

1

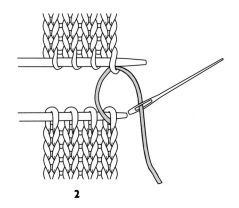

2

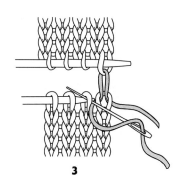

3

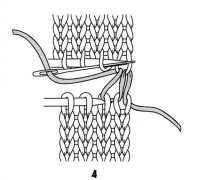

4

KITCHENER STITCH SIMPLIFIED

Once you get going, the Kitchener stitch is worked in a series of steps. The steps alternate between inserting the tapestry needle knitwise or purlwise through the stitch on the front and back needles, and they alternate between leaving a stitch on the needle and dropping one off. I recite the following chant with perfect results every time.

Set-up Step 1. Purlwise on front needle to anchor, leave on.

Set-up Step 2. Knitwise on back needle to anchor, leave on.

Step 1: Knitwise on front needle, drop off; purlwise on front needle to anchor, leave on.

Step 2: Purlwise on back needle, drop off; knitwise on back needle to anchor, leave on.

Repeat Steps 1 and 2 until all of the stitches have been joined.

Sewn Bind-Off

This flexible bind-off technique works well at the cuff of a sock.

Cut the yarn, leaving a tail about four times the circumference of the knitting to be bound off, and thread the tail on a tapestry needle.

Working from right to left, *insert tapestry needle purlwise (from right to left) through the first two stitches (**Figure 1**) and pull the yarn through.

Bring tapestry needle knitwise (from left to right) through the first stitch (**Figure 2**), pull the yarn through, then slip this stitch off the knitting needle.

Repeat from * for the desired number of stitches.

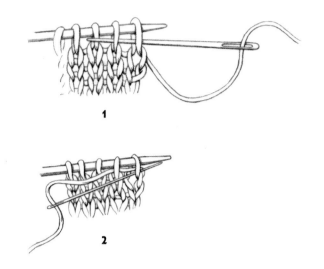

1

2

Three-Needle Bind-Off

This technique binds off two sets of live stitches together.

Place the stitches to be joined onto two separate needles and hold the needles parallel so that the right sides of the knitting face together.

Insert a third needle into the first stitch on each of the two needles (**Figure 1**) and knit them together as one stitch (**Figure 2**).

*Knit the next stitches on each needle together the same way, then use the left needle tip to lift the first stitch over the second and off the right needle (**Figure 3**).

Repeat from * until no stitches remain on the first two needles. Cut the yarn and pull on the loop of the last stitch until the tail comes free.

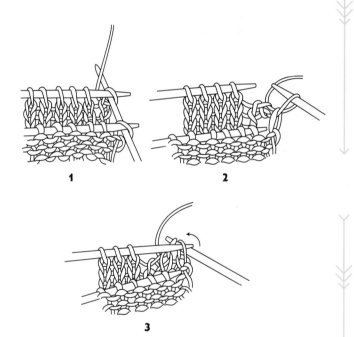

1

2

3

Tubular Bind-Off

This flexible bind-off method is ideal for k1, p1 ribbing at the cuff of a sock.

Cut the yarn, leaving a tail about three times the circumference of the knitting to be bound off, and thread the tail on a tapestry needle.

Step 1. Working from right to left, insert the tapestry needle purlwise (from right to left) through the first (knit) stitch (**Figure 1**) and pull the yarn through to the front.

Step 2. Bring the tapestry needle behind the knit stitch, up to the front between the knit stitch and purl stitch that follows, then insert it knitwise (from left to right) into the second stitch (the purl stitch; **Figure 2**), and pull the yarn through to the back.

Step 3. *Insert the tapestry needle into the first knit stitch knitwise and slip this stitch off the knitting needle.

Step 4. Insert the tapestry needle purlwise into the next knit stitch (**Figure 3**) and pull the yarn through to the front.

Step 5. Insert the tapestry needle into the first purl stitch purlwise and slip this stitch off the knitting needle (**Figure 4**).

Step 6. Bring the tapestry needle behind the knit stitch, up to the front between the knit stitch and the purl stitch that follows, then insert it knitwise into the second stitch (the purl stitch), and pull the yarn through to the back.

Repeat from * until one stitch remains on the knitting needle. Insert the tapestry needle purlwise through this last stitch, draw the yarn through, and pull tight to secure.

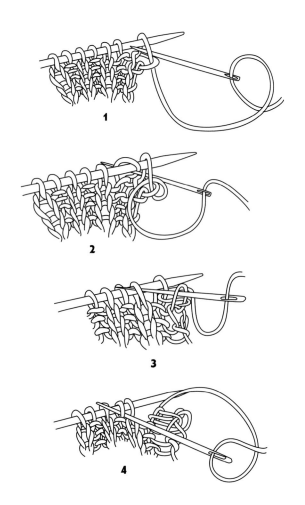

Cast-Ons

Backward-Loop Cast-On

This cast-on is a simple, but relatively unstable technique.

*Loop working yarn and place it on needle backward so that it doesn't unwind.

Cable Cast-On

This flexible cast-on technique works well at the cuff of a sock.

Make a slipknot of working yarn and place it on the left needle.

Insert the right needle tip into the slipknot knitwise, wrap the yarn around the needle as to knit, pull the loop through (**Figure 1**), and place it on the left needle in front of the slipknot (**Figure 2**).

*Insert right needle between the first two stitches on left needle, wrap yarn around needle as to knit, draw yarn through, and place new loop on left needle (**Figure 3**) to form a new stitch.

Repeat from * for the desired number of stitches, always working between the first two stitches on the left needle.

Crochet-On Provisional Cast-On

This cast-on technique lets you work stitches outward in both directions from the cast-on edge.

Make a slipknot on a crochet hook and hold it in your right hand. Hold a knitting needle and yarn in your left hand. Bring the yarn under the needle, then use the crochet hook to grab a loop of yarn over the top of the needle, and pull it through the slipknot. *Bring the yarn back under the needle, use the crochet hook to grab a loop over the top of the needle, and pull it through the loop on the crochet hook. Repeat from * for one fewer than the desired number of stitches, then transfer the loop from the crochet hook onto the needle for the last stitch.

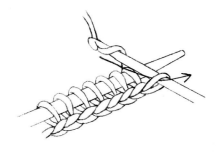

Emily Ocker's Circular Cast-On

This technique is used to cast-on stitches at the center of a circle or square.

Make a simple loop of yarn with the short end hanging down. With a crochet hook, *draw a loop through the main loop, then draw another loop through this loop. Repeat from * for each stitch to be cast on. Divide the stitches evenly on four double-pointed needles.

After several inches of the pattern have been worked, pull on the short end to tighten the loop and close the circle.

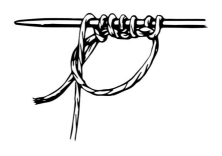

Invisible K1, P1, Rib Cast-On

This flexible cast-on technique is related to the Long-Tail Cast-On (see page 158) and works well for a k1, p1 ribbing pattern at the cuff of a sock.

Leaving a long tail (see How Long Is "Long"? on page 158), place a slipknot on needle. The slipknot counts as the first knit stitch.

Hold the end of yarn that's attached to the ball over your left index finger (called the "index" yarn) and the tail end over your thumb (called the "thumb" yarn); close your other fingers around both ends to provide the necessary tension.

Step 1: Bring needle over the top of the index yarn, under both strands, then over the top of the thumb yarn to put a loop on the needle (**Figure 1**), then under the index yarn so that the index yarn is in front of and below the needle (**Figure 2**)—1 purl stitch made.

Step 2: Bring needle to the front, under the thumb yarn, then over the index yarn to put a loop on the needle (**Figure 3**), then bring needle to the front under the thumb yarn (**Figure 4**)—1 knit stitch made.

Repeat Steps 1 and 2 for the desired number of stitches, ending with a purl stitch.

Join for working in rounds and set up ribbing as follows.

Rnds 1 and 3: *K1 (this is the slipknot), sl 1 purlwise with yarn in front; repeat from *.

Rnds 2 and 4: *Sl 1 purlwise with yarn in back, p1; repeat from *.

Continue in k1, p1 rib as usual.

Invisible Provisional Cast-On

This cast-on technique lets you work stitches outward in both directions from the cast-on edge.

Make a loose slipknot of working yarn and place it on the right needle. Hold a length of contrasting waste yarn (shaded dark) next to the slipknot and around your left thumb; hold the working yarn over your left index finger. *Bring the right needle forward under the waste yarn, over the working yarn, grab a loop of working yarn (**Figure 1**), then bring the needle back behind the working yarn and grab a second loop (**Figure 2**). Repeat from * for the desired number of stitches, always adding stitches in pairs.

When you're ready to work in the opposite direction, place the exposed loops on a knitting needle as you pull out the waste yarn.

Judy's Magic Cast-On

This cast-on technique lets you work stitches outward in both directions from the cast-on edge.

Leaving a 10" (25.5 cm) tail, drape the yarn over one needle, then hold a second needle parallel to and below the first, and on top of the yarn tail (**Figure 1**).

Bring the tail to the back and the ball yarn to the front, then place the thumb and index finger of your left hand between the two strands so that the tail is over your index finger and the ball yarn is over your thumb (**Figure 2**). This forms the first stitch on the top needle.

*Continue to hold the two needles parallel and loop the finger yarn over the lower needle by bringing the lower needle over the top of the finger yarn, then bringing the finger yarn up from below the lower needle, over the top of this needle, then to the back between the two needles (**Figure 3**).

Point the needles downward, bring the bottom needle past the thumb yarn, then bring the thumb yarn to the front between the two needles and over the top needle (**Figure 4**).

Repeat from * until you have the desired number of stitches on each needle (**Figure 5**).

Remove both yarn ends from your left hand, twist the two strands to secure the last stitch, rotate the needles like the hands of a clock so that the bottom needle is now on top and both strands of yarn are at the needle tip. Using a third needle, knit the half of the stitches from the top needle (**Figure 7**). There will now be the same number of stitches on two needles and twice that number of stitches on the bottom needle.

The two needles with the smaller number of stitches will form the bottom of the foot; the needle with the most stitches will form the top of the foot.

Using a fourth needle, begin working in rounds.

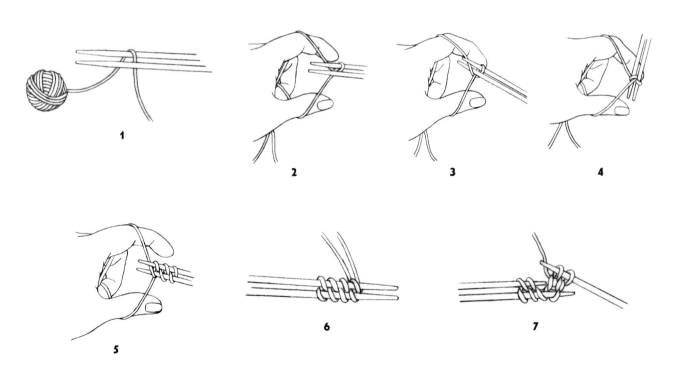

Long-Tail Cast-On

This cast-on is an all-purpose method for casting on. Be sure to leave about ¼" (6 mm) gap between each cast-on stitch to ensure suitable elasticity.

Leaving a long tail (see How Long Is "Long"? below), make a slipknot, and place it on the right needle

Place the thumb and index finger of your left hand between the yarn ends so that the working yarn is around your index finger and the tail end is around your thumb.

Secure both yarn ends with your other fingers. Hold your palm upward, making a V of yarn (**Figure 1**).

*Bring the needle up through the loop on your thumb (**Figure 2**), catch the nearest strand around your index finger, and bring the needle back down through the loop on your thumb (**Figure 3**).

Drop the loop off your thumb and place your thumb back in the V configuration while tightening the resulting stitch on the needle (**Figure 4**).

Repeat from * for the desired number of stitches.

HOW LONG IS "LONG"?

The length of tail needed for the long-tail cast-on depends on the size of the needles and the number of stitches to cast on. A good estimate is to measure the length of yarn needed to wrap around the needle the number of times as stitches to be cast on, then add about 6" (15 cm) for safety. For speed and simplicity, I usually allow about ½" (1.3 cm) of tail for each stitch to be cast on. This ensures that the tail won't run out before I've cast on the proper number of stitches.

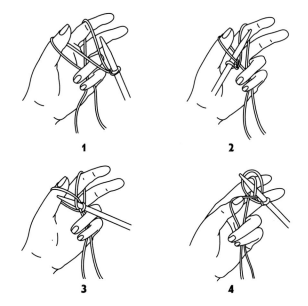

Old Norwegian Cast-On

This flexible cast-on technique works well at the cuff of a sock.

Leaving a long tail (see How Long is "Long"? above), make a slipknot and place it on the right needle.

Place the thumb and index finger of your left hand between the yarn ends so that the working yarn is around your index finger and the tail end is around your thumb. Secure both yarn ends with your other fingers. Hold your palm upward, making a V of yarn (**Figure 1**).

*Bring needle in front of your thumb, under both yarns around your thumb, then down into the center of the thumb loop, forward in front of your thumb, and then over the top of the yarn around your index finger (**Figure 2**).

Use the needle to catch the yarn on your index finger, then bring the needle back down through the thumb loop (**Figure 3**) and to the front, turning your thumb slightly to make room for the needle to pass through.

Drop the loop off your thumb (**Figure 4**) and place your thumb back in the V configuration, while tightening the resulting stitch on the needle (**Figure 5**).

Repeat from * for the desired number of stitches.

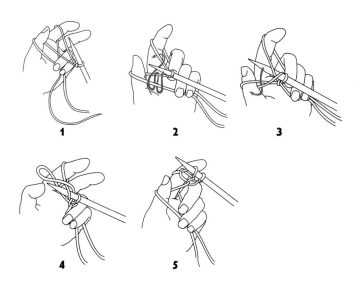

Turkish (Eastern) Cast-On

This technique lets you work stitches outward in both directions from the cast-on edge.

Hold two double-pointed needles parallel to each other. Leaving a 4" (10 cm) tail hanging to the front between the two needles, wrap the yarn around both needles from back to front half the number of times as desired stitches (four wraps shown here for eight stitches total), then bring the yarn forward between the needles (**Figure 1**).

Use a third needle to knit across the loops on the top needle, keeping the third needle on top of both the other needles when knitting the first stitch (**Figure 2**).

With the right side facing, rotate the two cast-on needles like the hand of a clock so that the bottom needle is on the top (**Figure 3**).

Knit across the loops on the new top needle (**Figure 4**).

Rotate the needles again and use a third needle to knit half of the stitches on the new top needle. There will now be the same number of stitches each on two needles (two stitches shown) and twice that number of stitches on a third needle (**Figure 5**).

The two needles with the same number of stitches each (two stitches shown) will form the bottom of the foot; the needle with double that number of stitches (four stitches shown) will form the top of the foot. Using a fourth needle, begin working in rounds.

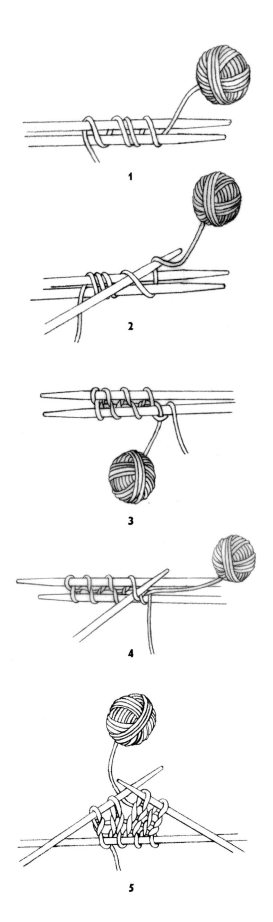

1

2

3

4

5

Decreases

Knit 2 Together (k2tog)

Knit two stitches together as if they were a single stitch.

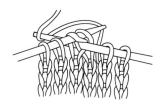

Purl 2 Together (p2tog)

Purl two stitches together as if they were a single stitch.

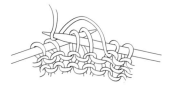

Purl 2 Together Through Back Loop (p2tog tbl)

Bring right needle tip behind two stitches on left needle, enter through the back loop of the second stitch, then the first stitch, then purl them together.

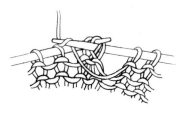

Slip, Slip, Knit (ssk)

Slip two stitches individually knitwise (**Figure 1**), insert left needle tip into the front of these two slipped stitches, and use the right needle to knit them together through their back loops (**Figure 2**).

1 2

Slip, Slip, Slip, Knit (sssk)

Slip three stitches individually knitwise (**Figure 1**), insert left needle tip into the front of these three slipped stitches, and use the right needle to knit them together through their back loops (**Figure 2**).

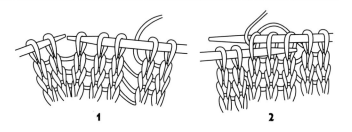

1 2

Slip, Slip, Purl (ssp)

Holding yarn in front, slip two stitches individually knitwise (**Figure 1**), then slip these two stitches back onto the left needle (they will be twisted on the needle), and purl them together through their back loops (**Figure 2**).

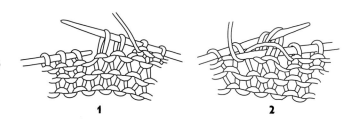

1 2

I–Cord

Working with two double-pointed needles, cast on the desired number of stitches (usually three). Knit across these stitches, then *without turning the needle, slide stitches to other end of needle, pull the yarn around the back, and knit the stitches as usual. Repeat from * for the desired length.

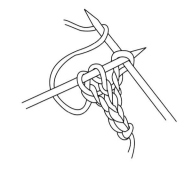

Increases

Bar Increases

KNITWISE (K1F&B)

Knit into a stitch but leave the stitch on the left needle (**Figure 1**), then knit through the back loop of the same stitch (**Figure 2**), and slip the original stitch off the needle (**Figure 3**).

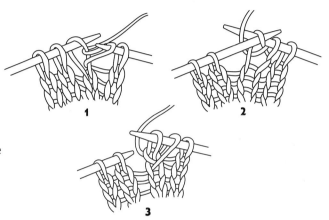

Raised Make-One (M1) Increases

Note: Use the left slant (M1L) if no direction is specified.

LEFT SLANT (M1L)

With left needle tip, lift the strand between the last knitted stitch and the first stitch on the left needle from front to back (**Figure 1**), then knit the lifted loop through the back (**Figure 2**) to twist it.

RIGHT SLANT (M1R)

With left needle tip, lift the strand between the needles from back to front (**Figure 1**), then knit the lifted loop through the front (**Figure 2**) to twist it.

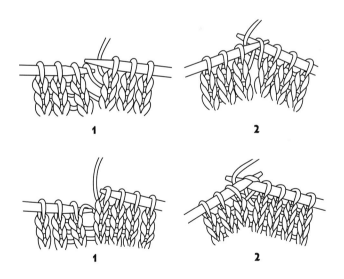

PURLWISE (M1P)

With left needle tip, lift the strand between the needles from front to back (**Figure 1**), then purl the lifted loop through the back (**Figure 2**) to twist it.

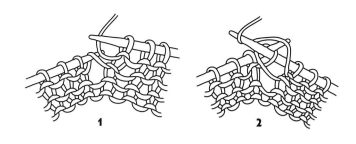

Lifted Increases

Note: Use the right slant (RLI) if no slant direction is specified.

RIGHT SLANT (RLI)

Insert right needle tip into the back of the stitch (in the "purl bump") in the row directly below the first stitch on the left needle (**Figure 1**), knit this lifted stitch, then knit the first stitch on the left needle (**Figure 2**).

LEFT SLANT (LLI)

Insert left needle tip into the back of the stitch (in the "purl bump") below the stitch just knitted (**Figure 1**), then knit this lifted stitch (**Figure 2**).

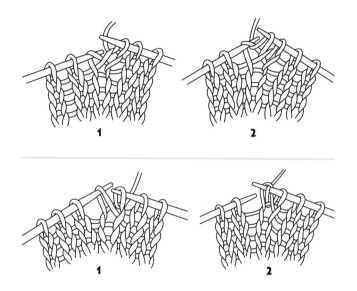

Jogless Jog

Meg Swansen championed this method for eliminating the "jogs" that can form between the last stitch of one color on one round and the first stitch of another color on the next round.

Let's say you've knitted a stripe with A and you want to knit a second stripe with B. Drop A (light) and work to the end of the round with B (dark; **Figure 1**), then work the first stitch of the round again with B by using the right needle tip to lift the stitch in the row below onto the needle (**Figure 2**), then knit this lifted stitch together with the first stitch of the round. Although the first stitch has been knitted twice, it was worked into the row below the second time and therefore shows up for just one round. There is no jog between the two colors, but the beginning of the round shifts one stitch to the left.

Each time you change colors, work the first stitch of the round a second time into the row below the stitch on the needle to eliminate subsequent jogs. The beginning of the round will shift one stitch to the left at every color change.

Because each color stripe appears as a complete circle, a round can begin with any stitch. When it's time to shape the heel, for example, simply shift the stitches on the needles as necessary to put the beginning of the round at the desired place, join new yarn, and continue as usual.

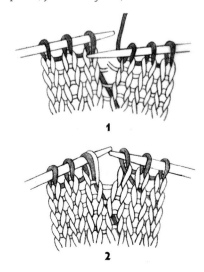

Pick Up and Knit

There are many ways to pick up and knit stitches along the gusset (or other) edges.

Pick Up a Single Loop

For very little bulk along the pick-up edge, pick up stitches through the front half of each edge stitch. *Insert the needle under the front half of the selvedge stitch (**Figure 1**), wrap the yarn around the needle (**Figure 2**), and pull a loop through. Repeat from * for the desired number of stitches (**Figure 3**).

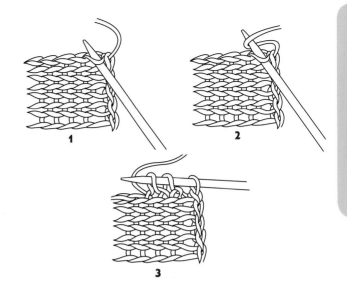

Pick Up Both Loops

For a sturdier join, pick up the gusset stitches through both halves of the edge stitches. *Insert the needle under both halves of the selvedge stitch (**Figure 1**), wrap the yarn around the needle (**Figure 2**), and pull a loop through. Repeat from * for the desired number of stitches (**Figure 3**).

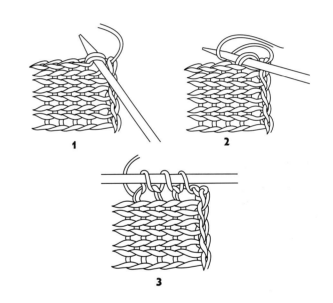

Pick Up Through the Back Loops

For a very tight join, pick up the stitches by working into the back loop of either the first half as shown, or both halves of each edge stitch. *Use the needle in your left hand to lift the selvedge stitch, then insert the right needle into the back of the lifted stitch (**Figure 1**), wrap the yarn around the right needle (**Figure 2**), and pull a loop through. Repeat from * for the desired number of stitches (**Figure 3**).

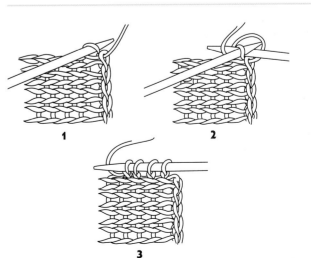

Pick Up and Purl

With wrong side of work facing and working from right to left, *insert the needle tip under both legs of the selvedge stitch from the far side to the near side (**Figure 1**), wrap the yarn around the needle, and pull a loop through (**Figure 2**). Repeat from * for the desired number of stitches.

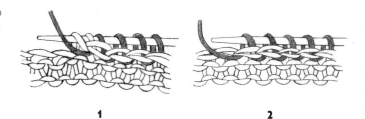

Short-Rows

Short-Rows Knit Side

Work to turning point, slip next stitch purlwise (**Figure 1**), bring the yarn to the front, then slip the same stitch back to the left needle (**Figure 2**), turn the work around, and bring the yarn in position for the next stitch—one stitch has been wrapped, and the yarn is correctly positioned to work the next stitch.

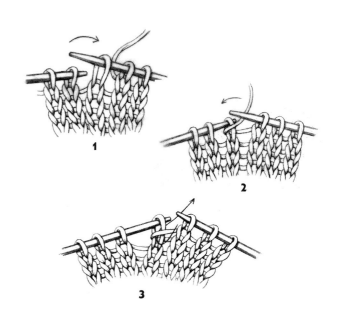

When you come to a wrapped stitch on a subsequent row, hide the wrap by working it together with the wrapped stitch as follows: insert right needle tip under the wrap (from the front if wrapped stitch is a knit stitch; from the back if wrapped stitch is a purl stitch; **Figure 3**), then into the stitch on the needle, and work the stitch and its wrap together as a single stitch.

Short-Rows Purl Side

Work to the turning point, slip the next stitch purlwise to the right needle, bring the yarn to the back of the work (**Figure 1**), return the slipped stitch to the left needle, bring the yarn to the front between the needles (**Figure 2**), and turn the work so that the knit side is facing—one stitch has been wrapped, and the yarn is correctly positioned to knit the next stitch.

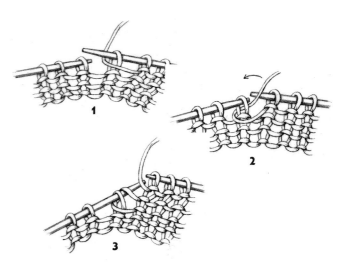

To hide the wrap on a subsequent purl row, work to the wrapped stitch, use the tip of the right needle to pick up the wrap from the back, place it on the left needle (**Figure 3**), then purl it together with the wrapped stitch.

SOURCES FOR YARNS

BISCOTTE & CIE

1315 Roberval St.
Saint-Bruno, QC
Canada J3V 5J1
BiscotteYarns.com

BLACK TRILLIUM FIBERS

BlackTrilliumFibers.com

BROWN SHEEP COMPANY

100662 County Rd. 16
Mitchell, NE 69357
BrownSheep.com

CASCADE YARNS

PO Box 58168
1224 Andover Park E.
Tukwila, WA 98188
CascadeYarns.com

DREAM IN COLOR

DreaminColorYarn.com

FROG TREE YARNS

PO Box 1119
East Dennis, MA 02641
FrogTreeYarns.com

KATHRYN ALEXANDER DESIGNS

PO Box 202
Johnsonville, NY 12094
KathrynAlexander.net

KOIGU WOOL DESIGNS

Box 158
Chatsworth, ON
Canada N0H 1G0
Koigu.com

LOLA-DOODLE'S

Etsy.com/shop/LolaDoodles

KNITTING FEVER, INC./ NORO

PO Box 336
315 Bayview Ave.
Amityville, NY 11701
KnittingFever.com

PLUCKY KNITTER

ThePluckyKnitter.com

SKACEL COLLECTION, INC./SCHOPPEL WOLLE/ SCHULANA

PO Box 88110
Seattle, WA 98138
SkacelKnitting.com

STRING THEORY

132 Beech Hill Rd.
Blue Hill, ME 04614
StringTheoryYarn.com

SWEETGEORGIA YARNS, INC.

110-408 E. Kent Ave. S.
Vancouver, BC
Canada V5X 2X7
SweetGeorgiaYarns.com

TWISTED FIBER ART, INC.

406 S. Jefferson, Ste. B
PO Box 721
Mason, MI 48854
TwistedFiberArt.com

WOLLKENSCHAF

Wollkenschaf.de

ROHRSPATZ & WOLLMEISE

Andreas Wellman
Poststr. 1
85276 Pfaffenhofen/Ilm
Germany
Rohrspatzundwollmeise.de

UNICORN BOOKS & CRAFTS/ZWERGER GARN (OPAL)

1338 Ross St.
Petaluma, CA 94954
UnicornBooks.com

TECHNICAL EDITOR	*Lori Gayle*
PHOTOGRAPHER	*Donald Scott*
STYLIST	*Allie Liebgott*
PHOTO ART DIRECTOR	*Charlene Tiedemann*
COVER AND INTERIOR DESIGN	*Courtney Kyle*
ILLUSTRATORS	*Gayle Ford and Kathie Kelleher*

Text © 2015 Ann Budd

Individual patterns © 2015 specified designers

Illustrations and photographs © 2015 Interweave, a division of F+W Media, Inc.

Published by Interweave, an imprint of F+W, A Content + eCommerce Company, 10151 Carver Road, Suite 200, Blue Ash, Ohio 45242. (800) 289-0963. First Edition.

a content + ecommerce company

12 11 10 09 08 5 4 3 2 1

Distributed in Canada by Fraser Direct
100 Armstrong Avenue
Georgetown, ON, Canada L7G 5S4
Tel: (905) 877-4411

Distributed in the U.K. and Europe by
F&W MEDIA INTERNATIONAL
Brunel House, Newton Abbot,
Devon, TQ12 4PU, England
Tel: (+44) 1626 323200, Fax: (+44) 1626 323319
Email: enquiries@fwmedia.com

Distributed in Australia by Capricorn Link
P.O. Box 704, S. Windsor NSW, 2756 Australia
Tel: (02) 4560 1600, Fax: (02) 4577 5288
Email: books@capricornlink.com.au

16KN01; ISBN-13: 978-1-62033-943-5

ACKNOWLEDGMENTS

I love working on contributor-driven books. They include a much wider range of styles and approaches than I could possibly come up with on my own. The socks in this book push the limits of traditional construction, and I applaud the following designers for their efforts: Kathryn Alexander, Kate Atherley, Anne Berk, Cat Bordhi, Carissa Browning, Anne Campbell, Rachel Coopey, Hunter Hammersen, Marjan Hammink, General Hogbuffer, Jenifer Leigh, Heidi Nick, Louise Robert, Betty Salpekar, Jeny Staiman (who also provided great help with the illustration on page 129), Nicola Susen, and Natalia Vasilieva.

My sincere thanks to the yarn companies who so generously supplied the yarn for the projects, many of which were specifically chosen for the patterns: Biscotte & Cie, Black Trillium Fibers, Brown Sheep Company, Cascade Yarns, Dream in Color, Frog Tree Yarns, Kathryn Alexander Designs, Koigu Wool Designs, Lola-Doodle's, Knitting Fever, Plucky Knitter, Skacel Collection, String Theory, SweetGeorgia Yarns, Twisted Fiber Art, WOLLkenSchaf, Rohrspatz & Wollmeise, and Unicorn Books & Crafts.

Many, many thanks to Lori Gayle for her herculean efforts to find and correct errors in these innovative patterns and to guide the reader through their many twists and turns.

Thanks also go to Interweave/F+W Media for believing in my vision and creating the book you hold in your hands.

Finally, I'd like to thank my family of boys—David, Alex, Eric, and Nicholas—for once again putting up with distracted-me while this book was in process.

INDEX